THE IRISH FACE IN AMERICA

Dedicated to Eileen Regan McNamara, my mother, for her love and support, wisdom and laughter

— J.M.

Dedicated to one Irish American who sparkles with all the qualities that shine from these pages, my wife, Anne

— J.S.

edited by Julia McNamara introduction by Pete Hamill photographs by Jim Smith

THE IRISH FACE IN AMERICA

Bulfinch Press New York ● Boston

Bulfinch Press

Time Warner Book Group
1271 Avenue of the Americas, New York, NY 10020
Visit our Web site at www.bulfinchpress.com

First Edition

Library of Congress Cataloging-in-Publication Data
The Irish face in America / edited by Julia McNamara ; introduction by Pete Hamill ; photographs by Jim Smith. — 1st ed.
 p. cm.
 ISBN 0-8212-2883-8
1. Irish Americans — Pictorial works. 2. Irish Americans — Social life and customs. 3. Irish Americans — Biography. I. McNamara, Julia. II. Smith, Jim. III. Title.

E184.I6I6815 2004
973'.049162'00922 — dc22 2004000563

For information regarding sales to corporations, organizations, mail-order catalogs, premiums, and other non-book retailers and wholesalers contact:

Special Markets Department
Time Warner Book Group
Sports Illustrated Building
135 West 50th Street
New York, New York 10020-1393
Tel: 1-800-222-6747

Martin Sheen photograph on page 59 by Kevin Foley. Father Bill O'Donnell photograph on page 107 copyright (c) 2004 by Kat Wade/ San Francisco Chronicle.
Design by Wilcox Design

PRINTED IN SINGAPORE

CONTENTS

INTRODUCTION

PETE HAMILL

Of one thing I'm certain: there is no such thing as an Irish face, yet I know one when I see one. In physiognomy, Seamus Heaney does not resemble James Joyce and neither looks like Flann O'Brien. All three are triumphantly Irish. So are all the people in this wonderful book. Their faces tell us, in some mysterious way, that they are all part of the same tribe.

For decades now, anthropologists have explained to us that the ancient Celts were small dark-haired people. Yet there are many tall Irish people with red hair and blue eyes, and Irish people with mops of curly black hair, and others who are bald at twenty-three. Some have dour, angular, unforgiving faces while others seem formed by a state of permanent mirth. There are hawk-nosed Irishmen and pug-nosed Irishwomen. There are some with features as blunt as axes and others as refined as a Gainsborough. On a trip through Dublin or Cork or Belfast, or among the Irish of the various diasporas, there are Irish faces that are open and welcoming, and faces that are frozen into closed urban masks.

The variety of the faces reflects the island's long-tangled history. Look hard and you can imagine the Norsemen arriving each winter for warmth and pillage. For them, in flight from Scandinavian wind and ice, Ireland was a kind of Miami. You can see Normans and Anglo-Saxons roaming the Irish countryside, looking for targets of sexual opportunity. Centuries of colonists left certain faces behind, full of self-righteousness, of moral doubt, and, occasionally, of guilt. You can see the legendary sons of Andalusia cast upon Irish shores by the storm that sank the Armada, all those Castillos turned into Costellos. You can see the Spanish sailors who traded in Galway Bay and were driven by love to stay behind. You can see the abrupt features of German settlers in the twentieth-century South and of straying GIs in the North. There are as many different Irish faces as there are ways to be Irish. Ireland, like most countries, is plural.

In America, the Irish helped form the human alloy of cities, starting in the unhappy years of the nineteenth century. In my own New York, many Irish immigrants settled into the vile slum called the Five Points, which they shared with African Americans and a small number of impoverished Germans and Jews. The ghettos of the time were based on class, not race or religion; Harlem was a phenomenon of the early twentieth century. And so some Irishwomen married the sons of slaves. Some Irishmen married women whose parents spoke Ashanti or Yoruba. Most worked their way out of the Points. Some of those who stayed behind were savaged by racist Irish louts during the Draft Riots of 1863, usually for the crime

of loving someone from a different branch of the Irish tree. The best of them endured. So did their names — I've known three different black Americans named Kelly. And so did the Irishness in the faces of their children and their children's children: a certain amusement in the eyes, an Irish grin, a simmering Irish anger. You can see fragments of that Irish-African past today, on faces from New York to San Francisco and many places in between, including the American South. They should remind us (although the history is seldom mentioned anymore) that in the years before the American Revolution, the indentured Irish and the manacled Africans were sold together in the same British slave markets of Charleston and Wall Street.

But there were many other mergers among the strangers in a strange land. Irishmen and -women married Jews or Germans or Italians. They found love with Puerto Ricans and Cubans and Mexicans. In the years of racist anti-Asian immigration laws, when there were few Chinese women in New York or San Francisco, a number of Chinese men found Irish wives. Their children were beautiful. Such mergers were not general, but there were enough of them to show that some of the Irish, when they had forever left the Old Country behind, were comfortable among people who were not like them.

That was certainly true of life in the Old Country too. Those who were not like them were generally of the same race, if such a category has validity anymore. But there were barriers between the Irish themselves that seemed unsurmountable: class and religion. Yet even those barriers often fell. In the North, where the quarrels of the seventeenth century persisted, some friendships between Catholics and Protestants endured, even after the terrible years that followed 1968. Here and there, a Catholic married a Protestant, knowing that such a union could risk each partner's life. In the darkest of those years, I had people in Belfast or Derry tell me that they could distinguish a Catholic from a Protestant by the look of a face.

In the United States, religion was less important than class when judging Irish Americans. John O'Hara was a tough, prickly Irish-American writer, too easily offended, but in his 1935 novel, *BUtterfield 8,* he touched on the Irish face as a kind of evidence, like a flag. His autobiographical character, Jim Malloy, cranky and hard-drinking, takes a well-off young American woman to a speakeasy. As they look around, the subject turns to class. The woman, Isabel Stannard, protests his touchiness:

"I beg your pardon, but why are you talking about you people, you people, your kind of people, people like you. *You* belong to a country club, you went to good schools and your people at least *had* money —"

Malloy answers:

"I want to tell you something about myself that will help to explain a lot of things about me. You might as well hear it now. First of all, I am a Mick. I wear Brooks Brothers clothes and I don't eat salad with a spoon and I probably could play five-goal polo in two years, but I am a Mick. Still a Mick. Now it's taken me a little time to find this out, but I have at last discovered that there are not two kinds of Irishmen. There's only one kind. I've studied enough pictures and know enough Irishmen personally to find that out."

"What do you mean, studied enough pictures?"

"I mean this, I've looked at dozens of pictures of the best Irish families at the Dublin Horse Show and places like that, and I've put my finger over their clothes and pretended I was looking at a Knights of Columbus picnic — and by God you can't tell the difference."

"Well, why should you? They're all Irish."

"And that's exactly my point . . ."

A bit later he adds: "I'm pretty God damn American, and therefore my brothers and sisters are, and yet we're not American. We're Micks, we're non-assimilable, we Micks."[*]

Such talk now seems part of the distant past. Irish America has had its president. It has its captains of industry. It has more than its share of writers and journalists, acclaimed lawyers, honored professors, and scientists. Sports and entertainment were once the way out of the Irish-American ghetto, as they continue to be for African Americans. But there are no longer any Irish prizefighters, nor Stage Irishmen. In the National Basketball Association, there are far more Irish-American coaches than Irish-American players. The enduring O'Hara-like touchiness and defensiveness that I saw when I was young are almost completely erased. Gone too is the belief among many Irish Americans that the deck is stacked against them simply because of their Irishness. I have lived long enough to see Irish America win all the late rounds.

Perhaps that's why these Irish faces have a new aspect to them, one that was seldom seen a half century ago. There is pride in many of the faces, but little vanity. There is the knowledge of what it takes to overcome adversity. There is a relaxed quality to many of them, the ease that comes from knowing that you are getting the most that you can possibly get out of the only life you will ever live. There's also, in the eyes, a sense of irony. That sense is always based upon an understanding of the difference between what is said and what is done, what is promised and what is delivered. The Irish in America, like the Irish in Ireland, have paid all the dues necessary for such knowledge. There is no such thing as an Irish face, but I know one when I see one.

9

[*] O'Hara, John. *BUtterfield 8.* Random House (1994 edition).

PART I

CULTURE AND ENTERTAINMENT

THE IRISH INFLUENCE ON MUSIC, CULTURE, AND LITERATURE IN AMERICA

PATRICIA HARTY

When I was growing up in Ireland, every small town and village had its own amateur dramatics group. I still remember going to see productions at the village hall in Ballycommon as a child; I don't recall the names of the plays I saw, but I do remember recognizing several locals up on the stage and wondering at their transformation.

I suppose you would expect that the Irish, who descended from the Celts, a people who wore nothing but body paint when they went into battle, and the Vikings, who favored those horned headdresses, would have an inherited love of theater.

As an Irish child, you learned to have a party piece, a song or a dance, at the ready in case you were called upon to perform, whether it be for a wake or a wedding. Listening to the old Irish ballads, I am filled with that feeling of continuity and connection to the ancients that only such songs can bring. This handing down of song and dance and the love of a good story forms the essence of our culture, an essence that Irish immigrants brought with them when they left their homeland.

They brought it to the mining camps in Butte, Montana, and to the steel mills of Pennsylvania. They carried it to the Pacific Northwest, singing to the rhythm of hammering and tracklaying as they built the great transcontinental railroad, and to New Orleans, where they built the canals and died of yellow fever in the swamps. And they made up new ballads chronicling these and other experiences in the New World:

Ten thousand Micks
They swung their picks
To dig the new canal
But the choleray was stronger'n they
And killed 'em all away.
— Irish ballad, 1800s

Other songs, such as "Paddy's Lamentation" and "The Harp of Old Erin and Banner of Stars," tell of the Irish soldiers who fought in the American Civil War.

"The traditional music of Ireland was the only enduring cultural baggage, intangible as it was, that impoverished emigrants could take out of the country," Nuala O'Connor wrote in *Bringing It All Back Home,* a book on the influence of Irish music. The book complements the television series and CDs of the same name, creating a fascinating package that explores how Irish music changed as men and women left their native Ireland and traveled to new lands. Sometimes the music evolved, and other times it remained almost untouched, "a living vibrant bridge to the past."

One of the safekeepers of the Irish tradition was Francis O'Neill, a Chicago chief of police in the early part of the last century who collected thousands of Irish tunes that later made their way back to Ireland, reinvigorating the tradition when it most needed it.

But even as organizations such as the Gaelic League and Comholtas Ceoltóirí worked to preserve the purity of the traditional Irish artistic forms in America, we are, as the saying goes, "part of all that we met." And Irish music, dance, and literature found new forms of expression in a new world.

In New York City, where I live, there are more Irish *seisiúns* than you will ever find in Ireland. And throughout the United States, fiddle players such as the Bronx's Eileen Ivers, Portland's Kevin Burke, and Chicago's Liz Carroll and Martin Hayes continue to reinvent traditional music. On an evening in Paddy Reilly's Music Bar, I have listened as Joanie Madden (Cherish the Ladies) joined Seamus Egan (Solas), both flute players, and been gobsmacked not just by the level of play but also by their love of the music. For me it's particularly poignant when a musician or singer is American born and the gift, the love of Irish music, has been handed down.

Remnants of Irish music exist in many different musical genres. You can hear the strains of an Irish fiddle in bluegrass and country music. The Irish-American Dorsey brothers interpreted their music through jazz and swing. And, of course, there are artists who can perform an operatic piece and just as quickly switch to an Irish tune. In the tradition of the great John McCormack, who played to sold-out concert halls across the United States, there are the Irish tenors, chief of whom is Ronan Tynan, now a New Yorker, and soprano Mary Dunleavy, who astounded everyone at *Irish America*'s Top 100 Awards with an operatic aria followed by a simple Irish song handed down to her by her father. Today, uilleann piper Chris Byrne, formerly of Black 47, performs Celtic hiphop with his group Seanchai.

Byrne is a former police officer in New York City, where the tradition of pipers leading armies into battle and the dead to their graves is carried on by the Emerald Society Pipe and Drum Band of the police and fire departments. The sound of the pipes will now forever be associated with the funerals of the fallen heroes of September 11. It is always poignant to watch the FDNY pipes march in the St. Patrick's Day Parade, but it was particularly so in 2002 when 343 new recruits, each holding a flag for a lost firefighter, followed the pipers up Fifth Avenue.

The influence of Irish music cannot be discussed without mentioning the Chieftains, who have partnered with a bevy of international rock stars, such as Mick Jagger, Sting, and Van Morrison. Paddy Moloney, the chief Chieftain, has also written songs for Hollywood movies, including Stanley Kubrick's *Barry Lyndon* and *Far and Away,* starring Nicole Kidman and Tom Cruise. Director Ron Howard says *Far and Away* was actually inspired by the Chieftains' music. Most symptomatic of how ubiquitous Moloney has made Irish music is his lead song for Disney's *Winnie the Pooh* movie, which earned him a Grammy nomination in 1996. But when *I* think of Paddy Moloney, I see him playing an Irish wake tune — "Táimse i mo Chodlagh" — on his tin whistle for the workers at Ground Zero. Irish music was there when words could not communicate the loss.

But out of September 11, too, grew new respect for the many fine writers who found the words to express the inexpressible — journalists such as Pete Hamill, Jim Dwyer, Michael Daly, Denis Hamill, Keith Kelly, and Jimmy Breslin, all following along in the great tradition of Irish "shoe leather" reporters, getting to the essence of the story. It was Nellie Bly, an Irish-American woman, who in the 1880s pioneered the development of "detective" or "stunt" journalism, the forerunner to full-scale investigative reporting. Born Elizabeth Jane Cochran on May 5, 1864, one of 14 children of Michael Cochran and Mary Jane Cummings, Bly posed as a mental patient in a New York institution and published her experiences in Joseph Pulitzer's *New York World* in an explosive story that led to reform in mental health facilities.

While Bly devoted herself to writing about the American landscape, the Irish-born John Boyle O'Reilly, a Fenian who escaped prison in Australia and later became the editor of the *Boston Pilot* in the latter half of the nineteenth century, had Ireland in his heart even as he campaigned for the rights of the Indians and blacks, as well as those of the Irish immigrant. *Harper's Weekly,* which didn't always agree with O'Reilly, wrote on his death in 1890: "[He was] easily the most distinguished Irishman in America. He was one of the country's foremost poets, one of its most influential journalists, an orator of unusual power, and he was endowed with such a gift of friendship as few men are blessed with."

Today, the tradition of the *Pilot* is held up by a plethora of Irish immigrant newspapers, including the *Irish Voice,* the *Irish Echo,* the *Irish Edition,* the *Irish Herald,* and the *Irish American News.* Like O'Reilly, Niall O'Dowd, publisher of the *Irish Voice* and *Irish America Magazine,* sought a solution to Ireland's Troubles and was influential in the Irish peace process.

"The Irish are by nature storytellers," says Mary Higgins Clark. Mary should know — she is one of the best-selling authors of all time. Her mystery stories are extremely popular and many have been made into movies, but I remember her most for an emotionally moving piece she wrote about her mother that was published in *Irish America.* (Mary and her daughter Carol, also a writer, contribute essays to the Generations section of this book.)

William Kennedy, a native of Albany, New York, who won the Pulitzer for *Ironweed,* said, "I believe that I can't be anything other than Irish American. . . . [It's] a psychological inheritance that's even more than psychological. There's just something in us that survives, and that's the result of being Irish." John Steinbeck concurred: "I am half Irish, the rest of my blood being watered down with German and Massachusetts English. But Irish blood doesn't water down very well; the strain must be very strong." Even F. Scott Fitzgerald, who tried to distance himself from his Irishness, wrote to John O'Hara in 1933, "I am half black Irish and half old American stock." The black Irish came from his mother's side; her father, Philip Francis McQuillan, emigrated from Fermanagh in 1843, made lots of money selling groceries, and died at age forty-three. Interestingly, it was the "black" Irish who had the wealth, which the Fitzgerald family was forced to live on when Edward, Scott's father, proved himself a miserable failure in business.

While Ireland is not known for appreciating its own authors (the work of James Joyce, Edna O'Brien, John McGahern, and a slew of other authors was once banned in Ireland), in English literature classes at San Francisco State University, I began to recognize the Irish influence on world literature as we studied James Joyce's *Dubliners* and Frank O'Connor's "First Confession." At this time, too, I can recall reading William Faulkner's *Light in August* and becoming aware of the Irish cadences in his writing. For just as Irish music became a part of Southern music, Irish lyricism is infused in the work of such writers as Pat Conroy (whose family came over from Ireland and went to the Appalachian hills) and Flannery O'Connor, whose maternal grandfather was Patrick Harty from Tipperary and whose short story "Everything That Rises Must Converge" can surely hold its place as a classic.

James Joyce, of course, was supported by Irish American John Quinn, who virtually funded the Irish literary renaissance spearheaded by poet W. B. Yeats. It was Quinn, at this time a lawyer in New York, who argued the case of the publication of *Ulysses.* And though he found Joyce difficult, he supported him by buying original manuscripts of his work. "*Ulysses* may not be the final thing. But it may lead to a new literary form," he rightly predicted. While Joyce fathered "a new literary form," Americans Henry and William James, grandsons of an Irish immigrant, were putting American literature on the map. Though the James brothers were not particularly interested in claiming their Irish heritage (even though they had a sister who was an advocate for Irish freedom from Britain), others were.

Eugene O'Neill, a Nobel Prize–winning playwright, wrote in a letter to his son, "The critics have missed the important thing about me and my work. The fact that I am Irish." O'Neill's first experience with the theater came when he accompanied his parents on tour and watched his Irish-born father star in the play adaptation of *The Count of Monte Cristo.* Fifty years after his death in 1953, O'Neill is still in fashion. *Long Day's Journey into Night* earned Irish actor Brian Dennehy the 2003 Tony Award for best actor. Perhaps one of the greatest of O'Neill's pieces was *Ah, Wilderness!* in which he cast George M. Cohan as Nat Miller.

Cohan, the father of the American musical, was born in Providence, Rhode Island, on July 3, 1878, the grandson of Michael Keohane and Jane Scott of County Cork, both of whom escaped from the famine in Ireland in 1848. According to Cohan's biographer, John McCabe, Cohan's father, Jerry, was one of the best traditional Irish dancers in all of New England. His specialty was reworking Irish dance numbers for the American stage. George Cohan began his own career working as a member of the Four Cohans, which included his father, mother, and sister, Josie, in *Hibernicon,* an early Irish-American vaudeville show. James Cagney, another great Irish-American dancer and actor, would play Cohan in the 1942 Warner Brothers production of *Yankee Doodle Dandy.* "That Cagney, what an act to have to follow," Cohan remarked when he saw the movie just before he died.

Irish American Walter Huston also starred in *Yankee Doodle Dandy;* his son, John Huston, became a great director. John spent many years in Ireland and filmed *Moby Dick* there, a movie starring another talented Irish American — a very young Gregory Peck.

Peck, whose father spent his childhood in Kerry, recalled the making of the film in an interview with *Irish America* in 1997. "We were in Ireland because it was John's Irish period. It was definitely the wrong place to go out to sea looking for whales. There were no whales in the Irish Sea. But John wanted [the movie] to have some kind of Irish connection. It really was a struggle." The actor was almost killed one day during filming when the tow line on the back of the rubber whale broke and Peck was set adrift on very rough seas. "We always say that John Huston tried to kill all his leading men," Peck laughingly recalled.

It's somehow fitting that the last movie Huston made was an adaptation of James Joyce's short story "The Dead." "Asking about Joyce is like asking about Shakespeare," Huston said in an interview with Tom English for *Irish America* in 1987. "We're talking about a man whose work changed the course of history. It would be difficult, impossible really, to pinpoint his influence." Huston's love affair with Joyce began in his youth, after his mother smuggled a copy of *Ulysses* into the states in 1928. "It was banned at the time, but I remember it vividly, even the blue-paper cover it was wrapped in. And, of course, I'll never forget reading it; it is probably what motivated me to become a writer and a filmmaker," he told English. Huston is but one of the many Irish-American directors who left his mark on Hollywood. At an American Irish Historical Society evening in New York City a couple of years ago, Martin Scorsese gave a talk about the influence of Irish-American directors, including Raoul Walsh and John Ford, who was born Sean Aloysius O'Fearna to Irish immigrant parents in Maine.

Many of Ford's films weave in the Irish participation in the making of America, including *The Last Hurrah,* with Spencer Tracy and Pat O'Brien, which is based on the story of Boston mayor Michael Curley. And Ford will always be remembered for *The Quiet Man,* starring John Wayne and Maureen O'Hara, which is thought of as the quintessential "Irish" movie.

These days, Irish directors such as Jim Sheridan (*My Left Foot, The Field, In the Name of the Father, In America*), Neil Jordan (*The Crying Game, Michael Collins*), and Terry George (*Some Mother's Son*) have made names for themselves in the world of film. George and Sheridan started out by staging their work at the Irish Arts Center in New York City, where the tradition of Irish theater is being kept alive by both the center, which enjoys the support of actor Gabriel Byrne, and the Irish Repertory Theater, which produces Irish plays year-round. The Irish Repertory Theater recently sponsored an Irish night on Broadway hosted by Lauren Bacall. In other cities, too, you can find Irish theaters of a very high caliber, such as the Súgán Theatre Company in Boston.

On Broadway, Irish writers such as Colin McPherson have followed up Brian Friel's groundbreaking *Dancing at Lughnasa* success of the 1990s. And, off Broadway, Irish American John Patrick Shanley's *Dirty Story,* a satirical look at America's role in the Middle East, just completed a critically acclaimed run. (Shanley previously won an Oscar for *Moonstruck.*)

In Hollywood, well-known actors follow in the footsteps of the great Irish and Irish-American stars of past years — Errol Flynn, Victor McLaughlin, Maureen O'Hara, Dorothy McGuire, Maureen O'Sullivan. Today we admire Liam Neeson, Gabriel Byrne, Fiona Shaw, media darling Colin Farrell, and many others.

The Irish film industry is better now than it ever was. Hollywood has discovered Ireland as a place to make movies — Pierce Brosnan and Julianne Moore are filming *Laws of Attraction* there as I write this — and Irish filmmakers are making their own "Irish" movies. Brosnan's own production company, Irish Dreamtime, made the Irish-themed movie *Evelyn* in 2000. The year before that, Anjelica Huston starred in and directed *The Mammy.*

To ensure the future of Irish film, Gregory Peck helped set up scholarships at University College Dublin. "Money isn't everything. Originality, creativity, humor, and new points of view about the human condition coming from fresh sources are all important," he told *Irish America.*

And as the Irish reach new heights in Hollywood, it's hard to remember when Irish step dancing was not in vogue. Michael Flatley has made his everlasting mark on the world stage, but he is merely continuing the tradition of great Irish-American hoofers Gene Kelly, Donald O'Connor, and Debbie Reynolds. Kelly, one of the greatest song-and-dance men of all time, had Irish ancestors on both sides of his family and treasured his Irish roots. In a 1990 interview with *Irish America,* he referred to the Irish domination of popular dances as "a phenomenon of the time," saying, "I think it came from the fact that the dancing in Ireland for centuries had been clog dancing and reels, and these dances certainly influenced the American people in the late-nineteenth and twentieth centuries so that it actually became part of American tap dancing." Interestingly enough, Gene Kelly's big break came at the hands of another Irish American — John O'Hara.

The eldest of eight children, O'Hara, whose father, Patrick, was an accomplished physician, claimed, "Socially, I never belonged to any class, rich or poor. To the rich I was poor, and to the poor I was poor pretending to be rich." Early in 1940, George Abbot and Rodgers and Hart were planning to stage a musical adaptation of O'Hara's *New Yorker* short story "Pal Joey." Rodgers had Gene Kelly in mind but wondered "whether that guy Kelly" could sing as well as dance. It was Gene Kelly's rendering of an Irish ditty that convinced O'Hara that Kelly was right for the part in the stage version of "Pal Joey." The incident is recounted in Bob Callahan's *The Big Book of American Irish Culture:*

> "I thought," said Gene, "that if I sang one of his own songs, it would impress him, not knowing that there's an unwritten law that says never sing a song back to a composer at an audition, unless of course he specifically asks you to do so. But there I was, singing one of Rodgers's most beautiful — and difficult — numbers and not singing it very well because I couldn't sing then — and I still can't. Well, he didn't bat an eyelid. He said nothing, and when the song came to an end, he asked me to sing something else — a bit faster. So I went straight into a lively ditty I used to do in the 'cloops' called 'It's the Irish in Me,' which had a lot of pep and dash to it, and which I knew how to put across. After I was through, O'Hara, who hadn't said a word throughout the audition, called out from the back of the theater: 'That's it. Take him.' "

And so began the career of a man who would become a legend.

Today the tradition of Irish hoofers is still going strong. The Irish dance shows *Riverdance* and *Lord of the Dance* are bringing in millions, and the step-dancing phenomenon looks set to continue — three young Irish-American male dancers took firsts in the 2002 World Irish Dancing Championships in Ireland. Two of those dancers, Shane Kelly and Tim Kochka, performed for Irish American of the Year Michael Flatley at the *Irish America* 2003 Top 100 Awards.

So Irish culture is alive and kicking. It moves back and forth across the water, reinvigorating and changing but still remaining identifiably Irish. As the great Irish writer Elizabeth Bowen said, "We [Irish] are curiously self-made creatures, carrying our personal worlds around with us like snails and their shells, and at the same time adapting to wherever we are."

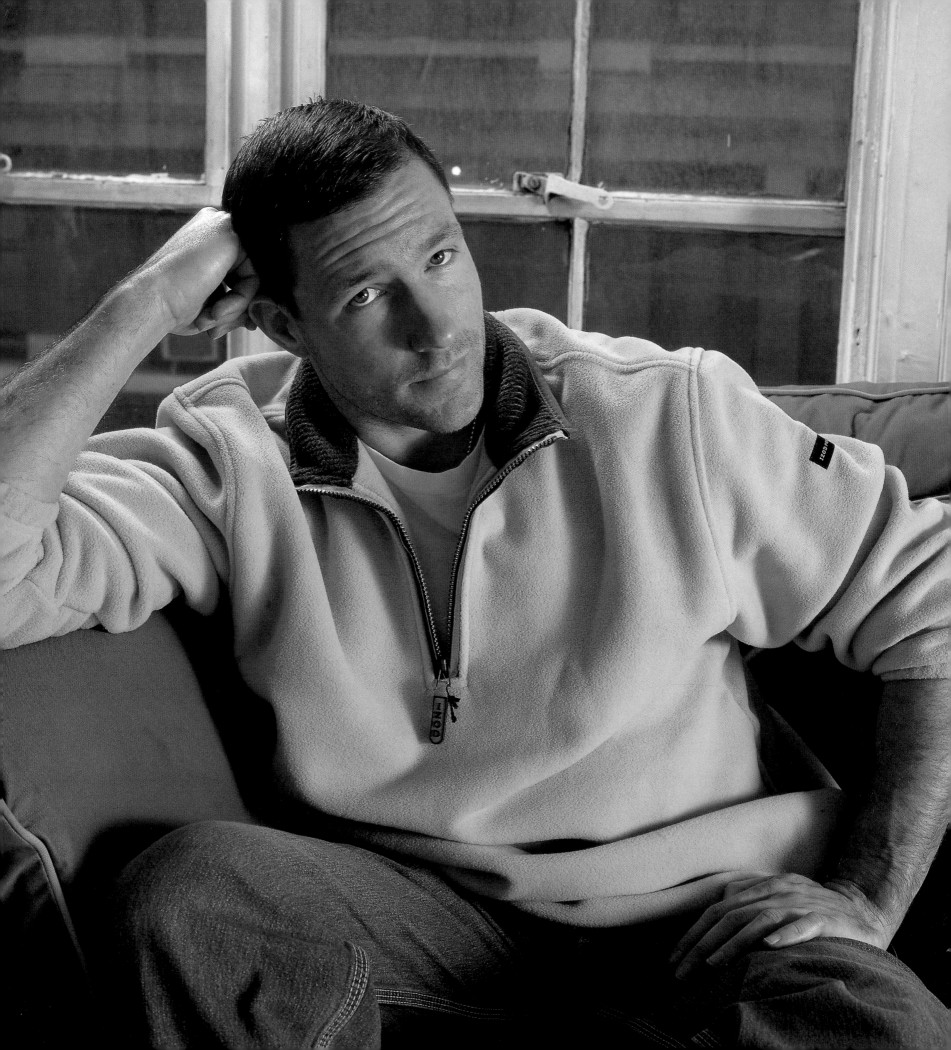

I was born in Woodside, New York, to an Irish-American family. Ours was a loud, boisterous household where the most valuable currency was a talent: the ability to tell a good story. As kids, we were forced to eat dinner with the entire family every night. Talk about a tough audience. As the storyteller you had to capture eveybody's interest from minute one, or you were out. Once you got everyone's attention, you also had to keep it. A story lacking in impact or a great ending would cost you credibility and the chance to tell stories in the future. ◉ As my brothers and I grew older, we wanted the prestige and recognition given to the successful tale-teller. We started spinning our own day's events into the dinnertime discussion, and the competition for airtime pushed me to hone my craft. I'm sure that my desire to be a writer came from growing up steeped in these stories. The drive to tell the

"I admire many traits attributed to Irish Americans, but the one that I relate to the most, both personally and professionally, is the value of a good story."

tale that kept the whole dinner table rapt developed into the drive to keep the viewer, or the reader, hooked. The audience expands, but the art form remains the same. ◉ Before I came into my own as a writer, I tried several different genres. Then my father gave me a book on screenwriting. After that, I wrote seven screenplays. My eighth was *The Brothers McMullen.* People say, "Write about what you know," and I did. ◉ I am proud of my heritage, both as an Irish American and as a New Yorker. My mother was a McKenna, and my maternal grandfather was a sandhog. Every Christmas when we drove through the Lincoln Tunnel, my mother would say, "You know, your grandfather built this tunnel." I also feel a strong connection to Hell's Kitchen. My paternal grandfather owned a trucking company there, and my grandmother used to work at the National Biscuit Company (NBC) on Eleventh Avenue. ◉ My father, brother, and several cousins are police officers. I may be the writer in the family, but trust me, all of us are storytellers. It's in the blood.

EDWARD BURNS Writer, actor, director, producer ◉ *New York, New York*

"Traditional music is intimate; each song tells a story, drawing the listener in."

I grew up in a large and locally renowned musical family in Cavan, and I've been entertaining others since I could walk. Or maybe before. In 1984, I set out on a one-woman mission to share traditional Irish music with American audiences. When I came to Georgia, I was the only female traditional Irish musician in all of Atlanta. ◉ I found a large and willing audience in Atlanta, and my passion soon turned into action. A few Irish-American friends and I have worked hard to develop the Atlanta Celtic Festival. A lot of the songs I sing are in Irish. I teach Irish language, singing, and music. To foster the growth of traditional music, I've also been working with an Atlanta-based group called Irish Music Traditions. ◉ The most beautiful part of Irish music is that much of it is sung a cappella, allowing the listener to hear the words and embrace the message of each song. In addition, the vocal inflections add "ornamentation." I sing a lot these days, both in public and in private, to my two-year-old daughter, Marianna. My singing always makes her smile and hopefully will preserve the tradition for another generation.

KATHLEEN DONOHOE Traditional Irish singer, musician ◉ *Atlanta, Georgia*

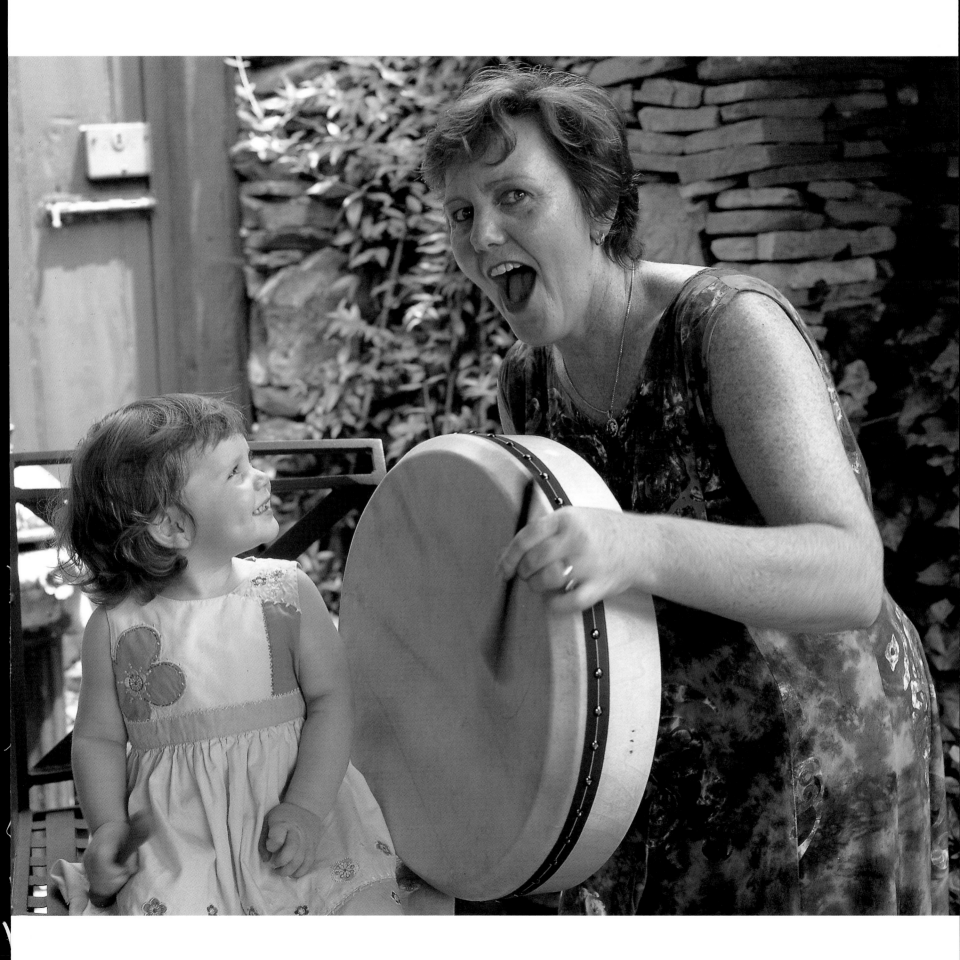

At age thirty I was tapped by a talent scout, whisked out of the restaurant where I was sitting, and turned into the new Calvin Klein "Jeans Girl" overnight. From that moment, so much good fortune has followed: I've worked as a Revlon model and an MTV VJ, and am now the host of an HBO show. ◉ But about four years after I was first "discovered," my lucky star dimmed; I was diagnosed with sarcoidosis, a rare, incurable disease that attacks the central nervous system. Once the news echoed in my ears, made its way down to my heart, and landed in the pit of my stomach, everything changed. ◉ Of course, I was stunned at first, but I never let myself get lost in the fear that my luck had left me. The diagnosis prompted me to strengthen my sense of humor and deepen my faith in God's goodness. These two forces sustained me through chemotherapy, hair and weight loss, and dreadful uncertainty. ◉ I'd been involved in serving others all my life, but now, suddenly, it was time to take care of myself. It was hard, but when I hit what felt like the lowest point in my fight, I met the ultimate ally — my future husband. We fell madly in love and eloped, not exactly what you'd expect from someone with my diagnosis. But we did it. We stayed positive, believed in tomorrow, and here we are. ◉ I have shared my story in a memoir entitled *Model Patient: My Life as an Incurable Wise-Ass.* Wry, irreverent, and fun as hell to write, it was not just a book for sick people but a book for sick people with a sense of humor. At its core are the faith and humor that sustain me in my struggle and humble me in my success. Faith and humor are my gifts. If I can share them with other people, then maybe I'm living up to that lucky star of mine after all.

KAREN DUFFY, AKA "DUFF" Model, actress, author, health care awareness educator ◉ *New York, New York*

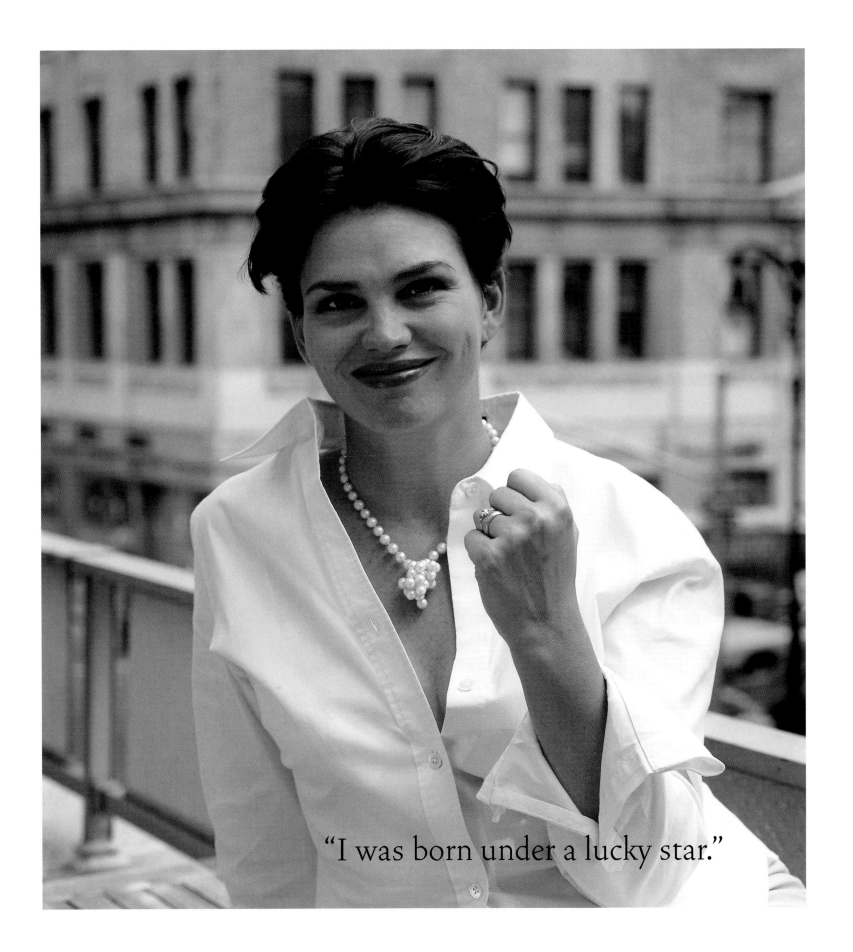

"I was born under a lucky star."

In 1947 my parents left Ireland and arrived in Chicago with nothing but their unshakable bravery and an unstoppable work ethic. Fueled by the fire in their hearts, they established a successful business, supported five children, and passed their Irish values on to my siblings and me. ◉ I may have inherited the drive to realize my dreams from my parents, but it was my maternal grandmother in Ireland who taught me how to dance. A champion Irish dancer herself, she showed me my first steps at age four and instilled in me the mantra "Nothing is impossible." Those three little words sustained me through every experience — from living through lean times to living out my dreams as an Irish dancer on the world's stage to traveling and appreciating art as a citizen of the world. ◉ As a child, I did the immigrant's dance between America and Ireland; I am a product of both cultures. As a performer on tour for the last fifteen years, I am a child of the world. Living out of hotel rooms for years on end has only fortified my connection to — and my pride in —

"If you're willing to work hard enough, you can have anything you want."

all things Irish. It's funny — sometimes we spend our entire life traveling the globe only to return to our roots and rediscover them at a new depth. With every year that passes, my Irish roots drop deeper into the soil beneath my feet. I see that the call of music, dance, and all things Irish is simply the call of my culture. No matter how far I travel, it will find me because it's within me. ◉ With *Lord of the Dance* up and running in Vegas, I am stepping off the stage and settling down as much as someone like me can. My work now is to give back to the communities that raised me, both in Ireland and in America. In truth, the Irish community is everywhere. It's the world community. If we can strengthen that community and if I can return some of the gifts that it has bestowed on me over the years, then we'll all have something to dance about. My grandmother used to say that the Irish have a magic that never quits. If my life is any indication, she's absolutely right. As far as I'm concerned, my work has just started, so fasten your seat belts!

MICHAEL FLATLEY Dancer, choreographer, artist, entrepreneur ◉ *Chicago, Ilinois, and Ireland*

As a native New Yorker, I've always had a special affinity for the New York Police Department and the pipes. I have so many relatives that are cops. One of my fondest childhood memories is attending the St. Patrick's Day Parade with my dad. Each year, we would pick our favorite police pipe band and march alongside it up Fifth Avenue. Now I live in California, and the closest I've ever gotten to becoming a police officer is playing the role of the police captain and chasing Roger Moore all over San Francisco in the James Bond movie *A View to a Kill.* I was, in fact, the last person to whom he said "Bond . . . James Bond." ◉ Five years ago, I retired from the Screen Actors Guild and started playing the pipes. The Los Angeles Police Emerald Society made an unusual gesture and allowed me to play in its band, a privilege usually reserved for police officers. The society reasoned that I was worthy of a spot in the band because I'm a character in good standing. ◉ My strong character probably comes from my time spent in the Navy. In my twenties, I was sent to the Philippines on the USS *Ticonderoga* aircraft carrier. After serving, I became a merchant marine for five and a half years and went back to Southeast Asia again. My work allowed me to circumnavigate the globe twice — once eastward, once westward. And I got paid for it! ◉ My journeys have also taken me to my favorite place in the world, Ireland. I'm going to Ireland again in November; I love the warmth of the people . . . and the fishing. ◉ I can't stand retirement, so in about three months I'm going back to acting . . . if I come back from Ireland.

JOE FLOOD Actor, piper ◉ *Los Angeles, California*

I grew up in a community that wasn't actively Irish American and in a family that wasn't particularly musical, but Irish music found me anyway. Every summer we traveled from our home in suburban Michigan to Ireland. One summer, when I was sixteen, I got my first set of bagpipes and immediately fell in love. The next thing I knew I was a sixteen-year-old competing in the over-eighteen category at the All-Ireland Championship . . . and winning! Irish music started as something I stumbled upon but fast became one of the greatest gifts of my life. ◉ After learning to play the bagpipes, I branched out to the uilleann pipes, the tin whistle, and the wooden flute. In high school, my brother and I formed an Irish band. At first we were surprised when the Polish girl next door asked to join our band as a piper. Then the German guy down the block decided to learn how to play the snare drum so that he could join as well. Our band was complete. Its eclectic cultural mix just goes to show that Irish music is soul music, and that you definitely don't have to be Irish to appreciate it. ◉ My wife is from Ireland and is also a musician. When we opened our pub in Chicago, we named it Chief O'Neill's in honor of the city's police chief at the turn of the century. At a time when Irish immigrants were assimilating into American culture, O'Neill created an anthology that helped preserve Irish music and save it from extinction. Thanks to him, a little kid from the United States doesn't have to go all the way to Ireland to discover Irish music, though it certainly worked for me.

BRENDAN McKINNEY Musician and pub owner ◉ *Chicago, Illinois*

My grandfather was a traveling Irishman, and he and my grandmother lived in Australia, France, and New Zealand, where my father was born. My grandparents had twelve children, remaining true to the Irish tradition of having a large family. Today, my grandparents live in Chicago. ☉ I inherited my love of all things Irish from my grandfather. For six years, I studied Irish dance with the famous Trinity Dance School. In the third grade, I began competing locally, in Wisconsin, Detroit, and Chicago. This year, I decided to hang up my dancing shoes for a little while because I'm trying another sport with a strong Irish background — crew.

PETER McMENAMIN Irish dancer ☉ *Chicago, Illinois*

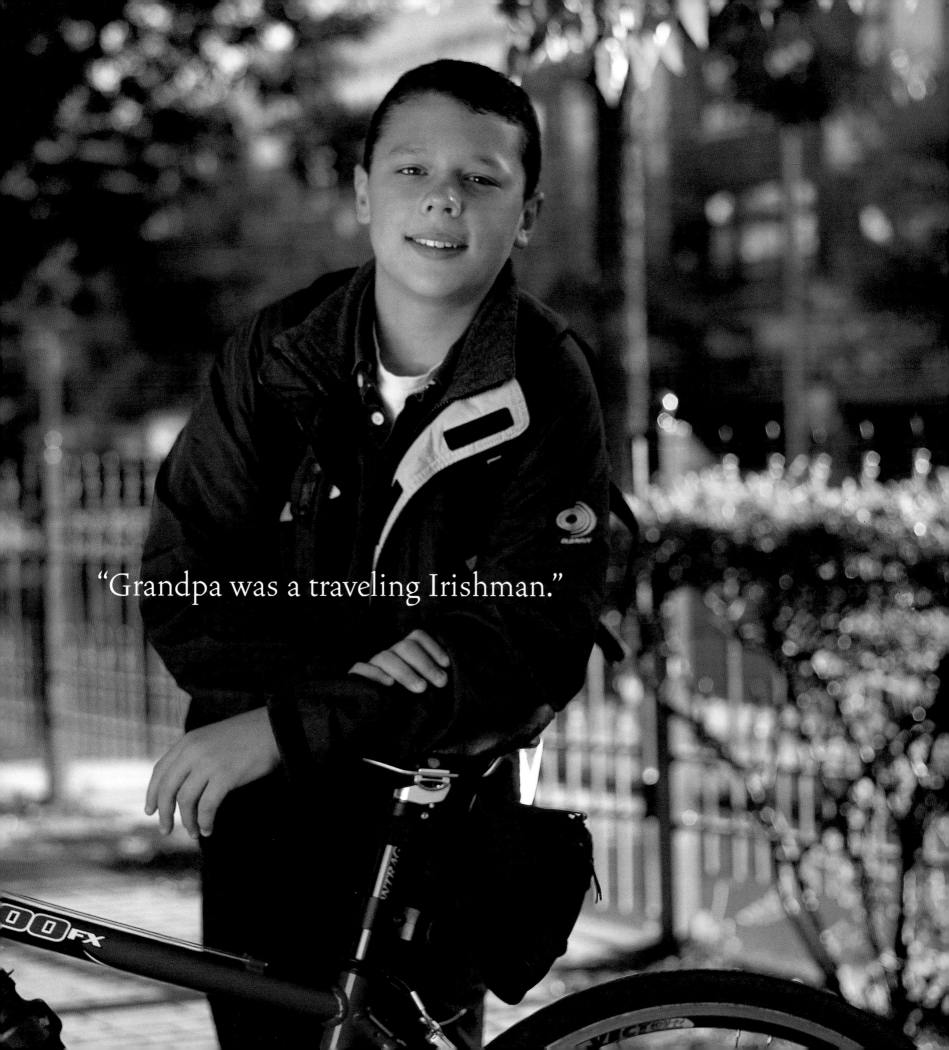

"Grandpa was a traveling Irishman."

46

Whenever I travel to Ireland, I feel I have come home. The country and the culture are part of me — and I am part of them. I feel such a connection, a comfort level. Yet at the same time, everything is brand new. When I am there, I feel a sense of belonging. And when I leave, I take such beautiful memories with me. I also carry the deep trust that the next time Ireland and I "see" each other we will pick up right where we left off — like I never left. To me, Ireland is like a good, old friend that I am thankful to have found.

BRIDGET MOYNAHAN Actor, former model ● *New York, New York, and Los Angeles, California*

"Discovering my Irish heritage was like meeting someone for the first time and feeling you've known that person your whole life."

My Irish-American story is truly unique. I was born in St. Paul, Minnesota, in 1951, and one year later, I was taken back to my mother's home, the Aran Island of Inishmore. Inishmore is not too far away from my dad's hometown of Connemara — "O'Flaherty country." After living among the Gaelic-speaking people of Inishmore for eighteen years, I returned to the United States a non-English-speaking American. ◉ The only reference most people have to the Aran Isles is *The Playboy of the Western World,* which is based on Inishmon, one of the Arans. Growing up there in the 1950s and 1960s was truly remarkable because I experienced the last Celtic generation — living without electricity, using a turf fire. I graduated from high school in the 1960s having never been exposed to or influenced by American or English television. ◉ Instead of watching television, I studied and fell in love with Irish history and with the Irish Republican leaders of 1916. Remember, when I was a baby, the country was only thirty years old, and its people were very proud. Thinking of all those who died over the centuries so that I could be free made me want to keep that torch of freedom and equality shining. ◉ Trying to keep the Irish language alive, I protested the predominance of English television programming during the sixties. ◉ In 1970 I came to Chicago. Almost overnight, I found myself part of the Irish Minstrels, singing and traveling around the United States. Although I loved the limelight, I soon decided it was time to revive other important Irish traditions. The first of my many projects involved breathing new life into a dying Gaelic tradition — rowing. The use of *currachs* (canvas boats used on the western coast of Ireland) was dying rapidly. (The name *currach* is the Gaelic word for "unsteady.") In 1992, we created the first Celtic Nations World Cup Regatta, in which the best high school seniors in Ireland row against the best in North America. Our kids here in New Orleans start rowing as young as age six. Now there are "Under twelve," "Under eighteen," and "Under twenty-one"categories. Irish teams compete, and the Irish government sends two ministers to watch the races each October. The Irish government also partially funds the races. ◉ About twelve years ago, some Irish-American friends and I started the Celtic Nations Heritage Fund in an effort to bring together the Celtic nations, including Ireland, Scotland, Wales, the Isle of Man, Cornwall, Brittany, and Galicia, Spain. Instead of focusing on religion or politics, the foundation uses music describing the contributions of Celtic people to promote solidarity. ◉ My ultimate goal is to build a theme park in Louisiana that focuses on the Celtic nations. ◉ It would encompass every aspect of Irish society — music, maritime life, and culture. It'll be like an Epcot Center without the commercialization. ◉ And, of course, there is my pub here in New Orleans, the bread and butter for all my projects. We run it more like a gathering place — where people stop in for a drink, a read, or some conversation. Owning a pub allows me to spend time with my family. Anyone who works at the pub must have a deep affection for Irish culture. Seven flags hang outside the pub, indicating that everyone is welcome and accepted. ◉ Overall, the most important factors in my life have been my son, Liam, daughter, Tara, and wife, Susan. I met my wife in 1980 while performing in Texas; we met again in 1985 for Mardi Gras. Three months later, we were married. We are settled in New Orleans, and instead of returning to Ireland, we bring elements of Irish culture here.

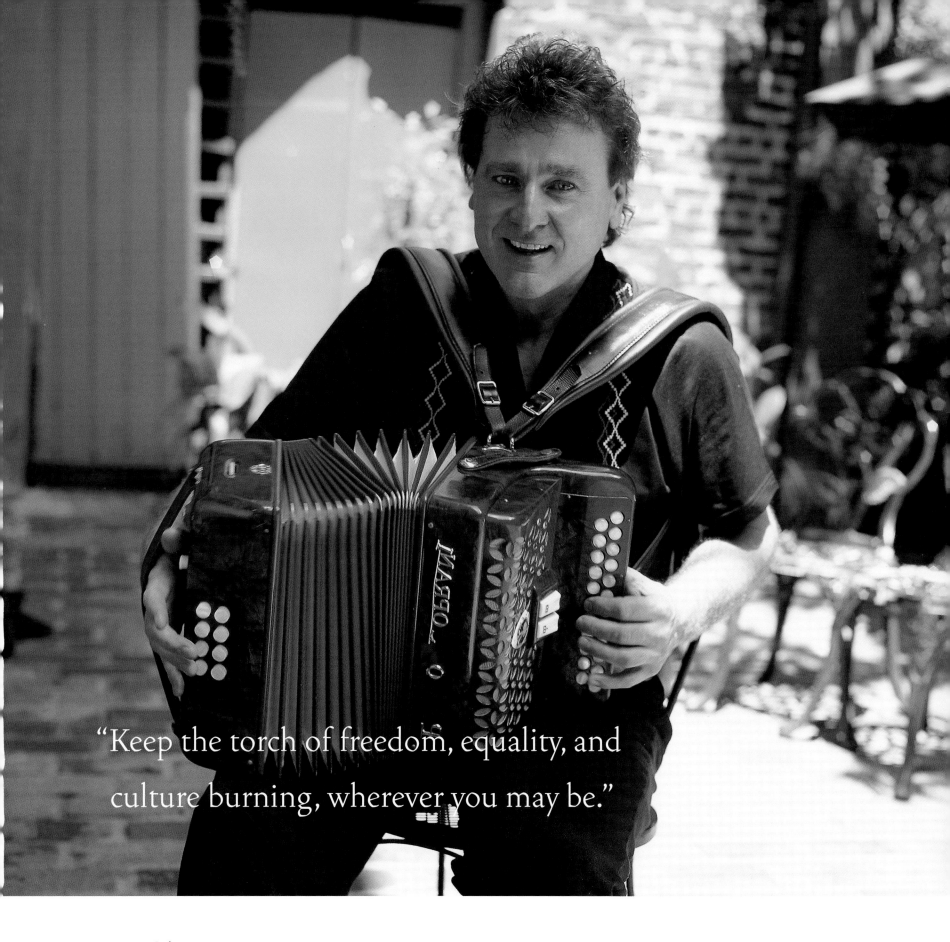

"Keep the torch of freedom, equality, and culture burning, wherever you may be."

DAN O'FLAHERTY Pub owner, professional singer, founder of the first Celtic Nations World Cup Regatta and the Celtic Nations Heritage Foundation ◉ *New Orleans, Louisiana*

I studied art at the University of Belfast. I also taught art for a year at Our Ladies of Mercy high school in Belfast. Soon thereafter, I began developing my own artistic style, much of which is based on elements of Irish folklore, using bits from the stories of Finn McCool and Cuchulain. I also incorporate some of the experiences I had while growing up in the war-torn north of Ireland. ◉ I started building images of standing stones to try to recapture the essence of Irish landscapes. On each piece, I carve lyrics from songs and lines from ancient Irish poetry. Some are hand painted, and some look pretty earthy. I've made eighty of them. ◉ My art has been well accepted at art shows around the country. I decided to move to New Orleans in 1990. Now I'm selling commissioned pieces and evolving my art

"I believe that there is an artist in everyone."

to different forms. I've painted a series of women with Celtic tattoos, as well as a series of Irish dancers. Currently I'm creating montages by combining pictures of childhood landscapes, both natural and political, into a background and superimposing costumes over them. In all of my work, you can see some aspect of Irish history, spirit, or style. Last year, O'Flaherty's sponsored a Celtic women's convention, where I spoke about the history and evolution of my art. ◉ In addition, my husband, who happens to be my childhood sweetheart, and I, bought a bar called Finn McCool's, located on Bank Street, midcity, outside the French Quarter. It's been open for fifteen months and serves as a gathering place for people of all backgrounds. It's also a wonderful setting to showcase my artwork. The pub definitely has a unique style, combining New Orleans and Irish art with lots of ironwork.

PAULINE PATTERSON Celtic artist ◉ *New Orleans, Louisiana*

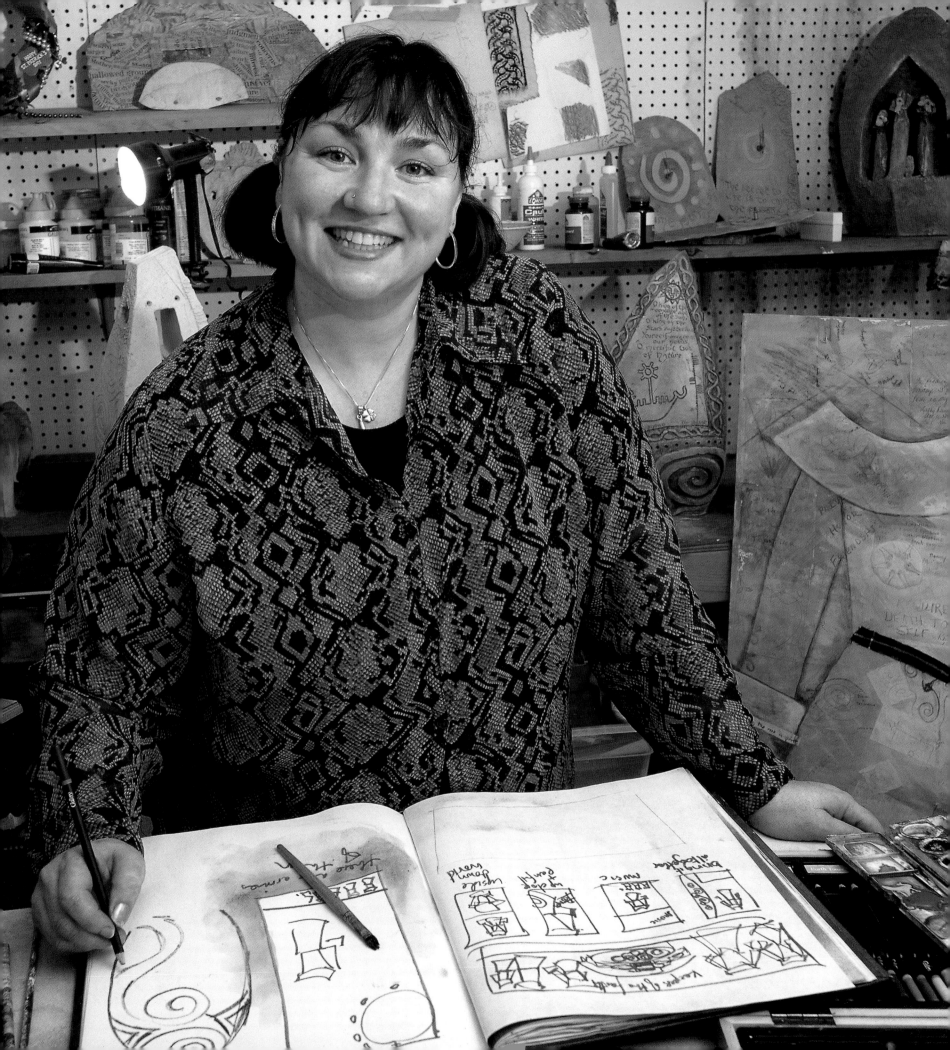

The way I see it, Irishness isn't a matter of blood or chromosomes or genetic inheritance. The essence of being Irish is the stories you absorb as a child, the ceaseless stream of words flowing through your brain from the first moment of unconscious perception, words sung, spoken, strung together in poems, speeches, prayers, games, and curses. My parents were the children of Irish immigrants. They came of age in New York in the 1920s, and their love of language — a love they passed on to their children — was a helix of metropolitan America and rural Ireland, the two blended in a martini of urban gin and immigrant vermouth — good-bye Tipperary, hello Times Square, Cork uncorked in the Bronx, ourselves alone and thrown in with everyone else, mixed, shaken, served straight up. ◉ We grew up in precincts paved. No western isle Tir Na Og, our borough was/is/will always be stuffed to the rooftops with mongrel desires, every block amok with characters starring in this moment's tragedy, comedy, variety show. "There's no greater sin than being boring," mumbled the old man on the stool next to me. For that drop of unforgettable wisdom, I had the barman fill his mute and empty mug with beer. ◉ My father was the son of an empire hater, union organizer, and roving Irish rebel. A frustrated actor and songwriter, he made his living (successfully, God love him) in politics. At his knee, we learned the sacred litany — *God, Roosevelt, and Kennedy.* The daughter of a maid from Blarney and a mechanic from Macroom, my mother had the walk of a queen. Joined at the hip (and in other places), my parents called me into existence, pushed me into Yankee sunlight, footloose on the Concourse (Grand, it called itself), richer than the king of England, with my heart, brain, and mouth filled with stories.

I've always admired the passage in John O' Hara's novel *BUtterfield 8* in which Jimmy Malloy tells his non-Irish girlfriend that she has to understand one essential thing about him. "'I am a Mick,'" he says. "'I wear Brooks Brothers clothes and I don't eat salad with a spoon . . . but I am a Mick. Still a Mick . . . We're non-assimilable, we Micks.'" ◉ That's pretty much the way I feel about being Irish. I'm a Mick. It's not that all — or even most — of my friends are Micks, or that I think being a Mick makes me better — or worse — than anyone else. It's just that my parents both came from working-class backgrounds and they planted in me this soul-seated sense of being Irish, a sense that over the years I've distilled to three essential ingredients: faith, hope, and charity. ◉ The faith that my parents gave me is that the universe has meaning. Both strong believers, they taught me that at the heart of existence, although sometimes obscured behind pain, loss, and tragedy, is a loving God. Hope, I learned from them, is rooted in a sense of humor, which is a supreme expression of human resilience. Charity, they instructed me, isn't just a matter of making occasional gifts to the poor. It also includes a commitment to work for a just society in which no one lacks for the basics. ◉ I love being a Mick. With it comes a license to laugh, sing, tell stories, and never take the world too seriously. It's a good counterweight to the American part of me, which is programmed to put work and success ahead of everything else. I'm doing my best to make sure that my kids turn out to be Micks, too — unassimilable and proud of it!

PETER QUINN Writer ◉ *Hastings, New York*

TOM QUINN Editor ◉ *Hastings, New York*

52

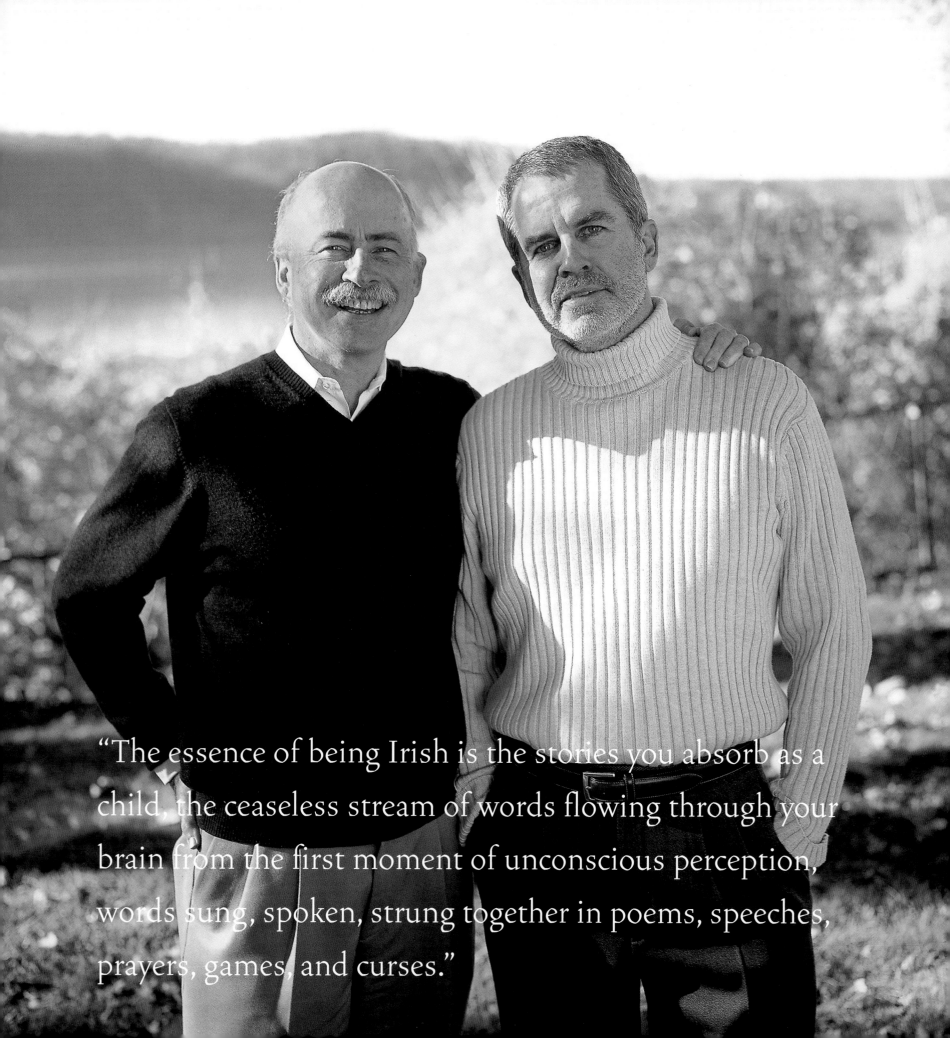

"The essence of being Irish is the stories you absorb as a child, the ceaseless stream of words flowing through your brain from the first moment of unconscious perception, words sung, spoken, strung together in poems, speeches, prayers, games, and curses."

My Irish heritage can be traced back to my great-grandmother, Fannie Clinchy, from County Longford, Ireland. Clinchy is a very unusual surname in the United States, so my boyfriend, Michael, and I decided to trace my roots back to Ireland. ◉ Michael located the exact plot of land where my grandmother was born and brought up. The house was no longer standing, but if you looked very carefully, you could see the outline of bricks that was the foundation of the house she grew up in. I can tell you that standing on that earth, I felt her spirit go into my pulse. To solidify her spirit and mine, I took an old brick, the cornerstone, actually, from her ancient house and brought it back to New Orleans. It now rests at the entrance to my door, connecting the path from Ireland to here. ◉ When Fannie immigrated here, she married a man named Rosario Bagnetto. He was a grocer, and they had eleven children. There are a lot of Bagnettos in the phone book. Because her husband was a grocer, Fannie was able to extend her charity to the local needy. I've been told that she often fed people from her home. Anyone was welcome at her door, especially widows and orphans. ◉ Her spirit has lived on in me. I'm sure that her charitable works and my heritage were the driving forces behind my decision to become an actress and a theater teacher in the New Orleans community. At the all-girl Catholic school that I attended, one of the nuns, Sister Mary Joanna, encouraged me to study speech and theater. While raising a family of three children, Timothy Scott, Jennifer Mary, and Shannon John, I taught speech and theater. Then, thirteen years ago, the New Orleans Center for Creative Arts/Riverfront called me and asked if I would be interested in teaching young people what I know — diction, voice, acting, scene study, monologue, audition. My students are fifteen to nineteen years of age, and I prepare them for conservatories. ◉ There is a wealth of Irish theater to delve into, characters that are so typically Irish yet also universal. In the last few years, I have acted in and directed more than twenty-five plays. My favorite roles have been the widow in *The Playboy of the Western World* and the daughter in *The Beauty Queen of Leenane.* What can I say? The drama definitely comes from the Irish side.

JANET SHEA Actor, producer, director, theater teacher, and coach ◉ *New Orleans, Louisiana*

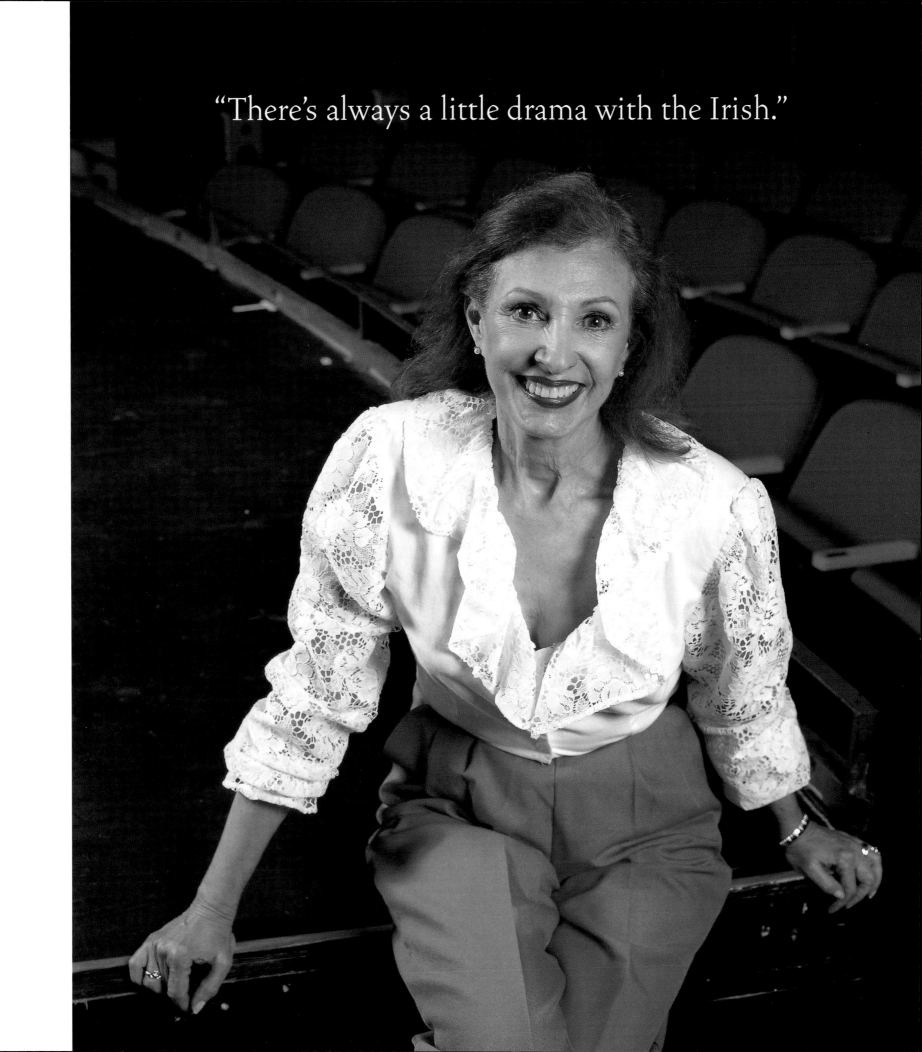

"There's always a little drama with the Irish."

I was born in Kingston, New York, but was exposed to New York City as a child. My mother, Sue Ellen Mulligan, grew up in the city, so every weekend we would make the one-and-a-half-hour trip. I can trace her Irish heritage back to her great-grandparents, who came from Ireland. They started a plumbing business on the West Side that is still operational today. My dad, Garin, also has Irish roots. I have a big Irish family — four brothers and a sister. I'm the baby. ◉ When I was a child, my mother took me to see *Les Misérables.* After that, I was hooked on singing and would sing Broadway parts to myself in the mirror. I met my voice coach at my grandmother's funeral — proof that every cloud has a silver lining. She taught opera students and also coached Ronan Tynan, one of the great Irish tenors. At this point I was in high school, and I made the journey from upstate New York to Manhattan twice a week for voice lessons. Now I'm a cantor at my church. I've done a few shows, and I sing at weddings. I seem to be in high demand for Irish weddings. ◉ My musical ability or, at least, love of music definitely springs from my Irish background. I grew up strongly influenced by the Clancy Brothers. All of their songs tell stories; the words are more important than the music. My entire life, I've had a dream. I want to go to Ireland and sing. It's such a strong image that I can see it quite clearly — me in Ireland, singing. I'd better enjoy my solos here, though. With the reputation that the Irish have for singing, I know that when I go to Ireland I won't be singing alone.

ROB SHEELEY Actor, singer ◉ *New York, New York*

"With the reputation that the Irish have for singing,
I know that when I go to Ireland I won't be singing alone."

My mother, Mary Ann Phelan, was an Irish immigrant, and my father, Francisco Estevez, was a Spaniard who came to the United States by way of Cuba, so I guess you could say that showmanship and social activism are in my blood. I was born into a very large immigrant family in Ohio. Both my parents were devout Catholics, and they raised my siblings and me in a Catholic home and sent us to Catholic schools. My parents were very compassionate, loving people who were concerned about the larger community. And there was a great sense of humanity and strong social values that I was born into and grew up with. I adored my mother, and even though she died when I was young, she had a profound effect on my life and character. She taught us all the Irish songs, and I identify very closely with her heritage. ◉ The values and support that my parents taught and gave me have inspired me throughout my acting career. I have worked in many aspects of the arts: theater, television, and film. My film career started in 1967 with *The Incident,* and for the last five years, I have starred as President Bartlet on *The West Wing.* ◉ I adore my lovely wife, Janet, and we have been married for more than forty-two years. Together, we have loved and raised our four children: Charlie Sheen, Emilio Estevez, Ramon Estevez, and Renee Estevez. All the love from my family and friends has brought me much happiness.

MARTIN SHEEN Film actor, activist ◉ *Los Angeles, California*

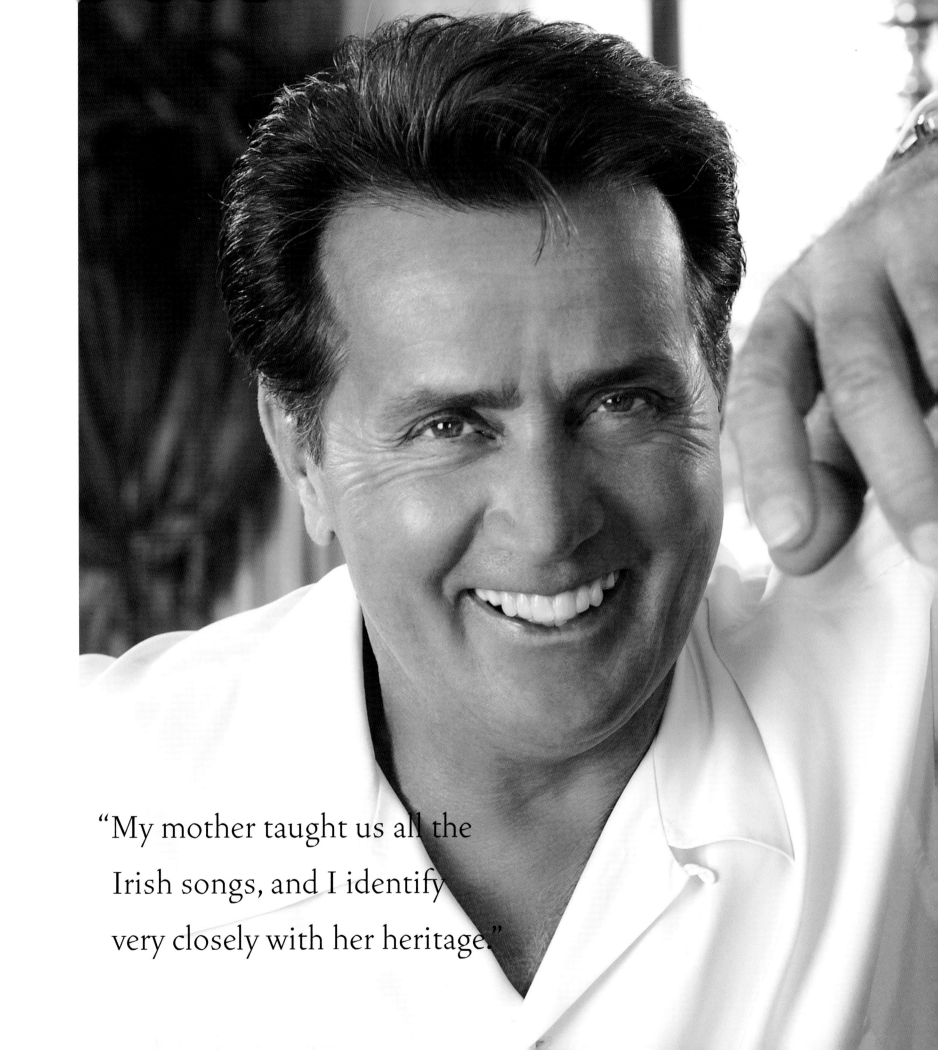

"My mother taught us all the
Irish songs, and I identify
very closely with her heritage."

"It's amazing how pervasive Irish culture has become, not just in America, but all over the world."

My work at the Irish Arts Center in New York reminds me every day how committed the Irish are to their culture. What surprises me even more is how committed other groups are to it, too. The Irish artistic repertoire is not limited to plays and novels, and other cultural groups know that. At the center we have gotten requests from the Latin community for exhibits of Irish photographers, dancers, and sculptors. Irish talent takes many forms, and it's terrific to watch it expressed and then so widely appreciated within and beyond the Irish community.

PAULINE TURLEY Director, Irish Arts Center ● *New York, New York*

As the only child of second-generation Irish-American Catholic parents, I am no doubt a rare species. My mother's family is from Antrim, my father's from Dublin. Though my father was born in the States, he knew every verse of "Kevin Barry" by heart. He was also an officer in the Air Force, so we lived all over the world, and I wound up here in Atlanta. ◉ The Irish are an innately poetic people, as evidenced by the oral culture of the Bards. Our spirits seek self-expression, and the spoken and written word are natural outlets. When you're oppressed as a culture, sometimes the only thing you can control are your thoughts, the words that dance in your head, and the phrases that turn themselves over and over in your mind and wear themselves smooth over time. For our ancestors, poetry was an act of expression but also of defiance. And so their talent became their power. In the economy of words, the man who can turn a phrase is a rich man indeed. ◉ Even during the Troubles, London was alive with that poetry. Despite the political climate at the time, Irish theater thrived, and people from all over England, from all over the world, flocked to see it. That undeniable response has a lot to do with the bone-deep honesty with which Irish artists write about universal human themes: family, disappointment, longing, loss, and exile. These themes slice straight to the soul, which is where the power is. That power, that poetry, is in our blood. And no one can take it away. ◉ In 1984, I founded the Theatre Gael as a place to celebrate that legacy and to inspire other people with it. To date we've staged sixty-five productions. I love the idea that someone can walk into a performance of an Irish piece, sit down, be mesmerized, and decide to travel to Ireland just by chance. But when it comes to Irish talent, there is no chance. It's good stuff. What makes the Irish so easy to relate to is their humor. In the Information Age, we have an amazing ability to share that Irish humor and enjoy an access to the arts and culture of Ireland that our parents' generation simply did not have. ◉ Many Atlanta locals volunteer at the Gael, hoping to reconnect with their Irish heritage. It must be that age-old search for self-identity that inspires these people to dive right in. I guess you can't change what's in your blood.

JOHN STEPHENS Playwright/director, Theatre Gael ◉ *Atlanta, Georgia*

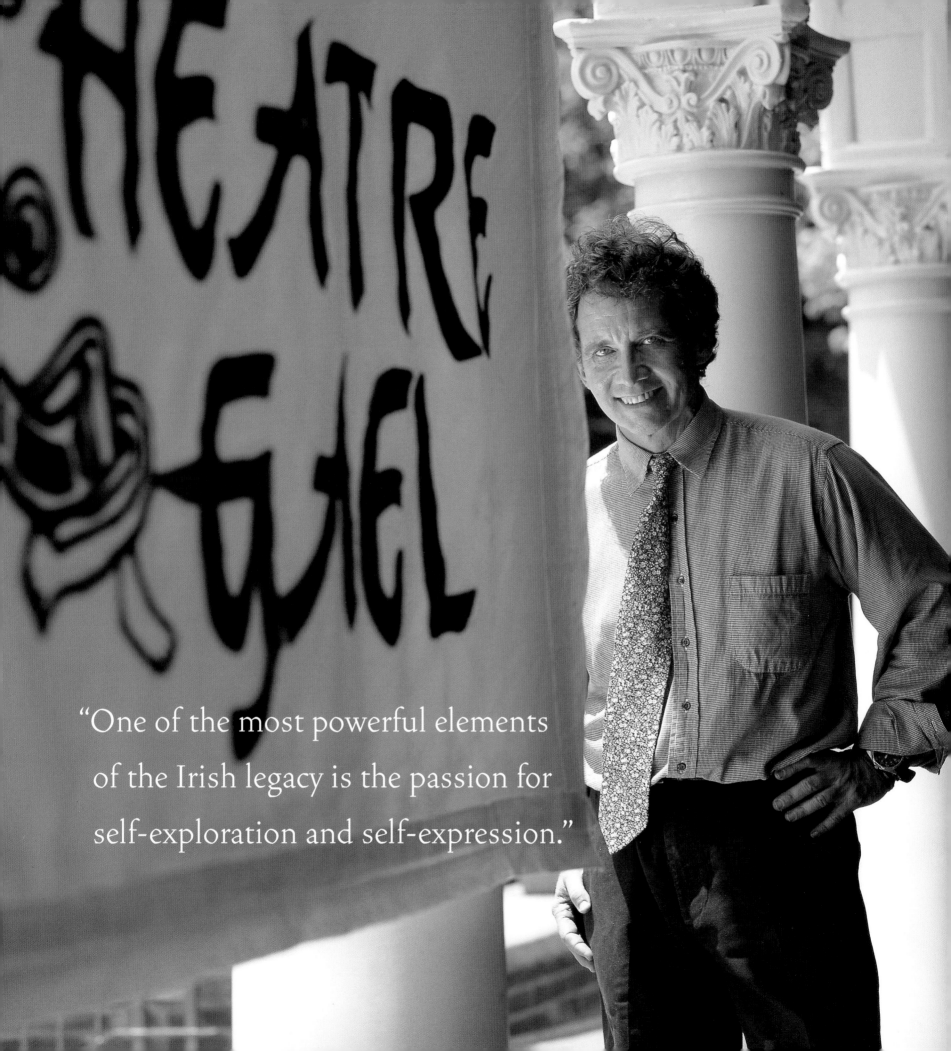

"One of the most powerful elements of the Irish legacy is the passion for self-exploration and self-expression."

"Margaret Mitchell, a fifth-generation Atlantan and Irish American, has been a great source of inspiration to me."

I'm not sure if it's the wealth of Irish writers or my exposure to the Margaret Mitchell House that inspired me to write. Maybe the combination of the two has helped inspire my diverse writing styles: I write about current events, I write poetry, and I was the editor of my high school yearbook, but I enjoy fiction most of all because I like creating stories and characters. ◉ Margaret Mitchell's love of writing began when she was old enough to hold a pencil. Of course, she's famous for penning *Gone with the Wind,* but she was also one of the first female reporters at the *Atlanta Journal Magazine.* Another interesting fact that many people don't know is that while writing *Gone with the Wind,* Mitchell had a different hiding place in her apartment for each chapter of the book. The first chapter was hidden in the icebox, in case of fire. A lot of people are also unaware that although *Gone with the Wind* seems to focus on a love story, Mitchell was greatly inspired by patriotism while writing the book. She hailed from a long line of veterans who had fought in the Irish Rebellions, the American Revolution, the Mexican Wars, the Civil War, and World War I. She was a tomboy growing up and would pay heed to her relatives' stories of the determination and fortitude needed to overcome the ravages of war and misfortune, a theme she would later incorporate into *Gone with the Wind.* ◉ My forefathers, too, saw their share of misfortune, but they contributed mightily to this country by digging the Erie Canal. I guess I've learned a lot from these stories and appreciate all that the Irish Americans went through in building this great country of ours. If it weren't for them, I wouldn't be able to tell my stories.

GINA WHITE Student, Margaret Mitchell House and Museum ◉ *Atlanta, Georgia*

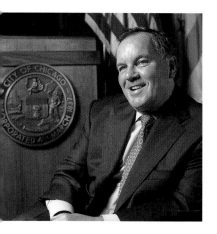
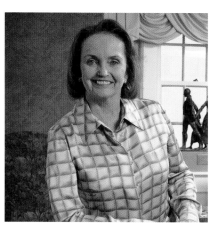
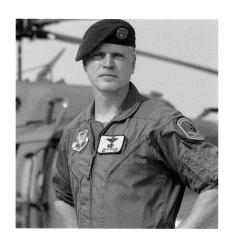
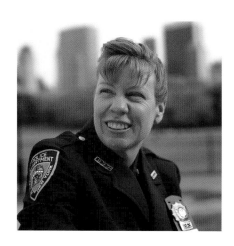

PART II

PUBLIC SERVICE

THE ASPIRATION TO SERVE:
IRISH AMERICANS IN PUBLIC SERVICE

TERRY GOLWAY

Perhaps it's a tribute to the communal life of days gone by in rural Ireland, where neighbor helped neighbor as each scratched out a living on rented land. Perhaps it's the inevitable result of an oppressed people sharing common burdens. Perhaps it's the only way the Irish could have survived the jarring transition from country lanes in Ireland to urban villages in New York, Boston, Chicago, San Francisco, and Philadelphia.

Whatever the reason, whatever the inspiration, there is no denying that Irish Americans have heard and answered a call to serve. In impressive and poignant numbers, they have been priests and nuns, politicians and police chiefs, teachers, firefighters, and soldiers. These are not professions that offer material riches. But they have allowed Irish Americans to help one another (and, eventually, many others) achieve the new life they sought when they sailed here.

More recently, with Irish Americans breaking into new professions in finance, law, medicine, and communications, the call to serve has taken on a different pitch. On any given night in all the old capitals of Irish America or in the surrounding suburbs, there are black-tie benefits and fund-raisers for any number of causes — Project Children, the American Ireland Fund, or maybe a neighbor fallen on hard times — during which Irishmen and -women come together to help where and how they can.

This is not a community that accepted WASP America's notion of rugged individualism. That was an indulgence propagated by those who could afford to fashion their own islands of affluence. For the Irish, flung from their rural life at home into the maelstrom of nineteenth-century urban America, survival meant cooperation. And cooperation required the assistance of friends and neighbors — their fellow Americans.

It's no secret that the Irish came to dominate certain sectors of American life, beginning in the mid-nineteenth century. The Irish cop, the Irish priest, and the Irish politician have become part of popular American folklore. There's a reason, after all, why all the priests in *Going My Way* had Irish names, why even Hollywood's cartoons featured cops with Irish accents, and why one of America's finest political novels, *The Last Hurrah* by Edwin O'Connor, features an aging Irish mayor.

It's almost commonplace to say that the Irish cop and the Irish priest and the Irish politician are more a part of the community's past than its present or, certainly, its future. The 1990s saw an explosion

of Irish-American talent in new and unexpected professions — the Irish CEO, the Irish entrepreneur, the Irish media mogul. They were the sons and daughters of the cops and politicians who opened doors once closed and who reinvented the image of the Irish American.

But even in these early years of the twenty-first century, a century that will see transformations in America's demography and sociology, the Irish continue to answer the call to serve. The professions that so defined the Irish experience have not been left behind in the rush to seize new opportunities. The police commissioner of New York City in 2004 is an Irish American named Raymond Kelly. The mayor of Baltimore is Martin O'Malley, and the mayor of Chicago is Richard Daley. The archbishop of Boston is Sean Patrick O'Malley. The chief medical officer of the New York Fire Department is Dr. Kerry Kelly, the first woman to hold that post. The cities in which they live and serve are far less Irish than they once were; indeed, New York, Baltimore, and Chicago could not be described as Irish at all, save in their legacies. Yet these Irish Americans continue to heed the call to serve, even in the face of change.

It would be romantic, but probably not entirely true, to say that the Irish-American commitment to serve was born of pure altruism. It was much more complicated and much more human.

During the Potato Famine, the Irish immigrated to America in great numbers with skills that were useless in the streets of New York, Boston, Baltimore, and the other port cities of the New World. They were farmers, but they could not farm in the cities. So they had no choice but to sell their labor, a hard living.

Urban America soon required employees to keep order and put out fires, and the Irish eagerly grasped these opportunities. Were they motivated by a chance to serve? No doubt. Did they also calculate that a city job, soon to be accompanied by a pension and other benefits, was better and more secure than carrying a hod? Of course they did.

Government service offered the Irish many of the things they were denied in the old country. There, they were subjected to the vagaries of landlordism and an imperial economy. They had no security. They could not plan for the future, for there was no future there, not as long as they labored for a landlord who could evict them at a moment's notice. Not as long as their health, their marginal existence, depended on nature and the potato.

Police work and firefighting, the signature civil service occupations of the Irish, were dangerous jobs, but with the advent of civil service after the Civil War, they were also decent-paying jobs that promised the blessing of economic security. Thousands of young Irishmen and -women would be reminded, upon coming of age, of the benefits of government work: You'll never get fired, and you'll get a pension after twenty or twenty-five years. Even to this day, even amid the celebrations of Irish success in business, young Irishmen and -women still respond to that message. The roll call of the dead on September 11

included dozens of Irish-American firefighters in their twenties and thirties who heard the call to service, but who also heard words from the Irish gospel of economic security: *You'll never lose your job; you'll get a pension.*

In the days before automobiles and interstate highways, firefighters and police officers often lived in the very communities they served, emphasizing that theirs was not just a job, but also a calling. That tradition is gone, and many Irish-American cops and firefighters live far from the places they protect. But they continue to serve, often following the path of parents and grandparents. And they are still regarded as heroes. Steven McDonald is a sergeant in the New York Police Department, although he has been in a wheelchair for more than a decade and a half. Paralyzed by a bullet while on patrol in Central Park, McDonald never left the NYPD. Today, he speaks to schoolchildren and has traveled to Northern Ireland to talk about peace and forgiveness. It would be harder to find a finer example of one person's commitment to serve not just a group but humanity itself.

For women, the chance to serve was more limited (although it should be noted that when New York hired its first female firefighters, more than half of the original two dozen had Irish names). Irish-American women came to dominate public school teaching positions in many cities during the early and mid-twentieth century. Their influence, on their fellow Irish as well as on the general population, was profound if less celebrated than that of the Irish cops and firefighters. They were the educators and inspirations of generations of schoolchildren, who learned firsthand of the strength and talents of Irishwomen.

Other Irish-American women took their commitment to serve to the convent, where they joined orders like the Presentation Sisters and the Sisters of Charity, among many. Still other women served neither in the classroom nor in the convent, but on the lonely barricades of social justice. Dorothy Day, a founder of the Catholic Worker Movement who died in 1980, was one of the twentieth century's greatest and most persistent voices on behalf of the poor. Living in near poverty herself, she was a witness to the squalor and indignity visited upon the Irish when they first arrived in America, and later suffered by their successors — blacks, Latinos, and other non-European groups — in the old neighborhoods. "What we would like to do is change the world — make it a little simpler for people to feed, clothe, and shelter themselves as God intended them to do," she once wrote. "And to a certain extent, by fighting for better conditions, by crying out unceasingly for the rights of the workers, of the poor, of the destitute — the rights of the worthy and the unworthy poor, in other words — we can to a certain extent change the world; we can work for the oasis, the little cell of joy and peace in a harried world." Her legacy can be found in nearly two hundred Catholic Worker communities around the world.

Bishop John Hughes of New York City by way of County Tyrone was another staunch advocate of social justice with an impressive legacy. Faced with a hostile, Protestant-dominated city, he built

schools, hospitals, and other social service organizations for Catholics, especially Irish Catholics, who desperately needed such facilities. No clergyman before or since was as determined to be of service to his flock than the man called "Dagger John," so named because he added a cross following his signature, and the ruling Protestants read the cross as a dagger.

Just as the service professions of firefighting and police work had their practical sides, so did politics. Powerless when they arrived in America, the Irish quickly realized that American democracy allowed them a chance to win power and influence in a way they could not imagine in Ireland. They took full advantage of the opportunity — sometimes, admittedly, in service not to the community but to themselves. But there were exceptions. The Irish built their political organization not on graft but on delivery of service. While the history of the American political machine is filled with tales of corruption, it's often forgotten that the clubhouse, dominated by the Irish, was a vehicle for a rough kind of social justice. The men, and the occasional woman, who worked their way from clubhouse to city hall were taught to remember that their power depended on outreach to the people. And the people often were poor, with all kinds of problems that today are treated by social service professionals. The social safety net had not been woven when the Irish political machine was at its height. So, in place of rugged individualism, the Irish and their allies offered the comfort of the ward heeler, the local clubhouse, and the favor bank. Corrupt? Sometimes. But any history of the New Deal must begin with the system presided over by bosses with names like Charles Francis Murphy and James Michael Curley. And history will note that one of the late twentieth century's leading voices on behalf of the poor was that of senator and scholar Daniel Patrick Moynihan.

It was Moynihan who once noted that when you're a doctor, nobody knows your name. He was referring to the rise of a new generation of educated Irish Americans and their less-prominent place on the public stage. It certainly is true that Irish Americans do not run America's cities anymore. But in their own way, they continue to serve. Kerry Kelly, a doctor, serves the still-Irish Fire Department of New York City; Kevin Cahill, a doctor, is one of the world's leading experts in tropical diseases and is a forceful voice in the campaign to ban land mines; Dr. Paul McHugh, a psychiatrist, is among the laymen helping to heal the Catholic Church's self-inflicted wounds.

You needn't be a prominent United States senator to serve the community. You can be an astronaut like Eileen Collins or Brian Duffy. A voice for the ailing like Karen Duffy. An actor who reaches out to the families of heroes like Denis Leary.

Or you can be somebody who writes a check for peace in Northern Ireland, or a family that takes in a child from the old war zone for the summer. The call to serve is as loud today as it ever was. And Irish Americans continue to hear and heed it.

"At Ellis Island, the authorities threatened to ship my father and his brother back to Ireland immediately, with or without my grandmother. . . . But Kittie Griffin, as she was known before she married, was not without her connections. . . ."

My father, Thomas Baldwin, was a New York City firefighter, so I guess the job is in my blood. Ireland was also in my father's blood, even though he spent most of his lifetime in this country. ◉ My father was born in Waterford, Ireland, in the 1920s. Tuberculosis killed his father, Michael, when Dad was barely a baby. My grandmother was advised by the doctors to pack up her two little boys, my father and his brother, and get them either to England or to America, where there was better treatment in case the children became infected. ◉ When my grandmother arrived at Ellis Island, the authorities threatened to ship my father and his brother back to Ireland immediately, with or without my grandmother, because the boys had contracted TB. But Kittie Griffin, as she was known before she married, was not without her connections and waited for her "reinforcements," the Ursuline nuns. On her voyage over, she had agreed to chaperone five novice nuns on their way to do missionary work in America. The Mother Superior of the Ursuline order and a few of her "troops" journeyed out to Ellis Island to reason with the authorities, explaining that my grandmother and her children would not be the responsibility of the state. I suppose, faced with a posse of that caliber, they must have agreed, because my father spent the next few years of his life in a TB sanitorium in Milwaukee, Wisconsin, until he was old enough to be in the fourth grade. My father and his brother were finally allowed to join their mother again, with a new stepfather (John Lennihan, also from Waterford), and they all moved to Park Slope in Brooklyn. ◉ Although he never made it back to Ireland in his lifetime, except during World War II on a navy destroyer, my father certainly grew up in an Irish household. As a boy, my father was exposed to many Irish traditions, including teatime and step dancing, but his favorite pastime was singing. He had a terrible voice, but he didn't care. He loved to have a "singsong." My grandmother discovered that my father was even sneaking off to sing in the choir of a black Baptist church on Sundays! They allowed the integration of this little Irish kid because he just loved to sing so much. This desire used to drive his own kids a bit crazy, especially when he would sing in the car *all the way* to grandma's, but his penchant for belting out a tune finally made sense after some of us visited Ireland as adults and witnessed the "singsongs" of our Irish relatives in Kilkenny. And, to be honest, in quite a few Irish pubs! ◉ But let's get back to that little two-year-old boy who was nearly put on the first boat back to Ireland. He grew up to become a captain of Rescue One in the New York City Fire Department. Those "TB" lungs sucked down smoke (and who knows what else) in the service of the people of the City of New York for twenty-seven years. His only two sons also became New York City firemen. I am presently a lieutenant on Ladder 40 on West 125th Street. ◉ My father may have left Ireland, but Ireland never left him. Even in his dying years, when his Alzheimer's took every memory away, if you wanted to see that "green" light return to his eyes again, you just had to share a little "singsong," preferably his favorite Irish tune of all, "Danny Boy."

JOE BALDWIN Lieutenant, Ladder 40 ◉ *New York, New York*

73

I'm proud of my Irish heritage, and I believe it has helped form my strong commitment to improving the quality of life of everyone in Chicago, regardless of race, religion, or ethnicity. ⊕ More than 150 years ago, hundreds of thousands of men, women, and children fled famine and oppression in Ireland and came to America to seek economic freedom and a chance at a better life. But instead of finding opportunity, many of them were met with open hostility and terrible discrimination. ⊕ But the Irish refused to be held down. They worked hard, made sure their children got an education, and became active in public life in Chicago and many other cities. Irish-American politicians practiced a policy of inclusiveness, providing much-needed services to everyone: recent immigrants as well as longtime residents. They put the day-to-day needs of people ahead of any abstract theories of government. ⊕ By the 1950s, Irish Americans had surpassed the U.S. average level of income and education, and NO IRISH NEED APPLY signs had become a relic of the past. It would have been easy for Irish Americans to turn their backs on more recent immigrants, the poor and the less fortunate. But for the most part, that hasn't happened. Most Irish Americans, because of their heritage, remain sensitive to — and opposed to — discrimination on the basis of race, religion, or national origin. We welcome the immigrants who come to this country seeking the same freedoms our ancestors sought. And we're committed to using every tool at our disposal — in government, as well as in the private and nonprofit sectors — to meet the many challenges facing the people of our cities. ⊕ In Chicago, we're focusing first and foremost on education because it is the key to a better life for all our people. We're working to produce more affordable housing, to make our neighborhoods safer, and to create jobs and economic opportunity. ⊕ We have made enormous progress, but we still have far to go. We can't claim victory until every adult has the opportunity to get a decent job, every child is educated to the maximum of his or her potential, and every neighborhood has an excellent quality of life. ⊕ This is not just an Irish dream. It's the American Dream.

RICHARD M. DALEY Mayor ⊕ *Chicago, Illinois*

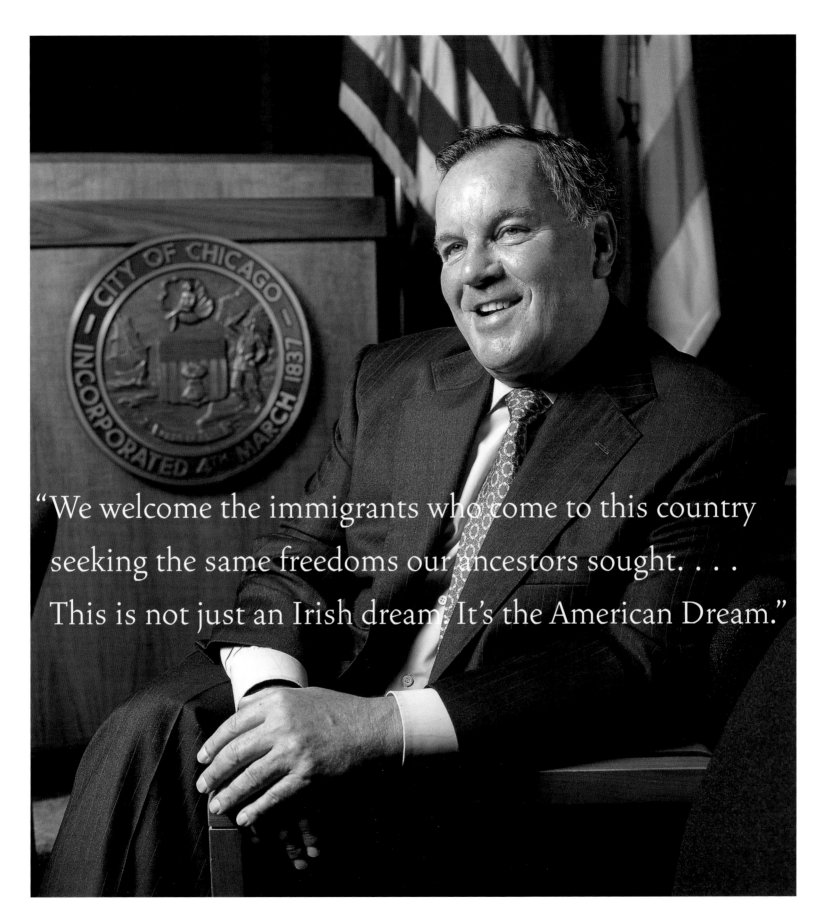

"We welcome the immigrants who come to this country seeking the same freedoms our ancestors sought. . . . This is not just an Irish dream. It's the American Dream."

"Faith, friendship, family, and athletics are the cornerstones of my life."

I'm the product of a classic Irish working-class family. My earliest memory is of watching my father leave for work, swinging his lunchbox and walking with an eager contentment that came from the promise of an honest day's work. My father was a plumber, an American icon of the workingman in the first half of the twentieth century. In those days, work, faith, and family were not sociological issues; they were simply the foundation of the lives people lived. ◉ When I was ready to leave the nest, it was basketball that won me a full scholarship to Notre Dame. After graduating from college, I attended law school, making my father as proud of me as I had always been of him. When he died, after forty years of exposure to asbestos, at first I felt betrayed by his job. Then I discovered a way to use my work as a lawyer to honor his memory and celebrate his values. I extended my law practice to serve working-class Irish who, just as my father had, worked under hazardous conditions. Because there were so many clients who needed my help, what began as an avocation quickly took over my law practice as a real vocation. ◉ As an assemblyman, I extended my work with the Irish community beyond the borders of the United States. A group of Irish-American politicians and I clearly realized our responsibility to help our people back in Ireland with the Northern Irish peace process. Along the way, I was lucky enough to assist with the McBride Principles, which prohibit U.S. companies from allowing religious discrimination in their Northern Ireland operations. ◉ As cohosts of a weekly Irish-American radio show, Adrian Flannelly and I discuss issues like these on the air each week. In cultivating my father's Irish values of work, family, and faith, I've found that a strong community — whether it's built through global politics or over the local radio waves — is always the key to a successful life.

77

JOHN DEARIE Attorney, former assemblyman, radio show host ◉ *New York, New York*

"My parents told us, 'Use the skills that you have, be the best that you can, and try to improve on the last generation.' "

My parents live the American Dream every day. Born in Hell's Kitchen, my parents and grandparents followed in the steps of so many Irish Americans by moving out to suburban New Jersey. My grandparents lived nearby, forming a large extended family. Everyone in my family truly appreciated the opportunity that this country gave them, enjoyed it to the fullest every single day. Their loyalty, pride, and strong work ethic created the cornerstone of my life. ◉ I had a ridiculously happy childhood. My youth was wrapped around sports because my parents were athletic. Dad had played stickball in the city, so he encouraged me to try everything. When I took up swimming and started winning competitions, my dad was so amazingly supportive. When I swam in college, Dad became the foremost authority on the sport. He always made every little thing that we did fun. My parents never pushed us to do something that we didn't like. They told us, "Use the skills that you have, be the best that you can, and try to improve on the last generation." When I graduated college, I was the first in my family to do so, and it was quite an event. The whole gang showed up at the graduation, and they were beaming with pride. ◉ We Devines are also very proud and loyal to our work. My father became a longshoreman when he was seventeen. He still is, and he is about to celebrate his sixty-sixth birthday. His father was also a longshoreman for more than fifty years; he reluctantly retired at seventy-five. My brother has been at UPS for twenty-five years. Mom was also at her job for twenty-five years. ◉ I've been at NBC for more than twenty years. I came to NBC after a college internship. I love my job because it allows me to utilize all my strengths — my gift of gab, my knowledge of television, and my marketing skills. The qualities that I inherited have made me what I am today.

79

KEITH DEVINE Senior advertising executive, NBC ◉ *New York, New York*

All of my great-grandparents arrived in the United States between 1860 and 1870, and settled in Brooklyn. Three of them were Irish, two from Cavan and one from Cork County. ❀ As first-generation immigrants in New York shortly before the Depression, my grandparents worked very hard for everything they had. When the opportunity arose in the 1930s to purchase plots of land in Rocky Point, my grandparents jumped at the chance. Both families bought land and built homes a couple of blocks away from each other. My parents met in Rocky Point. They married in 1955 and settled in the next town, Shoreham. ❀ Rocky Point was a very small, close-knit community. My father was one of the founders of the Rocky Point St. Patrick's Day Parade, still the largest and longest on Long Island. The Friends of St. Patrick is a small group of local businesspeople and residents who plan the parade each year. I am proud and happy to be a member and to continue my father's tradition. ❀ The Dougherty family is involved in not only the planning of the parade, but also the hosting of a party following the festivities. Family and friends are always welcome by standing invitation. We have the traditional meal — corned beef, cabbage, Irish soda bread, and, of course, beer! That is another tradition that I am happy to carry on. ❀ My

"John and I were lucky enough to survive many missions together. One particularly challenging mission later became known as 'the Perfect Storm.'"

father was one of six children, and about forty-two years ago, the siblings decided to get together each year for Thanksgiving. Although only one of my father's siblings is still alive, children, grandchildren, and great-grandchildren continue to attend. We have to rent the local Moose Hall because we have had more than one hundred people attend every year for the past ten years. It is everyone's favorite holiday. ❀ John Spillane and I met in parajumping school and became fast friends. Later, in 1982, John came to a St. Patrick's Day party at my parents' home. Laura, who would become his wife, and Barbara, whom I would marry, were friends of my sister Mary, and they also attended the party. John and Laura have been together since that party and so have Barbara and I. ❀ John and I were lucky enough to survive many missions together. One particularly challenging mission later became known as "the Perfect Storm." Often, people ask me if I was scared. I was, but I know that the strong work ethic instilled in me by my relatives made me go out there that day and do a good job.

JIM DOUGHERTY AND JOHN SPILLANE Pararescuers

Long Island, New York

My father was born in Clonmany in County Donegal. During the Depression, he set off from his tiny village in search of better opportunities. He and my grandparents settled in Boston at a time when success was more scant than ever. This only made my father more determined to succeed. He met my mother, married, and had five children. He was never able to finish school because he went straight to work to support his family. He worked as a mailman and did odd jobs on nights and weekends. ◉ My father's dream was that his children would enjoy a better life than he had. Through hard work and selfless sacrifice, he realized it. He believed that an American child armed with an education could do anything. Through unwavering love, he proved it — five times. His charge to his children was: "You can be and do whatever you want. Life isn't easy. Don't let anything or anyone hold you back. You can always outwork the competition. Never forget that." ◉ Well, we never did. My siblings and I were raised in Rockland, with extended family not far away in Southie and Dorchester. Our mother was a homemaker whose maiden name was Lindsay and whose mother's maiden name was O'Brien. She was a strong Irishwoman who made sure my siblings and I stayed on course. In encouraging us to soar, our parents raised a family of fliers. My brother is an F-15 pilot. My sister is a nurse and is married to an F-16 pilot. My other sister is a flight attendant. We like to call ourselves "the Family of Flight." ◉ As an eight-year-old boy, I remember learning about Alan Shephard's exploration of the moon and feeling a deep, lasting impression. In 1975, I graduated from the Air Force Academy in Colorado. Then I became an F-15 pilot. I can recall being nineteen years old as if it were yesterday, slicing through the air at 600 miles per hour and knowing that flying was what I wanted to do for the rest of my life. From there, I flew F-15s in Okinawa. Then came a chance to go to Edwards Air Force Base in California. Next stop was Florida, where I worked as a test pilot. I soon found out that NASA was looking for test pilots and that my prior experience was applicable. With a little luck and a lot of hard work, I eventually became an astronaut. ◉ My father passed away before I became an astronaut. It's unfortunate. He had always lived vicariously through his children's achievements, and it was no doubt his determination that helped to get me onboard a spacecraft in the first place. To honor my father, I pass his legacy on to my two children. My son just graduated from MIT with a degree in computer science, and my daughter is studying business at the University of Texas. They are living proof that if you work hard enough, you too can soar.

BRIAN DUFFY *Astronaut* ◉ Cape Canaveral, Florida

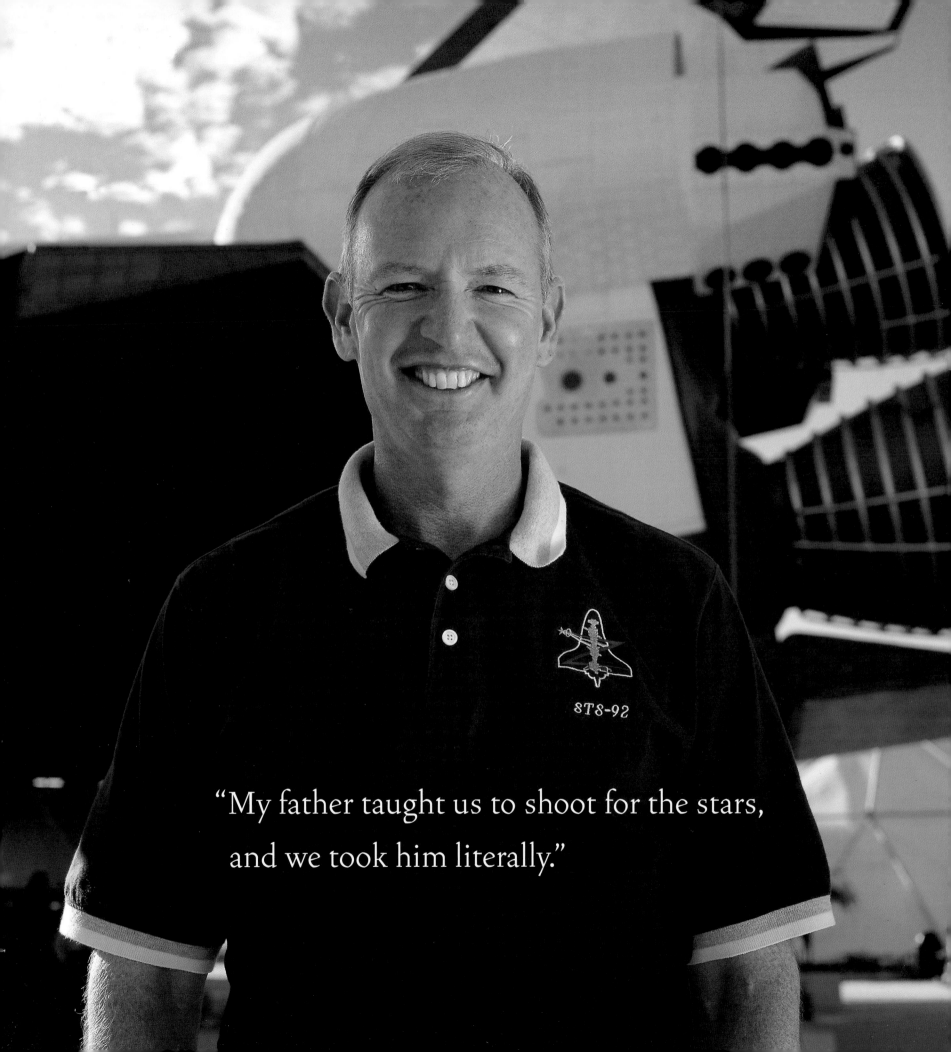

"My father taught us to shoot for the stars, and we took him literally."

My father was proud to hail from County Roscommon, Ireland, and my mother was a Salzburger from Austria. Though my mother was raised in the Baptist Church, she converted to my father's Catholicism. Together they raised six children, four girls and two boys, in Savannah, Georgia. ◉ The Sisters of Mercy is a national organization that serves the American community in the areas of health care and education. When I was in grade school, the Sisters of Mercy were my teachers, and so began my lifelong connection with the order. In 1944 I graduated from high school, and in September of 1945, I entered the convent. At that time, the order was training nuns as nurses and hospital administrators. In my group, six of the nuns were training to be nurses, but the Mother Superior tapped me for lab work. She had recognized a need (and a niche) for nuns who could study

"God has been good to me."

and train others in medical technology. I was willing to try anything, so while the other girls went back to the hospital, I went back to school. ◉ In 1953 I completed my training and took my vows. The sisters sent me to hospitals in cities all around the Southeast, including Atlanta, Mobile, and Savannah. I helped build hospitals from the ground up, ordering and managing brand-new medical equipment and implementing accounting systems. I drew up plans for labs in two new hospitals, modifying systems as the technology evolved. Later in my career, three colleagues and I initiated a medical technology program at Georgia State University, where I later taught chemistry and served on the faculty. ◉ The Sisters of Mercy gave me a gift, the prestigious McAuley Award for a life of service. Catherine McAuley came over from Ireland and founded the Sisters of Mercy more than one hundred years ago. As I accepted the award in her name, I realized how my path had come full circle. As my work began with the Sisters of Mercy, so it ended. Well, I may be retired, but I'm not done yet. I still enjoy sitting on the boards of hospitals and spending time with my family. Everything has its season, I suppose. And during each season of my life, God has been good to me.

SISTER MARIE FAHEY Former nun and retired medical technologist ◉ *Savannah, Georgia*

"The Ireland Funds have reunited me,
and thousands of people around the world,
with modern Ireland and have brought my life full circle."

Growing up as a coal miner's daughter in Pennsylvania, I knew Ireland only as a place from the past. My grandparents from Leitrim taught me to say all my prayers in Irish, but because they were trying to become American, they didn't speak Irish regularly. ◉ Had I only known at the time that I was losing such a large part of my Irish heritage. And while I can't turn back the clock and reclaim that part of my life, today I actively pursue and consider myself lucky to be able to enjoy, and help others enjoy, my Irish roots. I'm not sure if my initial motivation was to attempt to retrieve that bit of lost family history or to keep up with my husband, Lewis, a scholar of Irish literature. ◉ In either case, in response to the remarkable resurgence in Irish scholarship and creative arts, and at the urging of New York University president L. Jay Oliva, in 1991, my husband and I partnered with the university to create a center that would focus solely on Irish studies and culture. Two adjoining landmark houses at One and Two Washington Mews in historic Greenwich Village were renovated to serve as the home for Glucksman Ireland House. It has become a place where students can study and the public can enjoy the best in Irish and Irish-American culture. It also serves as a venue for Irish educational and cultural events. ◉ Why are people returning to their roots? I'm sure part of the reason is the continuing quest for self-identity. Surprisingly, people other than the Irish recognize the excellent contributions of Irish Americans and continually fill our lecture halls. ◉ Despite my grandparents' focus on becoming "American," my husband and I now spend most of our time in Ireland with many interesting and vibrant friends whom we have met through yet another great organization called the American Ireland Fund. From San Diego to Pittsburgh, the Funds have developed a unique network of committed and concerned citizenry joined by the common goal of promoting and fostering peace, culture, and charity throughout Ireland. ◉ My work with both organizations has brought me into contact with business and civic leaders. I am struck again and again by the deep gratitude so many people all over Ireland feel toward the Ireland Funds and Glucksman Ireland House. It truly means a great deal to them to know that people of Irish ancestry across the globe at last have a solid, successful way to express their concern and generosity and to actively preserve their heritage. ◉ These two organizations are much more than a link to my heritage. The Ireland Funds have reunited me, and thousands of people around the world, with modern Ireland and have brought my life full circle. Without a doubt, Ireland and its people have changed my life. I invite you to make that same connection.

LORETTA BRENNAN GLUCKSMAN Founder, Glucksman Ireland House ◉ *New York, New York*
Chairperson, the American Ireland Fund ◉ *New York and Ireland*

My great-grandfather Healy emigrated from Cork County in the 1800s. My mother's family, the Kellys, was from Limerick. My grandfather Healy was a glue salesman from Buffalo who ventured to Chicago to start the Admiral Corporation. My grandfather Kelly was a judge who knew Chicago's first Mayor Daley and organized a program for Irish livestock operations designed to introduce better, stronger lines of livestock from the Midwest to farmers back in Ireland. I was born in Chicago, the second of seven children. I was a policeman for twenty-eight years, specializing in narcotics and trying to keep Chicago clean of drugs and the damage drugs do to communities. Later in my career, I worked for the Chicago prosecutor's office. I have since retired and spend a lot of my time sailing. This autumn, I will make my first East Coast odyssey, heading down the Mississippi, then to Mobile Bay, dipping down to the Caribbean, and then darting back up the eastern seaboard and home to Chicago. ⊚ In his work as an entrepreneur running a film production company, my older brother has had the opportunity to bridge the "pond" between the United States and Ireland. He serves as a local resource that provides extras, sets, and locations for American studios to shoot films in Ireland. His first feature film was Mel Gibson's *Braveheart*. I'll bet that a lot of people don't know that those huge fight scenes are filled with Irish people, most from the army. ⊚ Everyone has a unique way of keeping in touch with his or her culture. It may sound strange, but having a mustache feels like part of my Irish connection. I grew my first one while I was in the Marines. My wife complained about it, so I went ahead and shaved it off. Then, of course, she missed it, so I grew this huge handlebar mustache to make sure she'd never have to miss it again.

88

JOHN HEALY Retired police officer ⊚ *Chicago, Illinois*

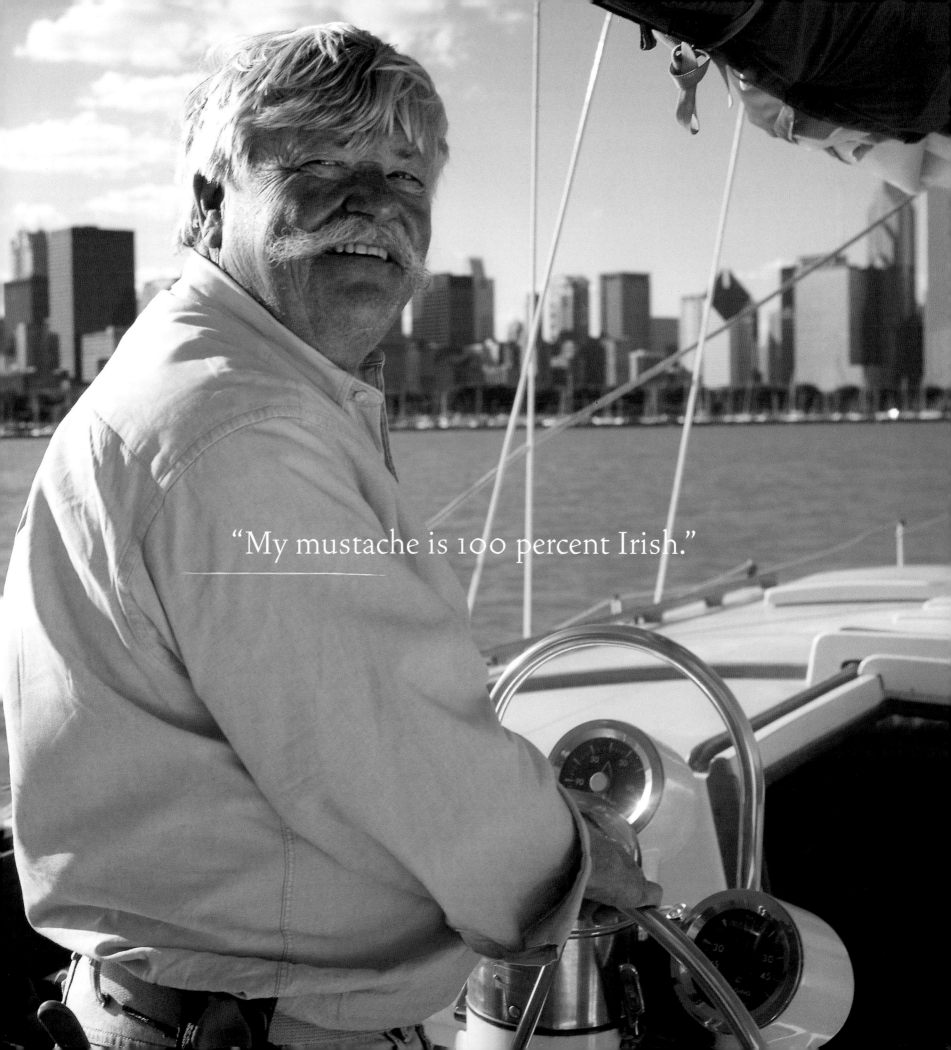

"My mustache is 100 percent Irish."

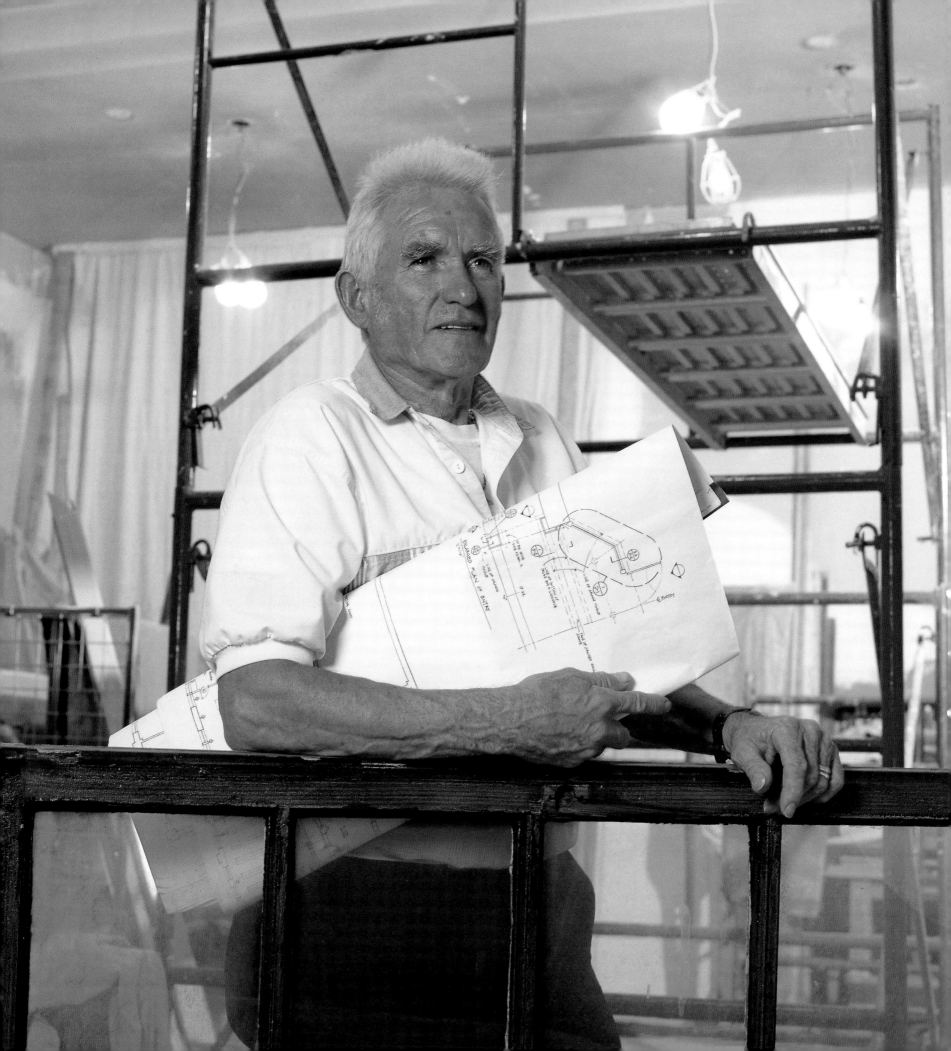

"My parents taught me to pass my good luck on to others."

I've always considered myself lucky, and I truly believe that I inherited a bit of the "luck of the Irish." As I grow older and the years season me, I'm not sure if this "luck" is so much the serendipity of good fortune as it is my taking advantage of the opportunities that God presents. Chances are, it's probably a bit of both. This is not to say that life was always easy. In their lifetime, my parents saw their share of hardship. Living through the Great Depression made them appreciate all that they had but never hoard it, and to keep giving to others. ❀ My parents' "waste not, want not" attitude bubbled up within me when I learned that a collection of abandoned buildings in downtown Chicago was going to be demolished. While others saw the buildings as dilapidated real estate on its deathbed, I saw them as the promise of a place for our community to dance, make music, and laugh together. So I rescued them, and now we're building an Irish-American Heritage Center right here in downtown Chicago. As we bring vibrant cultural life to an otherwise forgotten street, we carry the Irish values of ingenuity and generosity into the twenty-first century.

AMBROSE KELLY Contractor, developer ❀ *Chicago, Illinois*

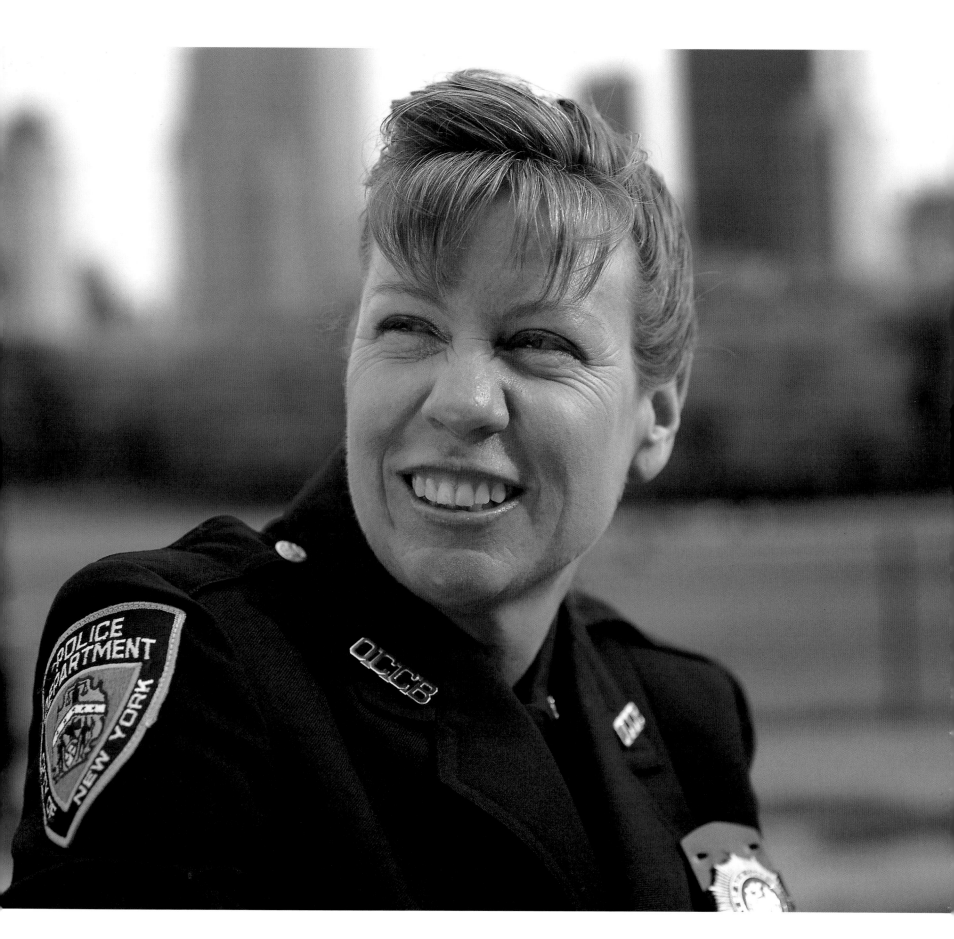

"I attribute my strong sense of dedication, loyalty, and community service to my parents."

When I was a child, my parents guided me in what was right and wrong and deeply influenced my decision to become a police officer. They insisted that I obtain a secure job with good benefits; attaining economic security was always a priority for them. They also encouraged social interaction with others. The Irish are well known for their mastery of social skills, a talent that allows them to strike up a conversation with nearly anyone, to give the best toasts, and to host the best parties. My heritage has helped me socially and, more important, professionally. This strong intuitive sense of people also allows me to serve the community. As a police officer, I take great pride in cooperating with others to better this great city of ours.

KATHY KELLY Police officer ● *New York, New York*

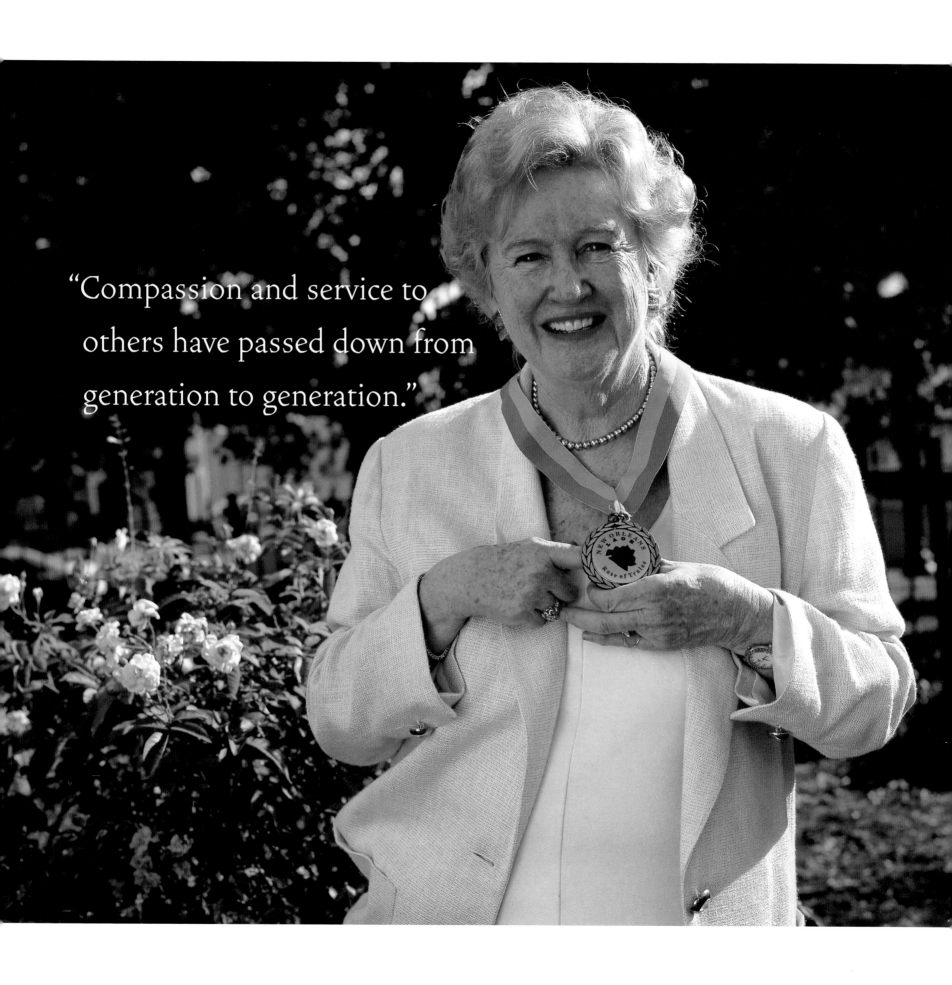

"Compassion and service to others have passed down from generation to generation."

My parents instilled in each of their seven children an innate sense of compassion and service to others. That is why I am working on a documentary to honor Margaret Haughery, a remarkable woman who arrived in New Orleans a penniless Irish immigrant and died one of the city's most respected philanthropists, known for her compassion and resourcefulness in providing for the city's needy children. Shortly after losing her husband and son to yellow fever in 1835, Margaret turned her misfortune into fortune. She used her ingenuity and sincerity to persuade landlords and local officials to help her establish four orphanages and several homes for the elderly, and at her death, she left more than $600,000 to New Orleans orphanages. All this from a woman who couldn't read or write. Her statue, believed to be the first to honor a woman in the United States, stands at the corner of Prytania and Camp streets in New Orleans. ◉ I also do volunteer work for the Rose of Tralee Committee, which honors young Irish-American girls. The Rose of Tralee Festival, held each year in Kerry, Ireland, hosts girls with Irish heritage from all over the world. Although some may look at the event as just another beauty pageant, contestants are chosen for their personality and character, undergoing two nights of interviews on Irish TV and becoming near celebrities. We, the New Orleans chapter, support the festival because it is a cultural and educational experience that whets the girls' appetite for discovering their Irish heritage. ◉ As far as discovering my own heritage, I was lucky enough to marry into a particularly Irish family. I credit my mother-in-law, Mrs. Delia Brigid Kennedy, with fueling my passion for my culture. She was born, raised, and attended Mass every Sunday in the Irish Channel. The Channel is the "Irish Quarter," the counterpart to the better-known French Quarter. Her passion for her Irish background permeated my generation. It has been passed on to my children and grandchildren. In fact, my eight-year-old granddaughter recently told her class, with much pride, that my job is to work for the Rose of Tralee Committee.

NORA LAMPERT Historian, member of the Ladies Order of the Ancient Order of Hibernians ◉ *New Orleans, Louisiana*

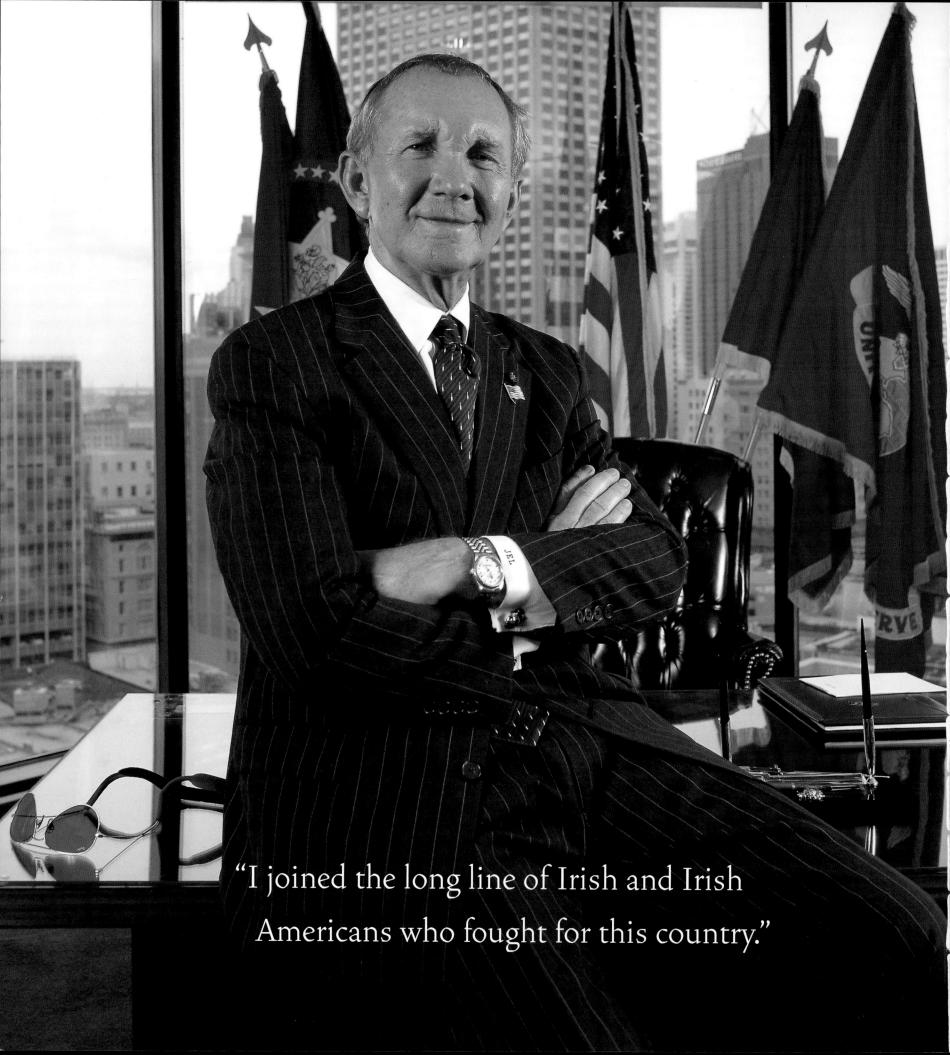

"I joined the long line of Irish and Irish Americans who fought for this country."

When I was awarded the Congressional Medal of Honor, I had to reflect on whom to thank for helping me achieve that great honor. First and foremost, I had to thank my parents for teaching me determination in the face of adversity. They taught me to handle life's ups and downs with a stiff upper lip and a dose of humor. My parents, probably because of their Irish heritage, helped me learn to appreciate freedom and love of country. ❀ I proudly served my country for thirty-three years before retiring in 1995. I was taught by my parents not to leave anyone behind. That's why I was awarded the Medal of Honor, the Distinguished Service Award, the Silver Star, the Defense Superior Service Medal, the Bronze Star, the Purple Heart, the Third Award, the Defense Meritorious Service Medal, the Navy Commendation Medal, and various other service and foreign distinctions. ❀ I am also proud to note that up through 1994, Ireland was the country with the largest number of medal winners — by far — with 258. And five of the nineteen fighting men who won a second Medal of Honor were born in Ireland. Three double winners of the medal are Irish Americans. ❀ If we look back a little farther, we can see that the Irish and Irish Americans have long contributed to this country. Eight of the original signers of the Declaration of Independence had Irish heritage. Irish Americans made up one-third of the troops in the Revolutionary War. ❀ In the Civil War, 150,000 Irish Americans fought for the Union and 80,000 for the Confederate Army; thirty-nine regiments had an identifiable Irish component. Sixteen generals of the Union Army were Irish born; six Confederate generals and eleven colonels were Irish born. Seventy Irish-born Americans received the Medal of Honor during the Civil War, and 202 received the award up through World War I.

MAJOR GENERAL JAMES E. LIVINGSTON

Executive president, Columbus Properties, LP ❀ *New Orleans, Louisiana*

Both my parents were born in Ireland. My dad was from Roscrea, Tipperary. My mom was born in Clare. I have two brothers and two sisters. ◉ Because I was first generation, I didn't really have a relationship with my heritage growing up. My mother passed away when I was a child, and my dad was always heads-down working. However, I lived in a predominantly Irish neighborhood in Bayside, New York, and I was exposed to Irish people who influenced me immensely throughout my life. My best friend growing up was James Donavan. His family, especially his grandfather, had a profound effect on my career decision. His grandfather, Mr. Cotter, was the former deputy fire chief and was a World War II veteran. He spent a lot of time telling stories to my twin brother, Gerard, and me when we were young, stressing the importance of civic duty. Moreover, he was an avid historian and built model airplanes. He had the patience to share his techniques with my brother and me. Over the years, we became enamored with the fire department — it's no wonder that both Gerard and I became firemen!

"Early in life, I was mentored by the former New York City deputy fire chief."

DAN MAHER Firefighter ◉ *New York, New York*

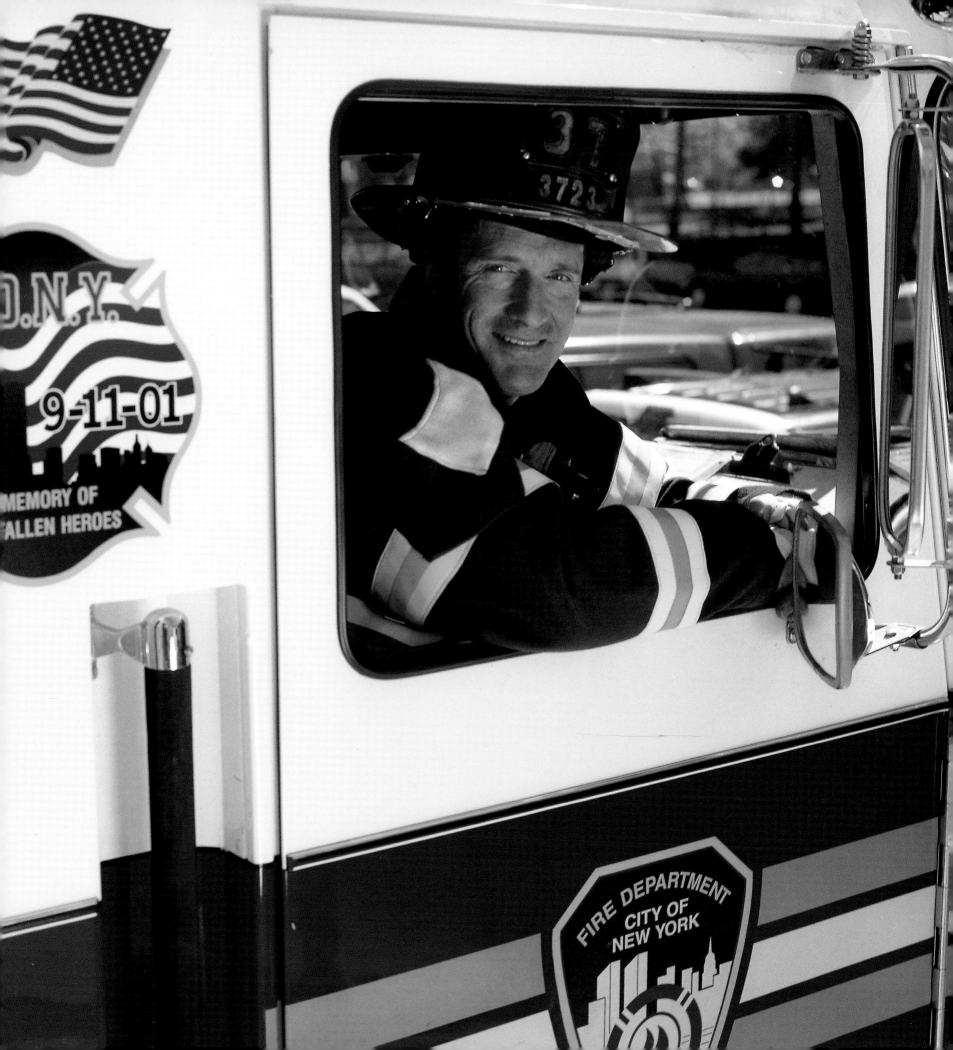

I was raised in Boston in an Irish-Catholic family, and politics was often the topic of discussion at the dinner table. Being a Republican was considered sacrilegious because the Democratic Party was — is — the "party of the people." Memories of the signs warning NO IRISH NEED APPLY and other forms of discrimination so common among immigrant groups still colored people's thinking. Mayor James Michael Curley — revered and respected — was credited with elevating the position of the Irish by providing them with jobs, money to help buy food or pay the rent, comfort when there was a death in the family, and gift baskets of food at the holidays. ◉ I met the love of my life — Jack McCaffery — at a campfire discussion in the Grand Canyon in 1962. The topic that night was "Is there a God?" and though strangers in the night, we seemed to agree about God anyway and continued our conversation long after the other campers had returned to their tents. ◉ We married the following year and within ten years had four sons and two daughters. Thoughts of the impending tuition expenses prompted me to return to school to earn a master's degree in nonprofit management at the New School in Manhattan. While in school, I worked part-time for the Society of St. Vincent de Paul, an organization that helps the poor. The job also gave me hands-on experience and material for my term papers. ◉ I always had a yen to run for political office, but circumstances made that impossible until we were over the college tuition hump. ◉ After losing four elections and vowing never to run again, I decided that 2001 seemed like a year in which a Democrat could win in Republican Oyster Bay. Without too much family opposition, I ran for the Oyster Bay Town Board, and surprise — I WON. ◉ Being a minority member of the board is a challenge. I'm a doer and a team player, and it is difficult for me to be on the outs. But in the tradition of Mayor Curley, I am doing what I can for my constituents and continuing to be involved with the Society of St. Vincent de Paul because that organization and my family provide a balance to the world of politics. ◉ And, by the way, Jack is a conservative Republican. We have a bipartisan marriage, a fact that, I think, helped me get elected.

MARY McCAFFERY Councilwoman ◉ *Town of Oyster Bay, New York*

"Helping the people
was a lesson learned
since childhood."

"Being able to listen to people with competing interests — being able to forge a middle ground — is an important component of Irish culture."

I am third-generation Irish-American. I grew up in Dorchester, but my parents, taking advantage of a veterans program after World War II, bought a house in Canton. Many members of the Irish community followed, and until I was in the eighth grade, I didn't realize that people other than the Irish existed. Our community was Irish, and my dad was a schoolteacher in the neighborhood for more than forty years. He felt it was his way of giving back to the community. My mother worked part-time. My father came from a family of fifteen kids. I have fifty first cousins and hundreds of second cousins. My mom only had one brother. ◉ When I married my husband, McCarey, I insisted on keeping my maiden name. No one could ever persuade me to change it — I liked it so much. For the last twenty-five years, I've worked with environmental issues. For the last five years, I've overseen environmental policies for the governor's office. It's very clear that my background has had an enormous impact on me. The work ethic in the Irish community is enormous. It's a work ethic that we learned from our parents. When they arrived in this country, they treated jobs as though they were sacred, as if they were gifts from heaven. Economic destitution was a fear that the Irish understood. ◉ My Irish background has been the foremost factor in my success. Being able to listen to people with competing interests — being able to forge a middle ground — is an important component of Irish culture. We are a culture that has no problem with disagreements. People are always going to have different views and thoughts. It shouldn't make people angry that they disagree. The difference with Irish people is that having an argument is not disrespectful. Listening is the key. You see the glow in someone's eyes when another person disagrees; it's just the beginning, not the end. Most people walk away; Irish people don't. ◉ People who are environmentally friendly are not competing with growth. There is a balance between jobs, the economy, limited resources, and quality of life. I am able to help the economy because I've not paid a lot of attention to the conflict. I'm not a tree hugger, I'm a people hugger, concerned with people's need for clean air and water.

103

REGINA McCARTHY Chief of operations for the Governor's Office for
Commonwealth Development ◉ *Boston, Massachusetts*

As an adolescent, when you are casting about for who you are, you look to your ethnicity for a hook. I was an adolescent in the 1960s and was fortunate that folk music, especially that of Irish groups such as the Chieftains, became very popular then. Bands such as the Clancy Brothers influenced me both musically and ethnically. My grandfather had been a musician; he played the banjo mandolin. He was born the second son in Kilkenny, on the family farm, and thus his economic prospects were already spoken for. So he set out for the United States shortly before World War I. After serving in World War I, as so many Irish did, he was granted his American citizenship. Sadly, he got to return to Ireland only once before he died. ◉ Shortly after I got married, my wife and I went over to Ireland to see the place where my grandfather was born. Luckily, the family farm was still in the hands of his sister-in-law. So we saw the farm gatepost where, every evening as a young man, he would encounter the "little people" and they would tell him stories. By that time, I, too, was a musician. My relatives showed me the barn where they had the *ceili* (Gaelic for "party") upon his first return. I'm so happy that I did that then, because now the farm has passed out of family hands. ◉ Everything in my life seems to circle back to my grandfather. I see a strong link between traditional Irish music and Celtic spirituality. Now I play an entire range of Irish instruments: the guitar, banjo, mandolin, tin whistle, costatina, and the Great Highland pipes. In addition to his musical influence, my grandfather also influenced me spiritually. ◉ After being a social worker, running an intensive drug and alcohol treatment center, I decided to become a priest. In 1989, I became an ordained deacon, and in 1990, I became a priest. I see my job as a ministry and have spent more than twenty years working with the chemically dependent. ◉ Now a father, I hope that I can instill in my two children, Liam and Mairi, the love and pride in my heritage that my grandfather passed down to me.

REVEREND JAMES McDERMOTT Priest, Church of Ireland ◉ Supervising corrections officer for Suffolk County ◉ *Port Jefferson, New York*

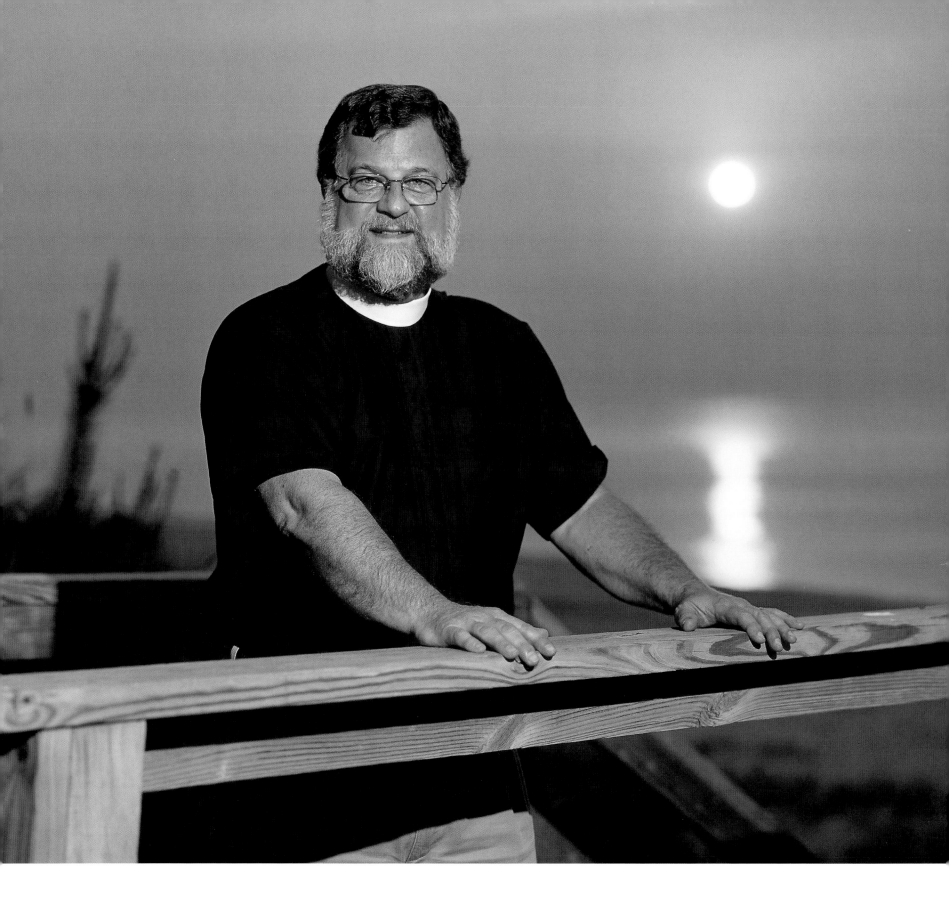

"Everything in my life seems to circle back to my grandfather."

And all shall be amen and alleluia.

When we shall rest, we shall see.

And when we shall see, we shall know.

And when we shall know, we shall love.

And when we shall love, we shall praise.

Behold the end, and there is no end.

— a grace of St. Augustine

I was born in Altamont, California, in the windy hills, at the beginning of the Great Depression. We never knew we were poor, but thinking back, it is clear that we were — you know, with just one pair of shoes and all that. My folks are Irish American. We raised cattle and horses and grew wheat, oats, and barley. We were Roman Catholic, and my mother would drive us to St. Michael's, the little Catholic school in Livermore, ten miles away, every day. My paternal grandfather was from Sligo, and all the people from my mother's side were Irish Canadians. My grandmother was saintly, one of three girls and fourteen boys who grew up in Peterborough, in eastern Canada. Her father was one of the Irish farmers brought to settle the frontier by the Brits as a buffer against the French. ◉ It was in the kitchen on the family ranch in California that I heard my grandmother's stories about the hedgerow priests who kept the community's faith and instruction alive against huge odds in dark times. Later, I taught myself more about ancestor Red Hugh O'Donnell, legendary for defending those who could not defend themselves. When I became a priest, I felt compelled to speak out against injustices I saw around me and soon became a nonviolent champion of the poor, of workers, of those condemned to capital punishment, of immigrants. I believe that it is part of my ministry to take a stand against the government when it "morally misbehaves." I struggled for years alongside Cesar Chavez; was in Alabama with Martin Luther King Jr.; traveled to Guatemala, El Salvador, and Mexico to be with beleaguered peasants; and marched arm in arm to witness against war, never afraid to pay the price of peacefully disobeying what I considered unjust laws and orders. By the time a federal judge sentenced me to six months in jail, at age seventy-two, for trespassing in a protest against the U.S. training of Latin-American officers involved in human rights abuses, I had been arrested 243 times. I can only hope that in my life I have served and helped others, and inspired others to speak out.

BILL O'DONNELL Parish priest, activist ◉ *Berkeley, California*

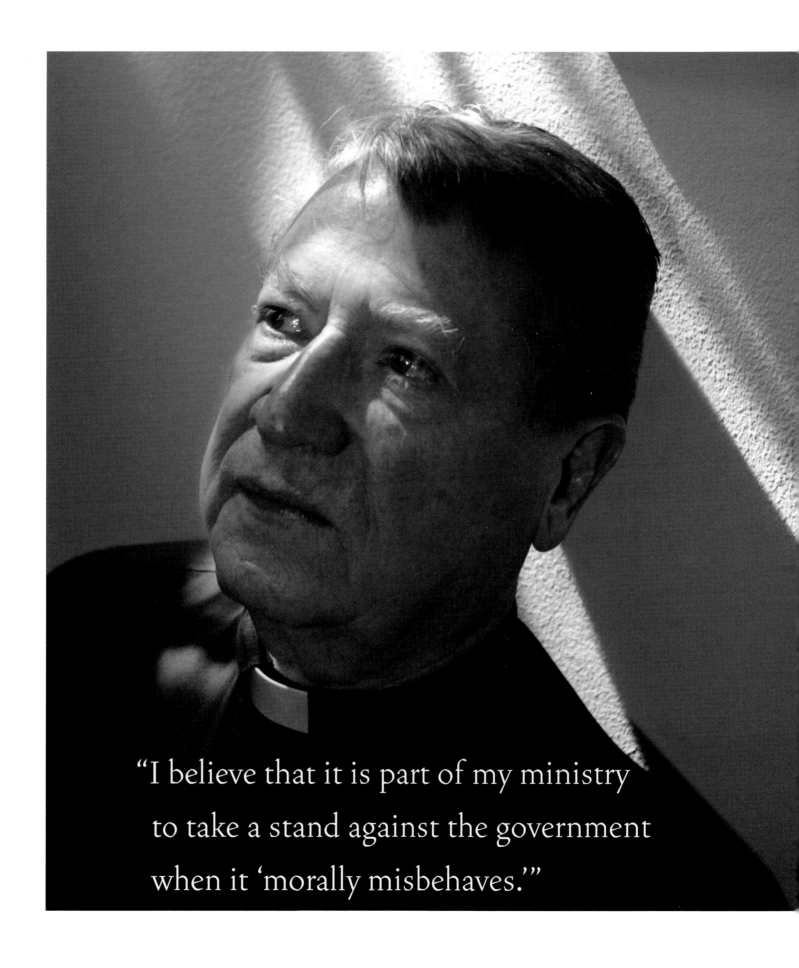

"I believe that it is part of my ministry to take a stand against the government when it 'morally misbehaves.'"

I'm first-generation Irish American. My parents are both from Belfast — my dad's from Falls Road and my mom's from New Lodge Road. When I was growing up, our house was always filled with Irish people — some lived in the United States, some lived in Ireland, some were visiting indefinitely. It was always a fun, boisterous, loving crowd. The neighborhood in which we grew up, Bayside, was also predominantly Irish. So my neighbors were the Murphys and the Connolleys, and many of them were civil servants — cops, firemen, and so on. ◉ I believe certain people can leave strong impressions on your life when you're young. And this community of cops and firemen influenced me strongly in my career choice. I knew when I was eight or nine years old that I wanted to become a fireman. It took a lot of time until I was finally here, but now that I am, I am ecstatic with my decision! ◉ I so enjoy coming to work. I feel that I make a difference every day. If I'm not fighting fires, then I'm training back at the house, preparing to fight better the next time. This line of work is truly a team experience. Everyone watches each other's back. ◉ As far as my family goes, I have two small children and will try to instill that sense of commitment to civic duty that my family and neighborhood instilled in me.

GERRY O'HARA Firefighter, Company 35, Ladder 40 ◉ *New York, New York*

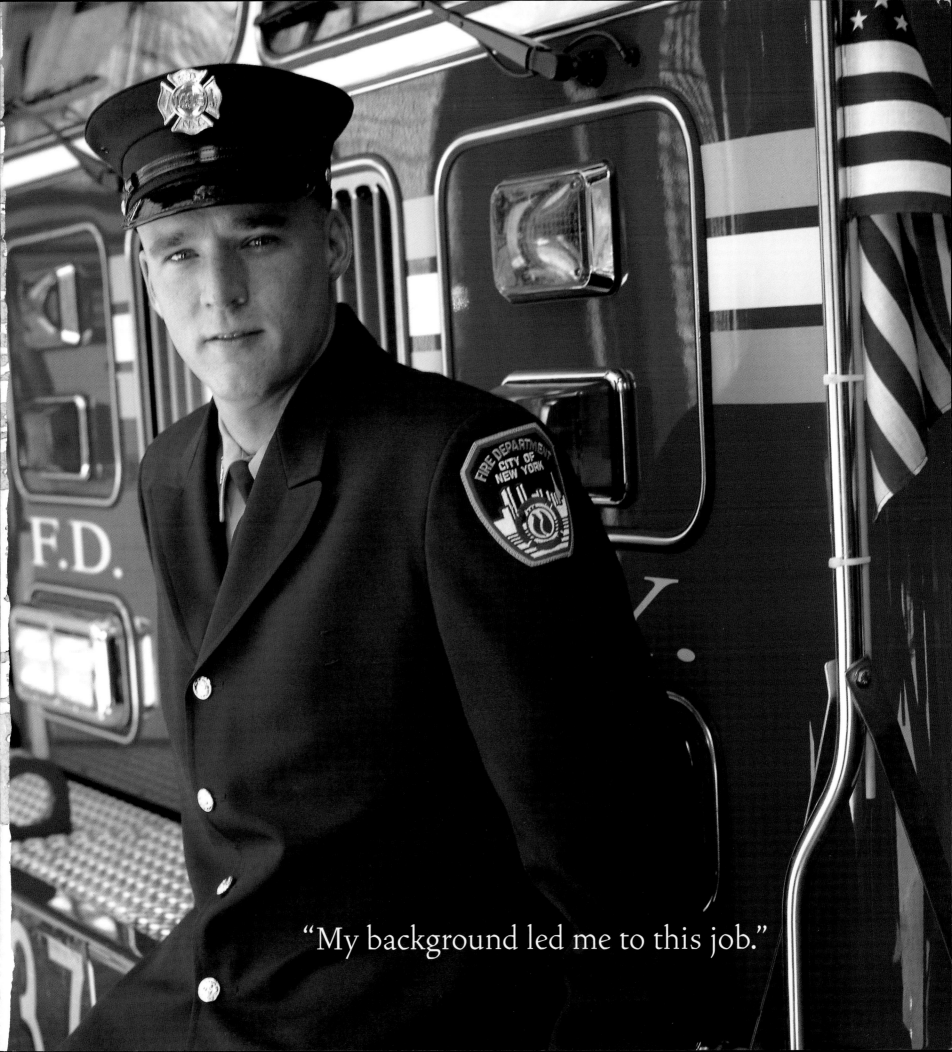

"My background led me to this job."

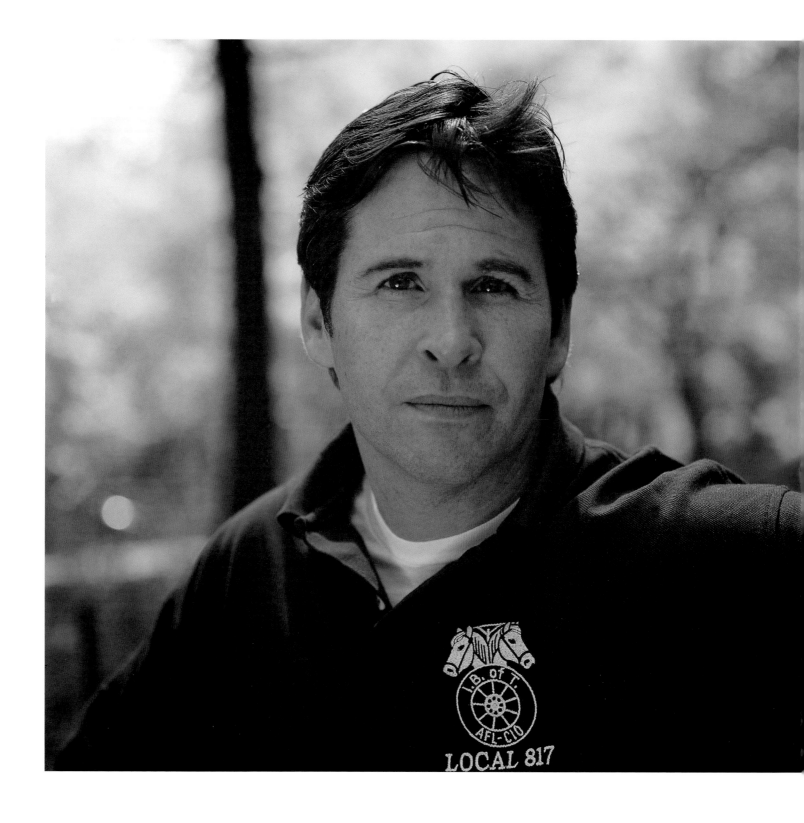

"I'm very proud of my Irish heritage,
and what I prize most is my family's commitment
to public service and politics."

Since the turn of the twentieth century, three generations of my family have been involved in public service and local politics in New York City. Thousands of Irish citizens living in New York in the last hundred years, whether new immigrants or not, felt disenfranchised because of their religious and economic status. By forming a strong Irish-American community and, therefore, a strong Irish-American vote, these citizens vastly improved their economic station from lower to middle class. Through this same unity and commitment to their fellow man, my family encouraged thousands of New York Irish to overcome discrimination, to rise to power in both the public and private sectors, and to realize the American dream. That hard work and tenacious fight for equality is what the Irish-American spirit is all about.

BOBBY SPILLANE Actor, model, writer, teamster ◉ *New York, New York*

PART III

SUCCESS

SUCCEEDING THROUGH HARD WORK
AND EDUCATION

DON KEOUGH

Over the last two hundred years, America has seen its Irish immigrant population rise from near poverty to the top rungs of American society. Today, countless American corporations, universities, foundations, and political parties have people of Irish ancestry at the helm. How did this immigrant group, which arrived on these shores with neither skills nor capital, achieve such rapid success?

I believe that the Irish who survived the transatlantic journey developed a resilience that was second to none. And the unique circumstances they left behind made them determined to attain for their children what they were denied at home — access to higher education. This desire not only fueled the immigrants' success but it protected future generations of Irish Americans from the vortex of poverty. This passion and respect for education, which ultimately led to the establishment of numerous colleges and universities, is propagated in the twenty-first century by Irish-American parents, students, teachers, and benefactors.

The great migration out of Ireland was a brave search for opportunity and a good and decent life. A future devoid of promise or hope necessitated this uncertain plunge into the unknown. The Irish did not want to leave their loved ones, but once they made the commitment, an amazing process of self-selection began. Only the strongest of mind and body survived. And those who survived had to be strong for others. They had to be strong for their brothers and sisters, wives and husbands, many of whom had pooled precious resources to send them to America. This self-selection process created a remarkable gene pool of determined men and women.

One might argue that this is the story of every immigrant group, but the Irish faced a particularly unusual challenge when they arrived. They were not greeted warmly. Unskilled and unaccustomed to urban life, they settled for the only work available to them — backbreaking manual labor. And the competition for jobs was fierce. The Irish competed with other immigrants, free blacks, and slaves for the most menial of jobs. Many, like my own great-grandfather from County Wexford, chose to head west to homestead. He left Pittsfield, Massachusetts, with a group of Irish homesteaders, hoping for a better life in Iowa.

I think of him and his family often. I know from stories relayed to me by my father and great-uncles how our ancestors braved those inhospitable winters. They cut wood for heat from trees fifteen miles away and pulled the logs one by one back to their fragile homes. They put roots down in Iowa. They watched the newly broken soil finally bear fruit to feed their families. I know that the Keoughs and the Irish neighbors who worked at their side tilled hard land and planted tough soil to bring alive the corn and oats that would allow my dreams and the dreams of my children to come true all these generations later.

In my father's years on the farm, life was hard. When things didn't work out, it wasn't possible to throw in the towel; there was no public assistance when the Great Depression came. My great-grandfather kept the farm but moved to Sioux City, Iowa, and became successful in the cattle business.

The hard work of my parents, and others like them, instilled fortitude and determination in my generation. Our parents told us to keep our nose to the grindstone, but also to aim high. To do that, we needed to obtain what my great-grandfather had been denied in Ireland — access to higher education.

The Irish who came to this country two hundred years ago still carried the folk memory of the Penal Laws enacted against Catholics for most of the eighteenth century. At that time, the government believed that Irish Roman Catholics had a stronger tie to the pope than to the King of England and, therefore, that they weren't loyal subjects.

One of the stated goals of the Penal Laws was to "assure that Roman Catholics and future generations of Roman Catholics would stay in their 'proper position' in the Kingdom." To achieve that end, the English denied them education. Under the code, Catholics were not allowed to attend university, keep a school, or send their children to be educated, at home or abroad. Any educated Irishman or schoolmaster who continued to teach schoolchildren had a bounty of anywhere between ten and fifty pounds placed on his head.

Consequently, when a large wave of Irish immigrated here in the second half of the nineteenth century, they brought with them their nightmares of persecution and discrimination. Once here, they vowed to make certain that education was made available to their children. Soon after their arrival, they began providing primary and middle school education in Catholic schools scattered across the landscape of America. These schools served well, and continue to serve well, the needs of Irish-American families. However, the critical component of the success of future generations of Irish Americans was the establishment of institutions of higher education.

Some noteworthy examples are the College of the Holy Cross, the University of Detroit, St. Louis University, St. John's University, Villanova University, Georgetown University, Marquette University, the Catholic University of America, Loyola University, DePaul University, Providence College, Iona College, Manhattan College, Siena College, St. Mary's College, and Boston College.

I became involved with Notre Dame University after my daughter went to study there. I saw Notre Dame as a great place for my children to further their education. Despite the university's strong Irish links, however, it didn't have any courses in Irish history and literature. I am proud to say that I have truly enjoyed giving back to the educational community by helping build an Irish studies program at Notre Dame that now has more than six hundred students per year and twenty-five different courses in aspects of Irish culture — including history, literature, film, and theater. There are four classes in Irish language, and there's a waiting list to get in! Moreover, the waiting list comprises names from every conceivable ethnic background. In fact, the first Ph.D. awarded by the program went to a woman who had grown up on a Native American reservation.

When I went to college, I left my home in Iowa and attended Creighton University, a Jesuit college in Omaha, Nebraska. During that time, I learned the skills necessary to succeed in life. I never forgot that these great institutions of higher learning were financed, constructed, supported, and attended by Irish Americans and other immigrant groups. They were operated by dedicated religious communities of men and women, communities largely populated by Irish Americans. The creation of these schools afforded the children of immigrants and future generations the full menu of opportunities that American society offers. They would never be deprived of an education by a government again. They could learn any trade or profession and could go on to occupy any position in a company or local or federal office. And Irish-American schoolmasters would shed their fugitive status, shrug the bounty off their head, and enter into the full esteem of the local community. In the unique American way, it was up to the individual to determine whether he or she would prosper.

Prosper they did. Droves of Irish Americans attended universities, many on athletic scholarships, and later went out and succeeded in all areas, not just in education but in business, politics, athletics, and community service. They gave back to the community by building, growing, and managing companies, giving other people a place to work. Take a look at the business leaders of major companies. So many of them have Irish heritage — Peter Lynch of Fidelity, Thomas Moran of Mutual of America, Cathleen Black of Hearst Magazines Division, David Browne of LensCrafters, Liam Coonan of SBC Communications, Thomas Corcoran of Lockheed Martin.

A number of athletes also got their start at these universities. Many of the coaches, referees, and student players helped build and eventually tie the college sports infrastructure into the fabric of this country. Take a look at "the Fighting Irish" of Notre Dame. On the one hand, the Irish in America suffered from the stereotype that they were prone to fighting and violence. On the other hand, Americans worshipped competitiveness and a fighting spirit. If it helped Americans view their Irish-American counterparts as fighters on the gridiron rather than in the streets, that was a positive development. Football players such as Frank Leahy, Ray Flaherty, George Connor, and Frank Gifford followed this route. Then there were basketball players such as Bill Bradley, Rick Barry, and Kevin McHale. In ice skating, Nancy Kerrigan, Peggy Fleming, and Dorothy Hamill come to mind.

Baseball began as an urban sport and was well suited to the Irish. By the 1890s, one-third of professional baseball players were Irish American. Early greats include "Black Mike" Cochrane, Eddie Collins, Hugh Duffy, Nolan Ryan, and legendary managers Connie Mack and John McGraw; among today's stars are Mark McGwire and Paul O'Neill. In boxing, there were so many champs across so many levels, but names like Jack Dempsey, Gene Tunney, and Jim Corbett are still very well known today.

Many Irish-American graduates never forget their roots, and their business success is rivaled only by their passion for putting money back into the community — often in the area of education. There are so many examples of Irish-American philanthropy, far too many to mention here, but consider the following cases:

- A gift of $7.5 million to Manhattan College — the largest in the college's history — has allowed the school to build a library for the twenty-first century. This was made possible by Tom and Mary Alice O'Malley.
- In the area of scholarships, the *New York Times* recently ranked the Mitchell Scholarships, named after Senator George J. Mitchell, as one of the six most prestigious scholarship awards, placing them side by side with Rhodes, Fulbright, and Marshall. Mitchell Scholars study in Ireland, thanks to the U.S.-Ireland Alliance, established in 1998.
- Teaching his renowned management skills to principals in New York's school system, Jack Welch is putting to creative and enduring use the skills he honed while building General Electric into a global powerhouse.
- Another Irish American who has long demonstrated her leadership in nonprofit and philanthropic circles is Caroline Kennedy. In her role as head of the Office of Strategic Partnerships for New York City schools, she is the chief fund-raiser for the city's schools and so demonstrates her commitment to education.
- John Duffy, CEO of Keefe, Bruyette & Woods, Inc., sits on the board of trustees of the Michael Smurfit School of Business, University College, Dublin, as well as on the boards of St. Michael's College in Colchester, Vermont, and the Ursuline School in New Rochelle, New York. His dedicated application of business skills helps to support and manage these institutions.
- At Fordham University, the Walsh Library was built with a gift from Bill Walsh and his family to his alma mater.

And those are only the people you hear about in the media. What about Chuck Feeney, cofounder of Duty Free Shoppe, who was recently uncovered as the anonymous donor of huge sums of money to various educational institutions. His motto, "Giving while living," has inspired him to donate more than $3.5 billion to charity in his lifetime.

Look back a little farther. When Henry Ford died, he left his fortune to the newly created Ford Foundation. One hundred years later, the foundation still ranks among the top three in annual giving. In 2001, it gave away a staggering $830 million.

This demonstrates how incredibly important the educational and philanthropic infrastructure of America is in ensuring that men and women of all backgrounds will never be kept "in their position" again. And, in this short space, I have only mentioned a few examples of the countless Irish-American men and women who helped to build and continue to support that infrastructure.

Tiny Ireland — 5 million people on an island — is a small dot in a global population of about 6 billion. However, her impact and influence in America over the last two hundred years is indeed enormous. More than 44 million people in this country have Irish blood in their veins, and America is a richer place for it. Irish Americans are a vital part of the great American adventure. I am proud to be one of them.

A little-known fact about Irish-American history is that many Irish immigrated to the United States through Canada. They went to Canada for several reasons. It was cheaper to immigrate to Canada, and many people immigrated there from Northern Ireland because Canada was part of the British Commonwealth at the time. I trace my heritage back through Canada. My mother's maternal grandfather settled in Winnipeg. ⊛ Her father's side of the family, the McKones, decided to immigrate to New York. Soon after, they headed south to Richmond, Virginia. A few years later, they headed north to Fargo to start a cigar business with two other Irishmen. ⊛ My dad's side of the family emigrated from Ireland and joined the ranks of Irish fighting in the Civil War. Great-grandfather Brooks fought on the Confederate side with friends from Kentucky. After being thoroughly disappointed with the outcome of the war and wanting no part of the new government, he headed out to California. Ten years later, he became the first U.S. attorney in California. Ironically, he ended up working for the government after all. ⊛ My dad must have inherited the political gene from great-grandfather Brooks. My father ran as a Republican in the '30s and later served in the state legislature in the 1950s and '60s. He fueled my interest in politics. ⊛ When I was young, I worked for Nelson Rockefeller as an advance man, trying to head off the Nixon campaign. Later, I worked for Hubert Humphrey. I ran for the U.S. Congress but lost, so I decided to pursue my other career interest: newspaper publishing. ⊛ I came down to St. Paul because the Twin Cities are a magnet for business. Since 1986, I've published the only Irish newspaper in the upper Midwest, the *Irish Gazette.* Recently , we've joined the American-Irish Media Network. Now we are part of a national newspaper publishing consortium that includes the *Boston Irish Reporter,* the *Irish Edition* (Philadelphia), *Irish American News* (Chicago), and the *Irish Herald* (San Francisco).

"Spreading the word about all things Irish American has become my mission."

JIM BROOKS Publisher, the *Irish Gazette* ⊛ *St. Paul, Minnesota*

My husband, Josh, and I are very different. He's Protestant; I'm Catholic. My family is from Georgia; his family is from South Carolina. I come from a large extended family; Josh is an only child. One of the things we have in common, however, is a love of Irish literature — especially James Joyce. ◉ Josh did not actively celebrate his heritage as a child, but at university, he met an Irish professor who persuaded him to join a master's program at Trinity College in Dublin. ◉ I had studied literature and theater. Our passion for Irish literature drew us together when we first met. Now, together, we sponsor the Savannah Irish Festival each February. Next year is the thirteenth year! We arrange for writers to be flown in to do a seminar on traditional literature or music. ◉ Our festival kicks off the St. Patrick's Day season, which is huge in Savannah. It's pretty amazing that Savannah is a city of only 300,000 people but has the second-largest parade in the country. ◉ To further the Irish art of conversation, we bought O'Connell's pub last year. We both had spent a lot of time there, so it just seemed like a logical next step. We've tried to make it very traditional and cozy, a gathering place for locals. ◉ And we get to show off our dogs, Great Danes. We have been told that the breed is distantly related to the Irish wolfhound. It's hard to believe that our sweet babies are connected to snarling, boar-hunting dogs.

SHELLEY CARROLL AND JOSH LOWTHER Restaurant owners, festival organizers

Savannah, Georgia

"The conversation is free; the whiskey you have to pay for."

I can trace my Irish heritage to the Declaration of Independence. One of the original signers, Mr. Charles Carroll of Carrollton, was a distant relative on my mother's side. In the United States, being related to a signer of the Declaration of Independence is almost like being related to royalty. ◉ Charles Carroll represents the aspects of my Irish heritage that I prize the most. He was not afraid of tough decisions, his actions supported his principles, and he demonstrated a tremendous work ethic until his death at ninety-two years of age. Charles was schooled abroad, and one would think that he would have adopted a predilection for the monarchical institutions of Europe. Instead, he returned to his home-state of Maryland, where he defended the local people against England. Because he was the wealthiest of all the signers, he risked the most — his property, his freedom — in support of his principles. ◉ For me, he exemplifies what is wonderful about being Irish. With their unrelenting work ethic and fierce determination, the Irish made contributions to this country too numerous to count. Their accomplishments, especially in the southern United States, are particularly bittersweet. The Irish did the jobs that no one wanted, such as digging the canals and levees. The Irish were considered dispensable. It was more economically feasible to use an Irishman to dig a canal than to risk a valuable slave. Thousands of men perished from heat and malaria while building these structures. Later, here in New Orleans, the Irish took jobs in the police and fire departments, with little respect and pay. Justice prevailed, however, and one generation after these Irishmen were finished digging the canals, an Irishman was elected mayor of New Orleans. ◉ These things have helped me understand that no dream is impossible. I look back at people that have passed before me and am so proud to be Irish. The heart and soul of my heritage lives in me today. The color, music, and approach to life have made me what I am. They taught me that if you are willing to work hard and keep a smile on your face, good things will happen to you and your family. I try to keep the family connection alive by traveling back and forth to Dublin and Derry each year. ◉ This year, Pat O'Brien's is celebrating seventy years of operation. True to its Irish name, it's a fun and lively place that employs a lot of people at restaurants in New Orleans and in Cancun, Mexico; Nashville; and San Antonio. I love the tradition of the place and its connection to my roots.

BILL COOLING General manager and head chef, Pat O'Brien's ◉ *New Orleans, Louisiana*

"I can trace my
Irish heritage
to the Declaration
of Independence."

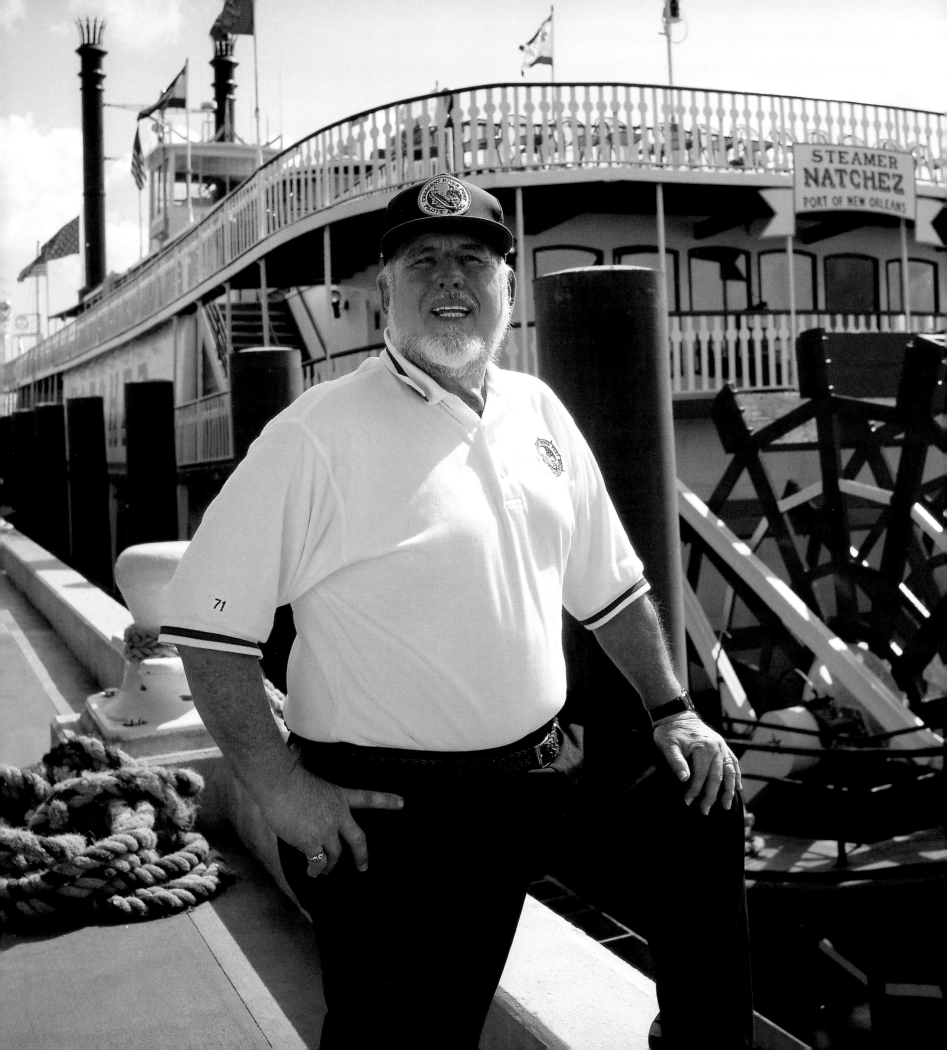

"Once you wear a pair of shoes on the deck it's hard to leave the river life."

As a young boy from the Irish Channel neighborhood in New Orleans in the early 1960s, I had few career options. Choices included working for the Southern Pacific Railroad, going to sea, or working for the naval base. My grandfather was a railroad man, and my dad was the first of his siblings to get into shipping. He kindled my love for the river. ◉ My father worked in the Tie shipyard. He started as a helper and ended up as superintendent of the yard. As a kid, I used to play on the river and grew up with stories of riverboats, tugboats, and deep cargo ships told by my dad, brother, and uncles. ◉ Navigating the river is the same today as it was in Mark Twain's day. He learned because someone showed him. It requires skills that you can't learn from reading a book. To successfully get down the river, you have to understand the currents and negotiate the points. Mother Nature just won't let you go straight. ◉ I went to college but never finished because the call of the river was too strong. My mother was not too happy about it. My father respected my decision and recommended that I work on the tugs rather than the oceangoing ships. But it was my uncle, my father's youngest brother, who helped train me and inspired me to pursue my position. ◉ Now, thirty-eight years later, I'm still a steamship pilot on the Mississippi River. And can you believe that with all this experience on the river, I have never swum in it?

125

CAPTAIN JAMES DONOHUE River pilot ◉ *New Orleans, Louisiana*

I am a fifth-generation Irish American. My father's family came over from Sligo in the 1830s, and in 1912, my father, James Mahon, was born in Dunmore, Pennsylvania. He was one of four children, so when it came time to finance college, he took a unique approach. My father played the saxophone with the band at the Hotel Casey in Scranton (the precursor to the Tommy Dorsey Orchestra). What an incredible player! As a child, I would drift off to sleep to the lilt of his sax. A CPA, he became an esteemed partner at what today is known as PricewaterhouseCoopers. Though accounting is typically considered left-brain work, my father brought his creative side to it, and that is why I believe he was so successful. He set up the first communications practice for the firm and encouraged the company to go global. He had a column in the *Journal of Accountancy* and wrote and edited many books. My father had a remarkable talent for blending the analytical and creative sides of the brain. ◉ My mother, Monica Sullivan, had an entirely different experience growing up. The eldest of three children, she was born in the States but raised in Mexico City from the age of five. Her father worked as controller at Sinclair Oil. After completing high school in Mexico, my mother went north to college (Nazareth College in Rochester, New York). My parents met through family friends, married, and settled in the Philadelphia suburbs just as my father began his public accounting career. They later moved to the New York area. ◉ I was born in Bryn Mawr, Pennsylvania, and am the eldest of six children. When I was two, I was diagnosed with polio. I had a number of surgeries, and during the quiet of my recuperation, I began reading. I devoured the Uncle Remus stories, the *Book of Knowledge,* the *World Book,* and scores of library books. Our house was filled with books on every subject. Even then I loved reading more than writing. ◉ When I went to college, Trinity, in Washington, I majored in biology because I was interested in psychology and in how the brain works. There was no point in studying English literature — I knew I would have already read all the books anyway! I wanted to use the communication skills inherited from my father to translate science for laypeople, so my classmates and I started a magazine called *Scope.* Lo and behold, it won a national award. ◉ After graduation, I continued to dance between the right and left side of my brain, integrating my knowledge of science and my love of books. I joined Doubleday & Company as an editorial trainee and within a few short years was responsible for science publishing and what was then Anchor Press. After ten years in editorial, it was time to broaden my skill set: I knew that I wanted to be a publisher, so I moved on to the finance group and oversaw several aspects of the business. Five years later, I transferred to the book club group, where I worked on editorial and marketing projects; I love the direct connection book clubs have to the customer. Then a friend suggested I come over to Warner. During my thirteen years here, I have learned the importance of communication, a long-running theme in my life, from a brand-new point of view. ◉ Thanks to my father, that theme runs through my life and through the lives of my siblings. It actually started with my father's father, an entrepreneur who owned a newspaper at one point, and his mother, who had a newspaper column. All of us inherited their passion for connecting, storytelling, and communicating. My sister Kathy owns an auction house, and her two eldest daughters are writers. My sister Pat is a marketing consultant. My sister Regina has published two books. Her daughter, Fiona, is already known for her poetry at the ripe age of eleven. One of my brothers, Harry, markets broadcast satellite time, and the other, Jim, is a managing director at a large investment firm. Even my husband David's background is in public relations. Communicating, in its many forms, is what our family does. Maybe that's why I've always enjoyed our family dinners — the talk, the stories, the connection.

126

MAUREEN MAHON EGEN President and CEO, Time Warner Book Group ◉ *New York, New York*

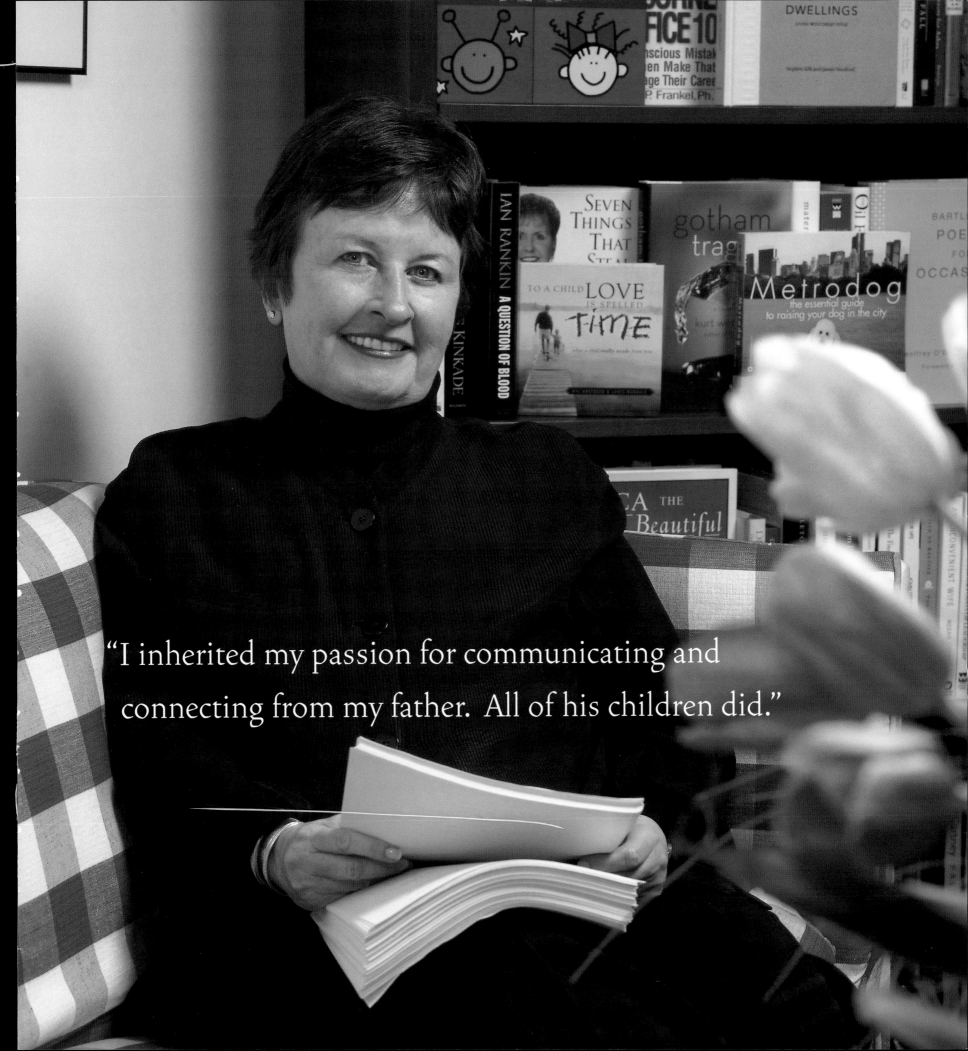

"I inherited my passion for communicating and connecting from my father. All of his children did."

My father was from Clonmacnoise, Offaly County, and my mother was from western Clare. My father was a die-hard IRA man, on the run from the Free State government. Mother was the youngest of nine children; her father was a shanoise singer. When local schoolmasters began collecting folklore in Ireland in the 1930s in order to preserve anything written in Irish, the local schoolmaster stayed to learn from my grandfather. An extremely well-rounded and talented man, my grandfather played the flute and loved music. He passed on stories of Celtic crosses and Irish history to my dad, who then planted the seeds of Irish culture deep in my soul. The stories gained new meaning for me the first time I read Yeats. ◉ There is a connection between idealism and passion. I believe that is the reason Irish Americans have been able to make so many contributions to American culture in such a short time. And I have my mother to thank for her emphasis on education. Despite being born in a peasant community, she had the utmost respect for the "learned" man, similar to the Celtic Ollamh — the complete teacher — who has to master disciplines in both the left and right hemisphere of the brain to be a complete person and to be the best at everything he does. They were a combination of critical thinking and the arts. When I won my professorship, I asked them to put *arts* first instead of *humanities* because art is where your passion lies, and one cannot do anything without passion. ◉ The Irish also valued those who could speak well. If it weren't for the contributions of Irish and Irish-American writers, world literature wouldn't have advanced as rapidly as it did. Each generation inspired generations of future writers, who have written major critical works as well as artistic ones. The Irish scholars that I've admired still know how to tell a story well, in the bardic tradition. The artists that I admire can sing a song but can also tell you the history of the song. In Yeats's play *The King's Threshold,* the bards were at the right hand of the king. ◉ When I went to Trinity College, I set out to study Ireland. I met a vast collection of interesting people, and lots of feelings about my culture that had been established in childhood came rushing back. Some people would call it sentiment, but I call it a real feeling that I hungered for. The Ireland of today is much different. As a teacher, I have continued to help people learn about their proud history and have tried to instill a hunger for knowledge in future generations of students.

JIM FLANNERY Yeats scholar, tenor ◉ *Atlanta, Georgia*

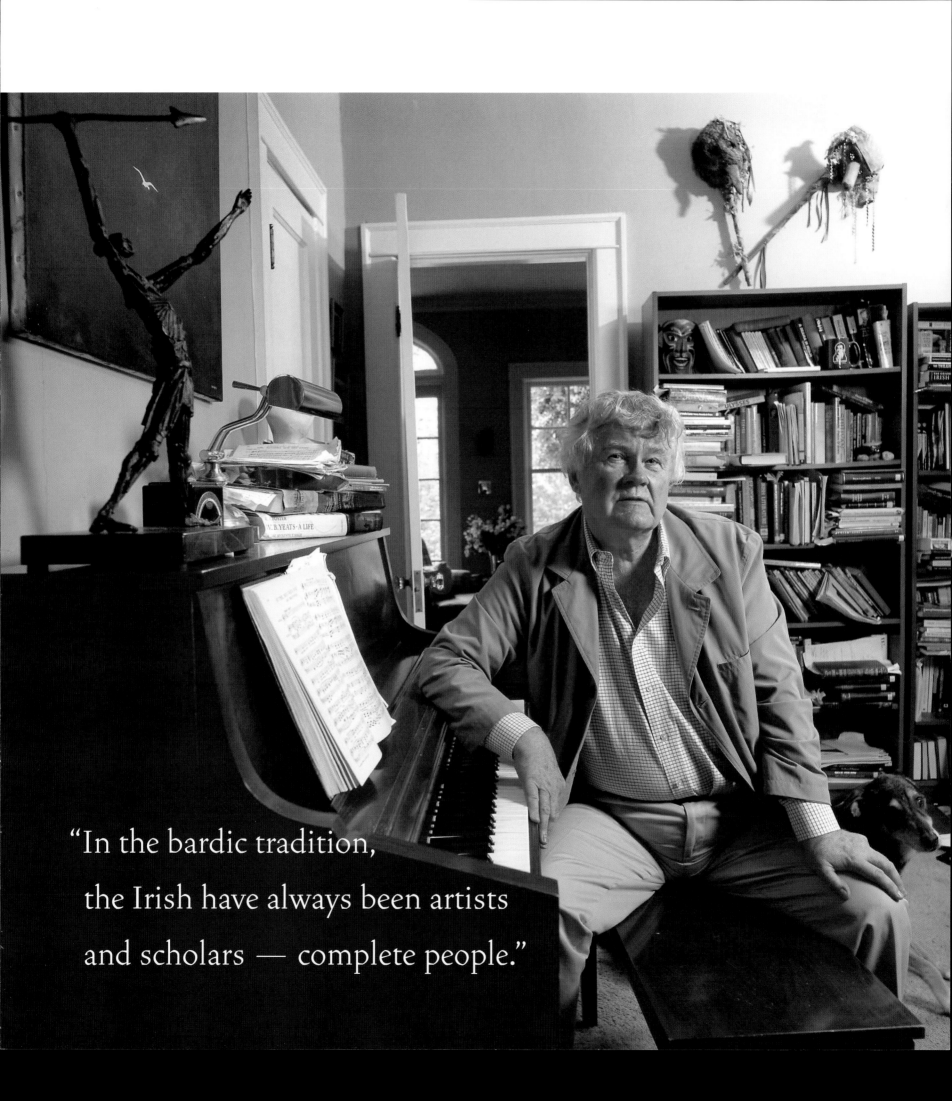

"In the bardic tradition,
the Irish have always been artists
and scholars — complete people."

Boxing is in my blood as much as being Irish is. My paternal grandfather, Ed Flynn, was a boxer who used to fight during the Depression to earn a few dollars. But because boxing could be such a physically brutal sport, he never let my father, Peter, fight. ◉ So my dad never really encouraged me to box, but I've always had an interest in it. About five months ago, I gave it a try, and now I'm hooked. I've always been athletic. During college, I played lacrosse (defense) and football (cornerback), but I didn't play professionally after college. I'm a physical education teacher for grades six through eight. So is my dad, who I would say has a competitive and fighting spirit. ◉ It helps to have a local hero as inspiration. Mickey Ward was from Lowell. He was a world champ at thirty-six, so I figured that I'm not too old to start. I'm a light heavyweight, and the training is very tough. I like the competition; I like that you have to work hard at it. It's an individual rather than a team sport, so success is all on you. ◉ I'm married with two-and-a-half-year-old twin daughters, Avery and Faith. My wife, Kelly, and I are expecting our first son this month. I'll encourage him to play sports, but I don't know if I'll let him box.

CRAIG FLYNN Amateur boxer, physical education coach ◉ *Billerica, Massachusetts*

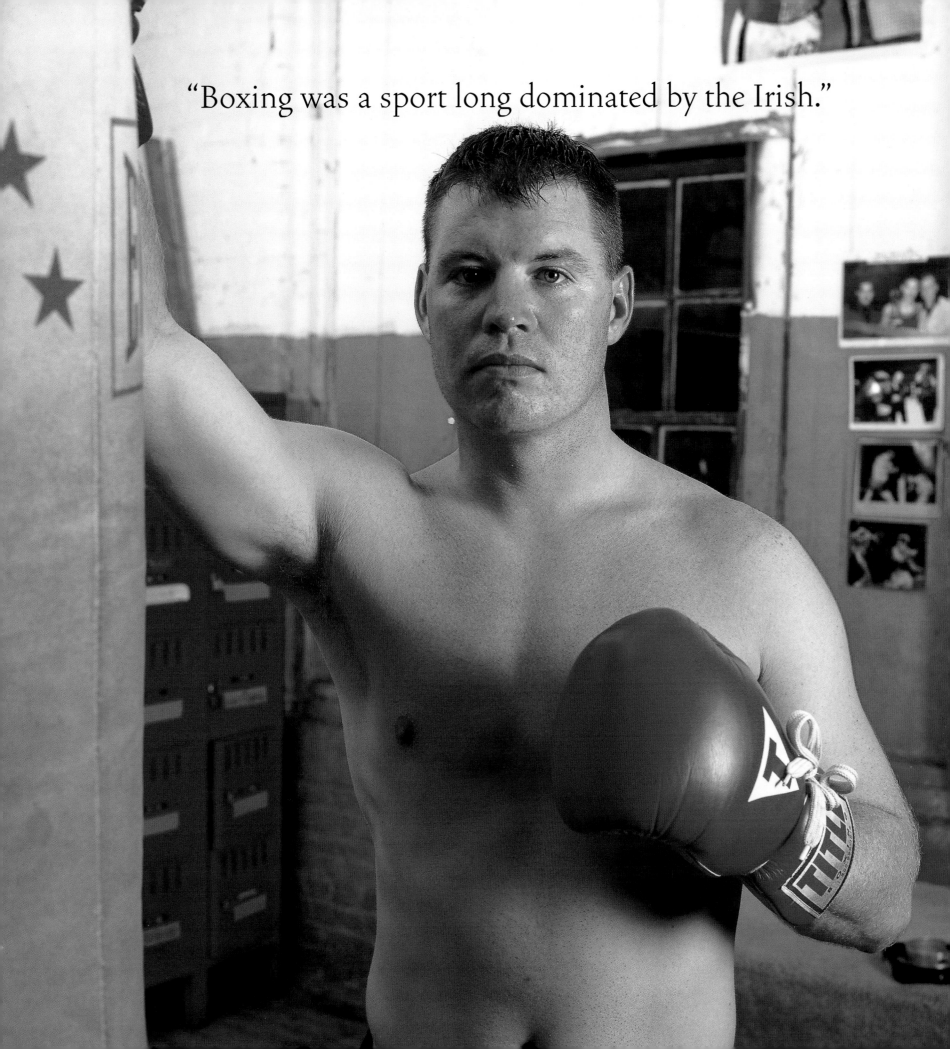

"Boxing was a sport long dominated by the Irish."

I was born in Springfield, Illinois, into a family made up of "thoroughbreds." My parents were proud that we were Irish on both sides. Mom's side of the family is from Skibbereen, Cork, and Dad's side is from Newton Hamilton, Armagh. Dad was one of eight children and Mom one of three. Both immigrated here in search of opportunity but never lost touch with their homeland, establishing citizenship in both countries. Our Irishness was a big feature of our lives. ◉ In 1971, my father bought some land in Kerry, near Dingle. He was able to build a house there. Everyone in our family has fond memories of going back to the "motherland" every summer. It's a wonderful place, and I take great pleasure in being associated with Ireland. I love Ireland, and my friends and coworkers are probably sick of hearing me talk about it. ◉ I'm sure that my gift of gab is what landed me in the communications department at Notre Dame, where I liaise with the media and write news releases and copy about the magnificent contributions of the university. There isn't a better environment for me.

MICHAEL GARVEY Media and public relations ◉ Notre Dame University ◉ *Notre Dame, Indiana*

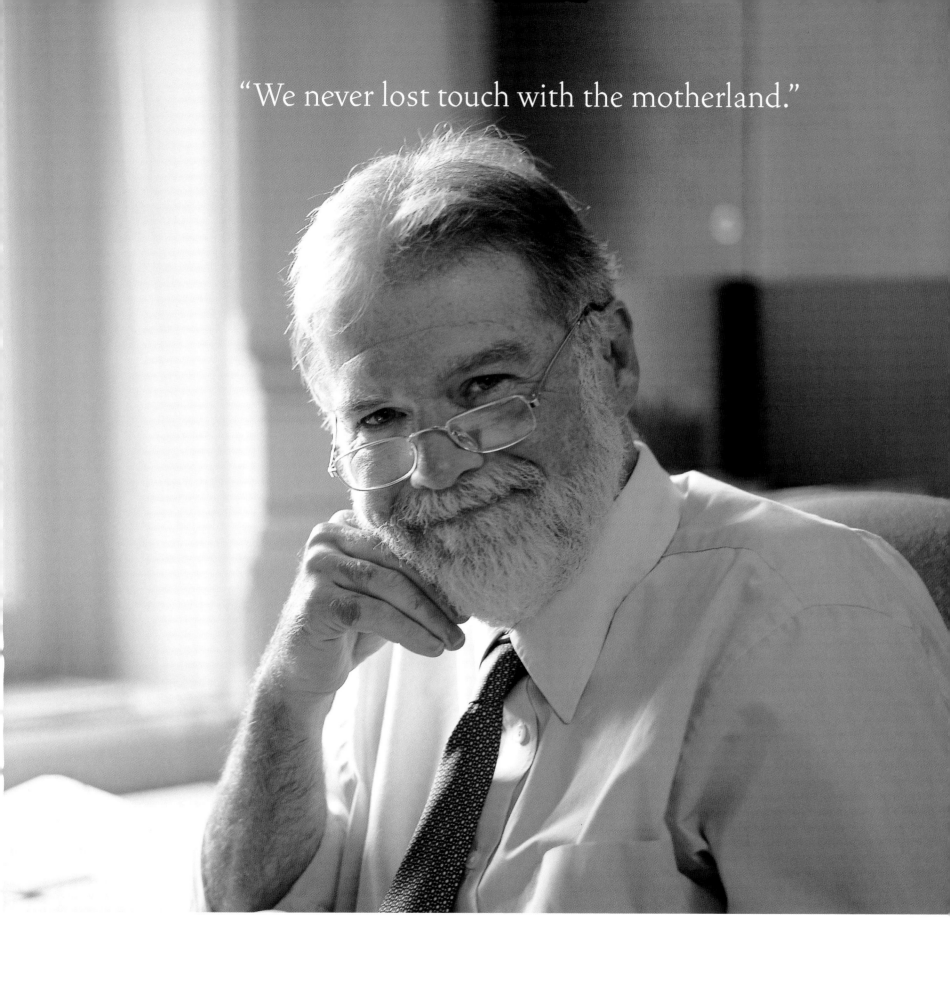

"We never lost touch with the motherland."

"People can tell I'm Irish from across the room."

Born and raised in Nashville, Tennessee, I was in the minority being Irish, Catholic, and a redhead as well! I was born in an ambulance going to the hospital, and my mother always joked that my hair was red because we stopped for a red light on the way. Everyone else in my family, the Joyces, Gibsons, and Hogans, had dark hair and blue eyes — "black Irish," my mother would say. Growing up, I was shy and self-conscious about my hair color because it drew attention to me. Everywhere I went, people would say to me, "You must be Irish!" Even today, people still stop me and comment on my coloring. I have grown to appreciate being a little different and would never consider changing the color. ❀ My parents, both born in Tennessee, were excellent role models and embodied the notion of down-to-earth, hardworking Irish-American parents. Their gifts to me were their sense of humor, common sense, and enjoyment of life.

SHEILA KING Human resources administrator ❀ *Los Angeles, California*

I didn't grow up in a particularly Irish family or town; however, I always felt a calling or a pull that was never satisfied until I actually rode my bike across Ireland. It's a pity that I didn't embrace my Irishness until later in life, but I think I've made up for it now. ⊙ My mother was one of six children. Her father was a Methodist minister and president of two colleges, Morningside, in Sioux City, Iowa, and Dakota Wesleyan, in Mitchell, South Dakota. My paternal grandfather was born and raised in Iowa; he was a cattleman and a cowboy. In the West, the cattle business is big business, and my grandfather was the result of a rugged gene pool that survived many hardships after traveling west in search of better opportunities. ⊙ I was born in Tulsa, Oklahoma, and raised in Omaha, Nebraska, and my family instilled values that we considered American, and they are. But they are also particularly Irish American. The most important trait, a strong work ethic, prompted me to start working at a Dairy Queen at thirteen years of age. ⊙ Another trait instilled in us was a love of the spoken and written word. Despite being a math major, I read books of short stories by Irish authors and watched distinctly Irish films, including my favorite movie of all time, *The Secret of Roan Inish.* ⊙ My parents also taught me not to be afraid of trying new things. So the day after I graduated from college, I packed everything in my little yellow Volkswagen and headed back east, settling in upstate New York. ⊙ I took what I thought was a summer job at Citibank. I've now been working in financial operations and general management for more than twenty-seven years. I've worked at several companies, such as Citibank, Eastman Kodak, and BellSouth. My profes-

sional career affords me a platform from which I can focus on issues that are important to me. ⊙ Currently, I am president of the Women's Resource Center to End Domestic Violence, a nonprofit organization based in Atlanta. I have an abiding belief that if there's one place that women should be safe, it's in their home. In addition, I am on the board of Create Your Dreams, a nonprofit organization that provides after-school educational programs and mentoring for kids, and two women's colleges, Mary Baldwin College and Spelman College (funded by the Rockefellers and started in a church to help slaves learn to read and write). They are wonderfully spirited schools. ⊙ But it was when I rode my bike across Ireland, as part of a group, that I truly embraced my Irish heritage. We started in Galway and rode up the coast of Connemara, staying in wonderful old castles. It was at that point that I understood the mystical and generous nature of the Irish people; they were very welcoming. One day, a quintessentially Irish-looking man drinking his Guinness met us in a pub where we stopped for lunch. He started to give us a local history lesson, but we had to leave. Off we went and kept bicycling along. How surprised we were to find him waiting for us at the next pub, where we stopped for dinner. He wanted to finish the history lesson! ⊙ Another funny thing happened on our trip. A fellow traveler, Katie McCarthy from Chicago, was passing through immigration. The guard looked at her passport and said, "Ah, Katie McCarthy, another of Ireland's daughters coming home." Maybe that was the calling all these years — the calling to return home to the land of my roots.

SUE McLAUGHLIN Businesswoman ⊙ *Atlanta, Georgia*

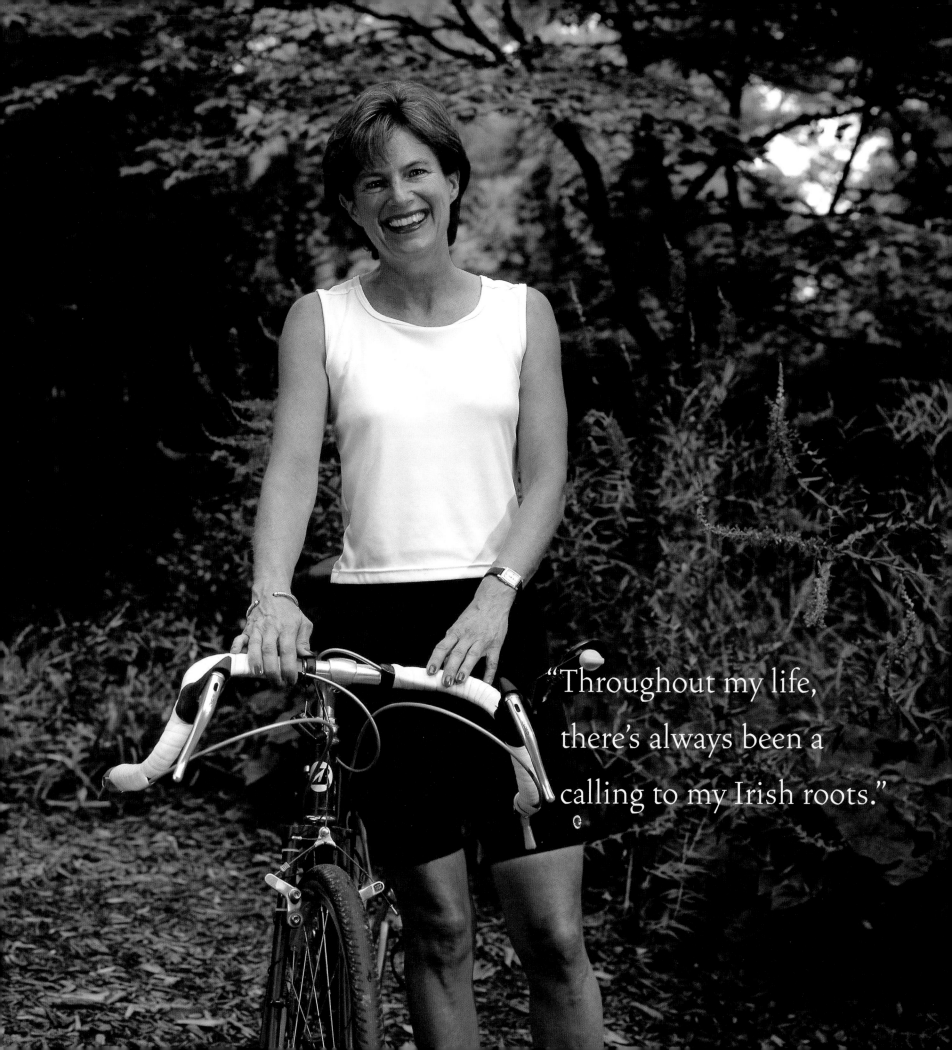

"Throughout my life, there's always been a calling to my Irish roots."

I grew up watching Notre Dame football with my dad and the "Boyle boys," three brothers — Tom, Dan, and George — from the south side of Chicago who taught me everything there is to know about Irish-American athletes and institutions. Every Saturday, my dad, the Boyles, and I would get together and watch the game on TV. A few years later, my family moved to Atlanta, Georgia, but we never lost touch with the Boyles. My dad and I and the Boyle boys would watch the game in our respective cities and then get on the phone at halftime to talk about it. ⊛ My first choice of colleges was clear. After all I had learned from my dad and the Boyle boys about Notre Dame and its rich legacy of athletes, why would I go anywhere else but Notre Dame? I decided to go and am so glad that I did. ⊛ Notre Dame is unlike any other school. The layout of the campus makes you feel like part of a close-knit family. And despite its reputation for being predominantly Irish American, the university boasts a wonderful mix of different ideas and ethnic backgrounds. ⊛ When I graduate, I hope to continue playing football. I know that I'm a little young to be thinking of this now, but if I have a son, I would like him to carry on the family legacy of playing football for Notre Dame. Nothing would make me prouder.

SEAN MILLIGAN Football player, Notre Dame University ⊛ *Notre Dame, Indiana*

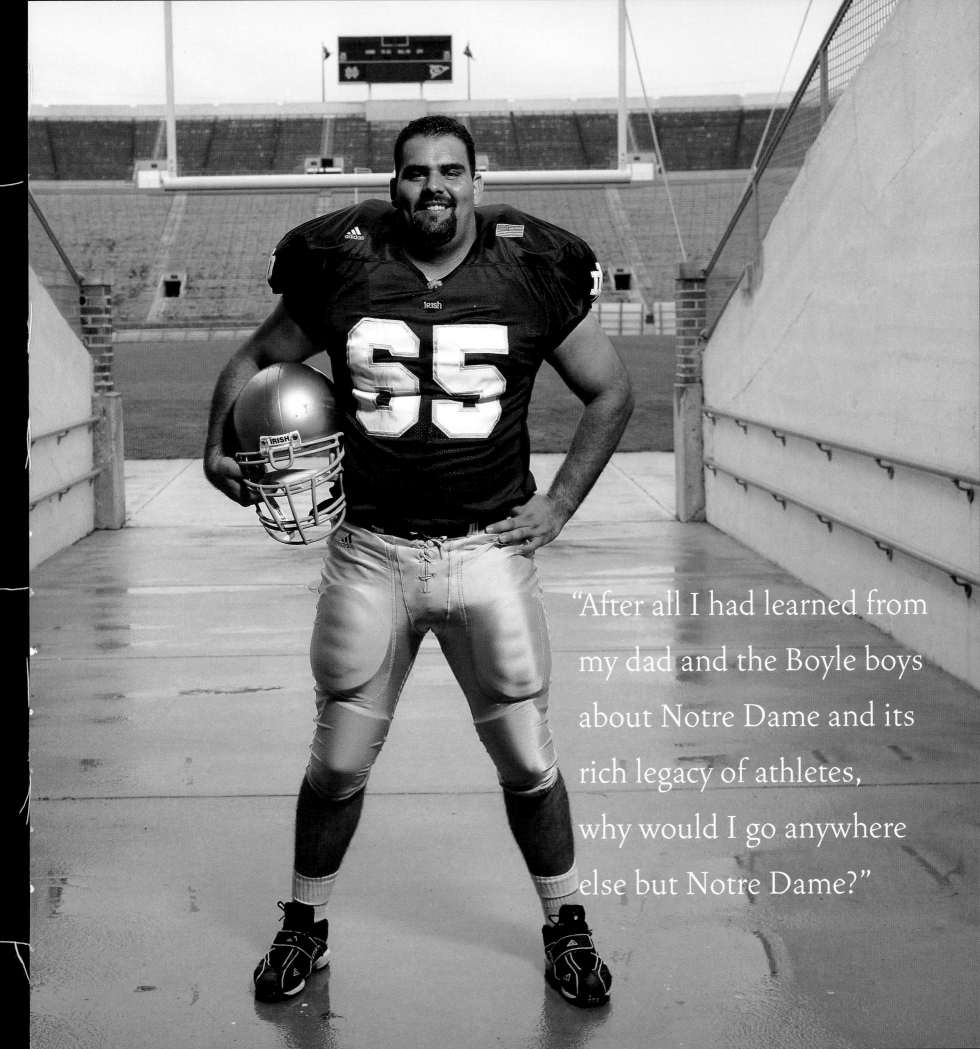

"After all I had learned from my dad and the Boyle boys about Notre Dame and its rich legacy of athletes, why would I go anywhere else but Notre Dame?"

My great-grandparents first emigrated from the west coast of Ireland to Liverpool, where a large Irish population had congregated. In search of a better opportunity for their children, my grandparents immigrated to Scranton, Pennsylvania, a thriving coal-mining town. When they arrived, they found that there were jobs available, but not in the mines. My grandfather worked at a company that provided mail-order education. The first type of "distance education." Funny how my life has come full circle. ◉ My work running the Irish studies program at Notre Dame has led me back to my roots in Ireland. When I was growing up, my heritage wasn't a driving force for me. But once I went to Ireland, I became extremely interested in the country and its culture. Going "home" made a big impression on me. And it's not a coincidence that I'm now working in education and promoting its use for economic development and employment. I've spent a lot of time in Northern Ireland and have experienced firsthand its harsh realities. Today, outreach extends to both Catholic and Protestant universities. The university has done outreach work with the University of Ulster (Belfast), Queen's University (Belfast), the University of Galway, University College Dublin, and, most recently, Trinity College Dublin. ◉ As a Catholic priest, I can say that the church in Ireland is going through a tough time. Irish Americans, especially those at Notre Dame, have a lot to offer in the modeling of religious participation and outreach to young people. Historically, the church in Ireland has had a strong tie to the government. This is changing. When Irish-American students go to Ireland to study, they are often disappointed by the rigidity of the church. At Notre Dame, we hold masses at 9:30 p.m. to suit the students' needs. We have to add the flexibility that young people crave so that they can practice their faith.

FATHER "MONK" MALLOY President, Notre Dame University ◉ *Notre Dame, Indiana*

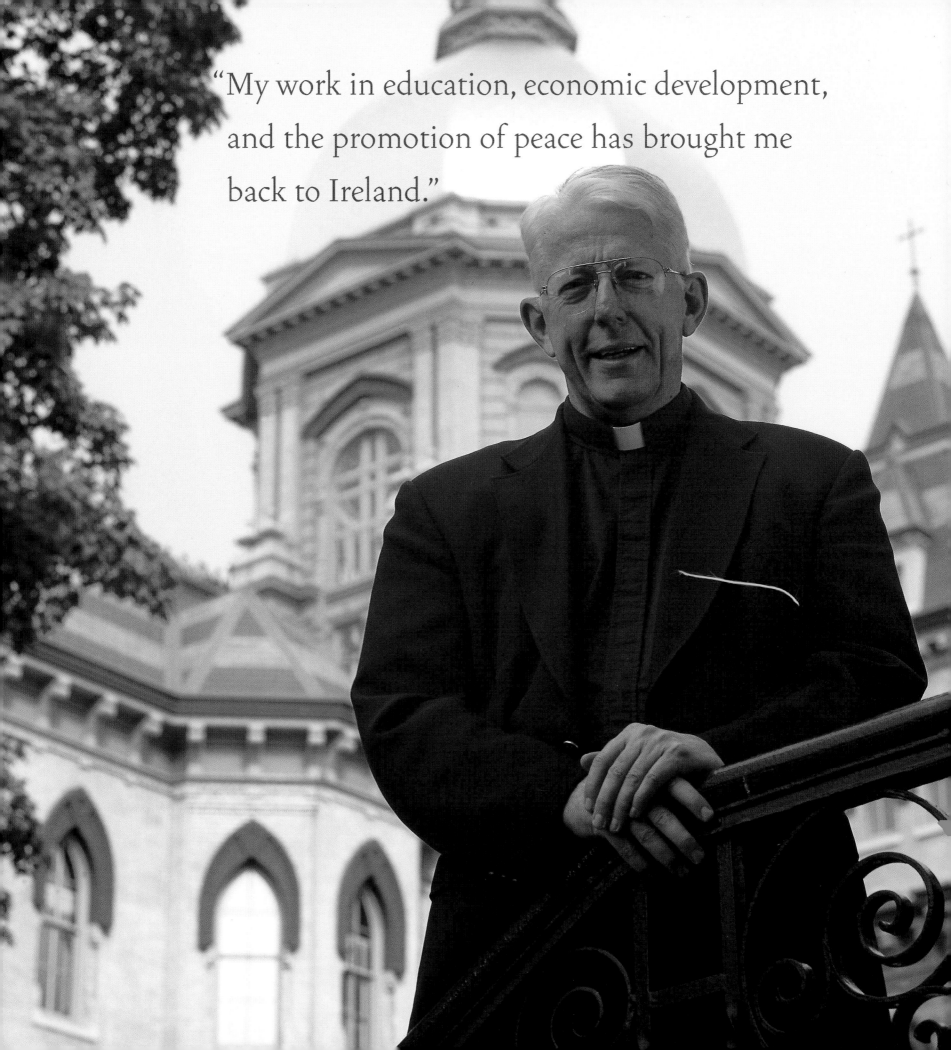

"My work in education, economic development, and the promotion of peace has brought me back to Ireland."

I can credit my successful and happy life to the lessons taught to me early on by my grandmother Marie Costello Moore. Her Irish temperament, her optimism, and her pursuit of a joyful life have had a huge impact on me. Most important, she lived by example; she was full of faith, never showing an ounce of bitterness despite experiencing many hardships in life. Marie's legacy as an Irish matriarch lives on today. She was dignified, strong, and kind, and her unconditional love and determination gave me and my brothers the strength and confidence to pursue our ideas, especially when we were told to take a safer path. When my younger brother wanted to become a Green Beret, it was Marie who encouraged him to "go for it." When my other brother decided to become a preacher, he told us it was Marie's unyielding faith that inspired him. ◉ When my wife and I decided to start a family, it was Marie who encouraged us not to focus on the worldly things but to be satisfied with what we had. Heeding her advice, we took the risk of leaving New York, buying a ranch forty-five minutes north of San Francisco and converting it into a functioning dairy ranch. ◉ My love of the land and natural things began with childhood visits to Marie's cabin in the mountains. The best times we shared together were the hours sitting on her porch, telling stories and listening to the creek and the wind in the pines. She was the greatest example of being fulfilled with what you have and never coveting someone else's lot. ◉ Another of Marie's great attributes was her superior Irish storytelling ability. She loved to tell stories dating back to her early childhood, remembering the smallest details. Listening to her describe life before airplanes, cars, and computers was like poetry to me. I so enjoyed her stories, even after hearing the same ones fifty times. ◉ Since my Irish spirit comes from my grandmother and my father, I make sure that my kids hear all the Irish tales. Thankfully, my kids have taken up the Irish love of the land, humorous stories, and music. We were lucky enough to have Marie until she was ninety-five. Even after her death, we are constantly reminded of and inspired by her.

JIM MOORE Former investment analyst, rancher ◉ *San Francisco, California*

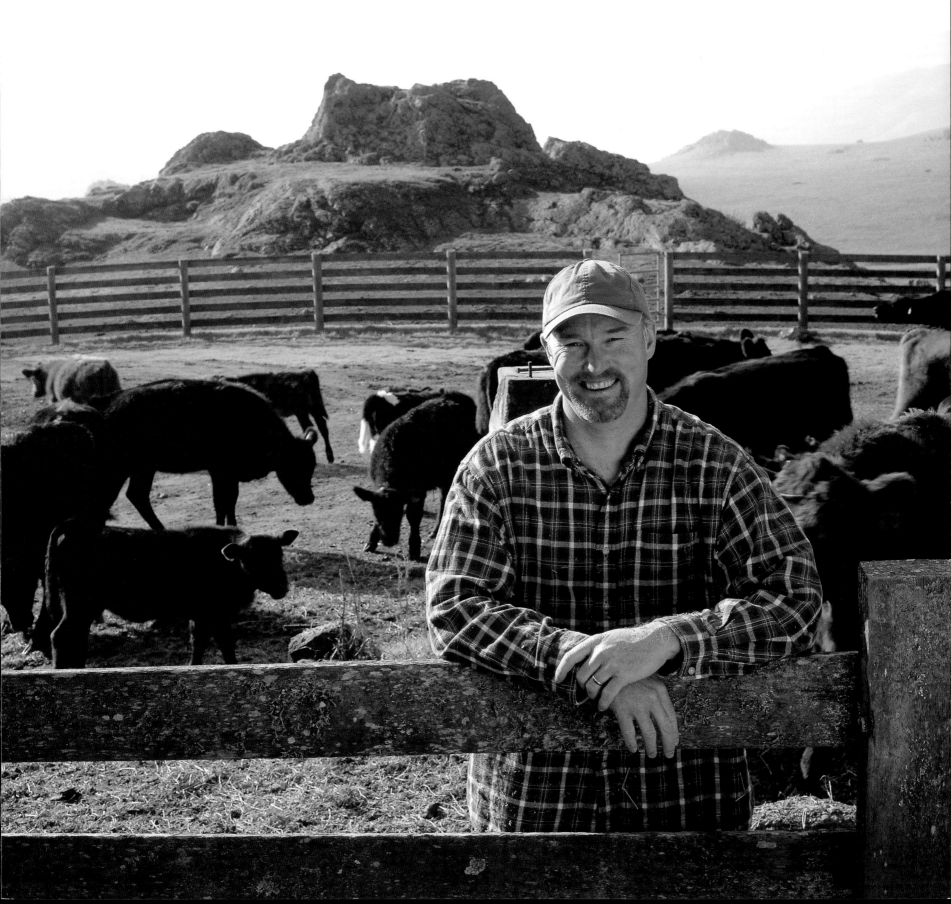

"Marie encouraged me to return to my roots—the land."

My siblings and I learned invaluable life lessons from my parents, Bob and Nelda. They taught us early on to respect all people, to have good manners, and to be honest. This strong emphasis on character created within me a passion for the Irish and for Ireland in general. It also influenced my decision to become a professional golfer. ◉ The lessons I learned from my parents have helped me over the years both personally and professionally, and my wife, Alicia, and I are trying to instill these same values in our children, Michelle and Shaun. ◉ Golf isn't just an athletic endeavor; it's about building long-lasting relationships. When people play golf together, they see one another take bad strokes with everyone else watching. Some days you win, some days others win. And on your good days, especially, you have to resist the temptation to gloat; you must always treat all people with respect. That is what I mean by strong character. It's a fundamental aspect of sportsmanship that I think extends to all parts of one's life. Strong character and strong sportsmanship help people handle adversity, and a round of golf furnishes plenty of that! ◉ Speaking of adversity and golf, there's an inspiring Irish-American golfer that deserves mentioning — Ben Hogan. His life had the fundamental elements of the classic Irish-American story. He overcame difficulties early in his life to become one of the best golfers in history. Many don't know that his father died when he was a boy, that he was close to poverty for too many years to remember, and that he had a head-on collision with a bus and suffered appalling injuries that severely affected his game. I was honored to have the opportunity to get to know Mr. Hogan when I first turned professional, and I actually represented the Ben Hogan Golf Company for a number of years. I will certainly treasure the time I spent with one of the legends of our game. ◉ We all know that some of the best golf courses in the world are in Ireland, and for that reason I'm usually in Ireland with a group of my friends each year on the way to the Open Championship in Britain. (I must admit, the fly-fishing is equally outstanding and is a high priority for me that week as well!) The courses, such as Royal County Down, Portmarnock, the K Club, and Ballybunion, are well known even to casual golfers. I just completed my first course design project in Ireland, and hopefully my course, Carton House, will one day be included in the great lineup of Irish golf courses. ◉ Just being in Ireland is always an uplifting experience, and it proved to be just the right preparation in 1998 when I went on to Royal Birkdale and won the Open Championship. It was certainly one of the highest points of my golf career, along with winning the Masters earlier that year. As an Irish American, it has been a true pleasure to share my Masters and Open triumphs with all of my friends on both sides of the Atlantic.

MARK O'MEARA Professional golfer ◉ *Windermere, Florida*

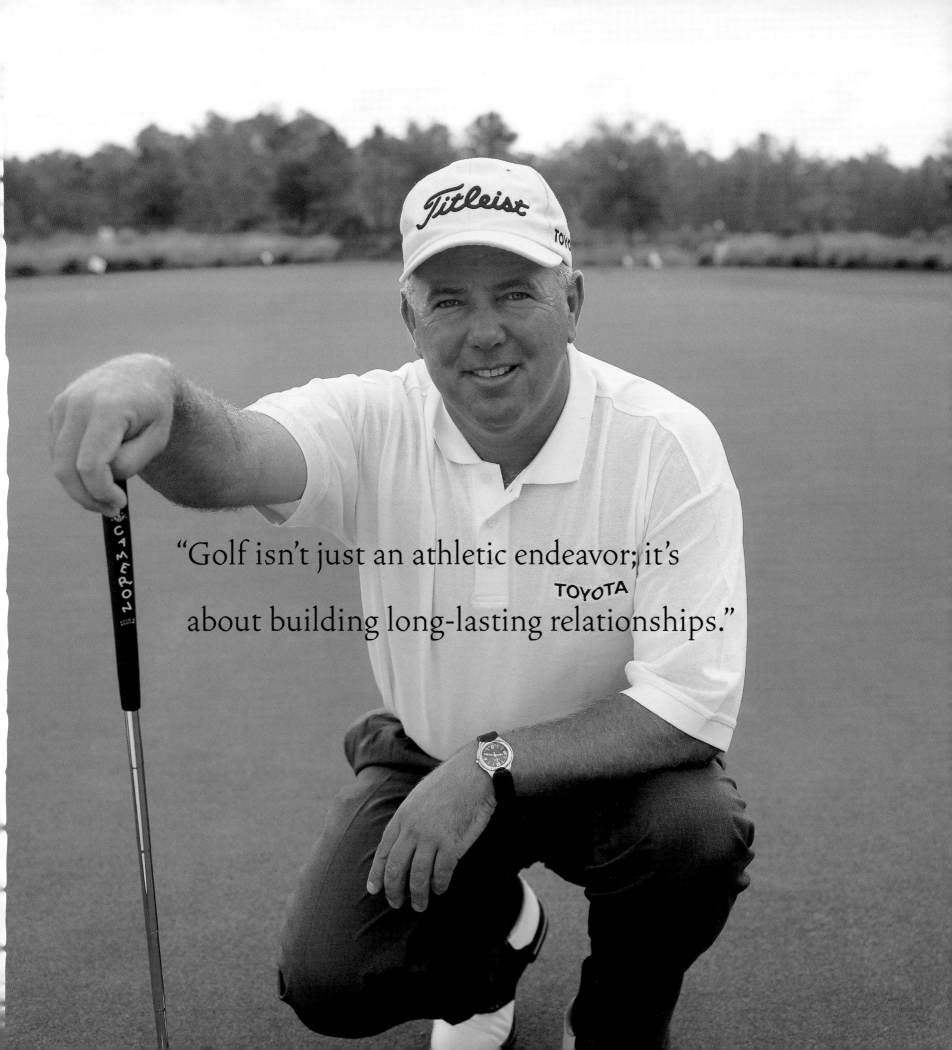

"Golf isn't just an athletic endeavor; it's about building long-lasting relationships."

"With a last name like O'Neill, we were recognizably Irish American."

I was the youngest of six children. My dad, Charles, was raised in Nebraska. My mom, born in St. Louis, was raised in Columbus. After returning from the service, my dad met my mom and settled in Columbus. My family didn't have any specific ties to Ireland, but we were proud of our culture. With a last name like O'Neill, we were recognizably Irish American, and people were always commenting on our name. My dad taught my siblings and me to be proud of our heritage. He exposed us to Irish music — and, yes, like any good Irishman, he would sing the occasional song. And he taught us to celebrate certain events. I marched in the Shamrock Club in high school, and my family always celebrated St. Patrick's Day. My dad and his dad were also the ones who passed on their love of baseball to me. They both played in the minor leagues when they were younger. ● Before my dad passed away, I sent him and my mom to Ireland. They really enjoyed the opportunity to see where they came from. He was so glad to see Ireland in his lifetime. I haven't been to Ireland yet, but I plan to go and practice my other passion — golf.

PAUL O'NEILL Baseball player (retired), New York Yankees ● *Columbus, Ohio*

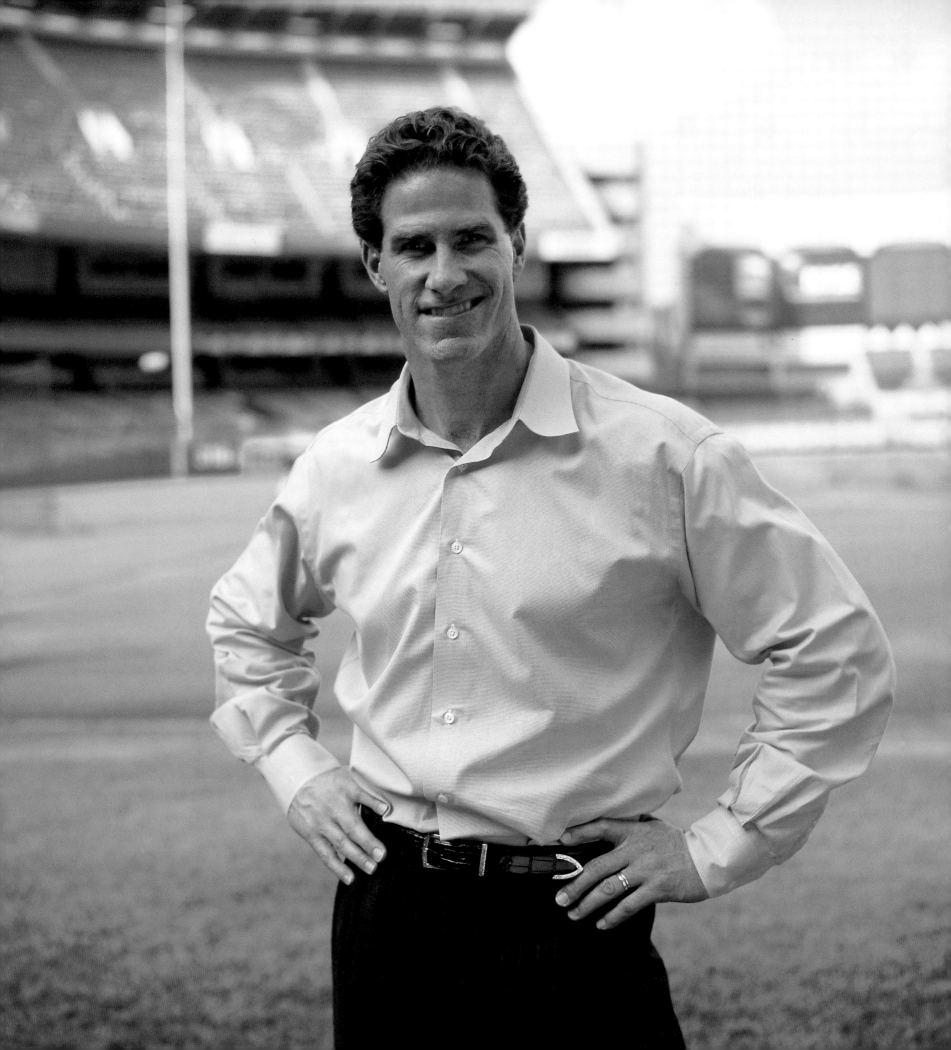

I was nearly born atop a mountain of books, the way my mother tells it. The morning she was to deliver me into the world, my father's Buick was filled, floor to ceiling, with his precious books, which were on their way to our new apartment. There was my mother in the front seat, books flying around her head as my father careered wildly through the streets of Pittsburgh to the emergency room. The precious cargo — the books and their first-born child — arrived safely, and I have been a bibliophile ever since. ◉ My mother learned to recite Oliver Goldsmith poems seven decades ago in a small country schoolhouse in County Armagh, and she still knows the verses today. My father could talk on any subject you chose — French literature, Irish history, the Pittsburgh Pirates, or the space program — for hours if you weren't careful. Both of them had a love of language and the written word, a love that their children inherited. ◉ They also had strong and impassioned feelings about being Irish, feelings my siblings and I shared. Love of knowledge set down in books is a centuries-long Irish tradition, one that began with the amazing illuminated manuscripts created by our ancestors during the Dark Ages. Acquiring knowledge, my parents taught their six children, is preeminent, because of what it leads to and what it reveals. As a result of her practical Ulster upbringing, my mother knew that education was the surest way to develop options in life. My father knew that learning led to self-discovery and a joyous intellectual life, a lesson he learned growing up in Pittsburgh's vibrant Irish community of Mt. Washington. ◉ Both were right. I've spent the past thirty years publishing books, and it has been a wonderful career and a joyful journey of self-discovery. When I moved to Atlanta and assumed the job of president and publisher of Peachtree Publishers, I wasn't sure how I would make the transition from the bustling ethnic landscapes of Pittsburgh, New York, and Boston. But I soon discovered that the South had its own magic and promise and, almost as a bonus, that it is filled with signposts of the Irish who immigrated there in times past. Emory University, where my husband, Jack McDowell, is a faculty member, has one of the world's finest programs on William B. Yeats and Irish theater, headed by Professor James Flannery. The sensibility of short story master Flannery O'Connor is apparent in the South, and so is the sensuousness of novelist Margaret Mitchell, who wrote *Gone with the Wind* less than a mile from our home. ◉ Mitchell understood that Tara wasn't so much a place to return to as it was a place in your heart that never leaves you no matter where you go. That is how I feel about my books and my family, and about being Irish.

MARGARET QUINLIN Publisher ◉ *Atlanta, Georgia*

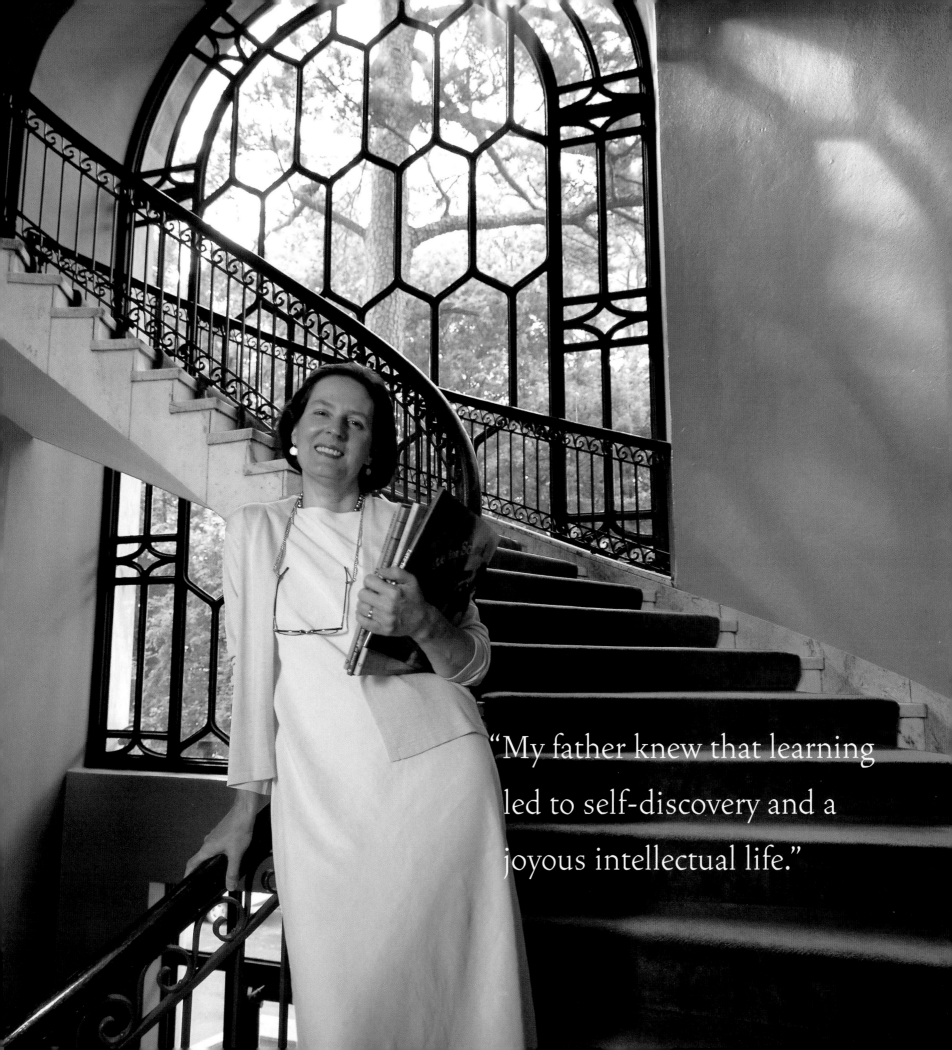

"My father knew that learning led to self-discovery and a joyous intellectual life."

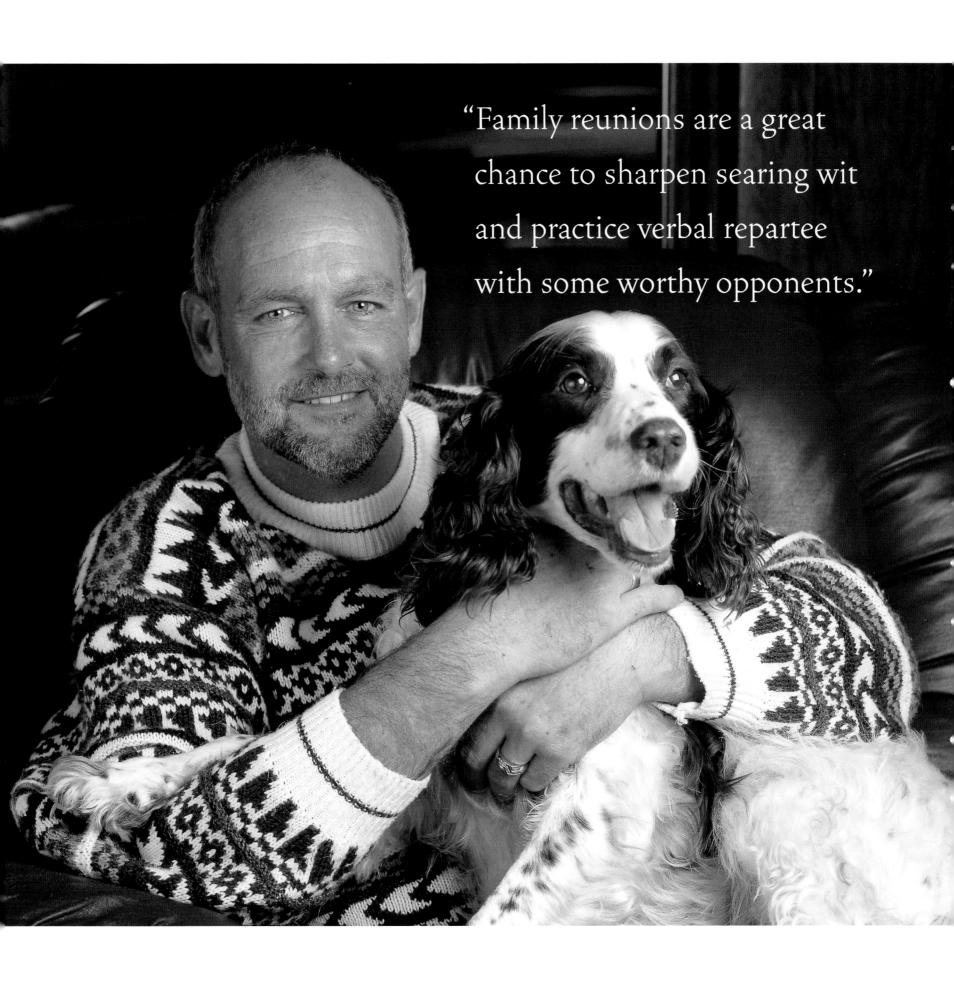

"Family reunions are a great chance to sharpen searing wit and practice verbal repartee with some worthy opponents."

My mother was one of five sisters born and raised in St. Paul. My father was an only son, with five sisters, born in Hastings. My mother is full-blooded Irish; her grandparents came over from Ireland. My father is Pomerian, from a province on the southern shore of the Baltic Sea, in what is now Poland. My parents met, married, and had three sons and one daughter. ◉ I was my parents' second child. During the summer between eighth and ninth grade, I noticed how much I liked to draw, and that's when I knew I'd have a career in drafting and design. I honed my love of design in the service in Germany, and now I am a senior mechanical designer working at Toro, a company that makes, among other things, tractors and lawnmowers. ◉ Over the years my second "job" has been organizing the Division Fair in Minnesota, an event that kicks off a three-day Irish festival that includes music, dance, and sheepdog races. Along the way, my son got involved in the planning with me. Now that I'm winding down and he's almost nineteen, he plans it and goes on his own. In recent years the festival has added Friday-night events for young people; this year, my son's favorite rock group, Flogging Molly, is giving a concert. If you couldn't tell by the name, they're an Irish band. ◉ My wife and I have been married for twenty-one years. In addition to building a family with our son, I plan a lot of family reunions. I like the emotion that wells up and the happy-go-lucky feelings that arise when the family gets together. The event is characterized by our ritual repartee, with the requisite needling, dredging up the past, and vying to outdo one another verbally. But this family game has one very important rule: It's all in good fun. No one takes it too seriously, and no one leaves mad. Anyone who does will only get teased more next time because the crew knows they can get a rise out of him. ◉ Nowadays, the only occasions that seem to bring the family together are weddings and funerals. At my age, there tend to be more funerals than weddings. It may sound odd, but in our community, funerals are joyous occasions. Wakes are a wonderful chance for people to sit and tell stories, usually about life before I was born. Maybe people open up because they realize their own mortality, and brandy no doubt lubricates the jawbone. Whatever the reason, those late nights of lore make me happy to be Irish.

151

THOMAS RADKE Senior mechanical designer ◉ President, Minnesota State
Chapter of the Ancient Order of Hibernians ◉ *St. Paul, Minnesota*

When I was asked to contribute this essay, my thoughts turned to my own family, and I began to see them in a new light and to wish I could have written happier endings for them.

My father was born in Roscommon, Ireland, and came to the United States in 1905, when he was twenty-one. I have the record of his arrival at Ellis Island; it states that he had five pounds in his pocket. Ten years later he became an American citizen. In those days he had to swear that he was neither an anarchist nor a polygamist and that he renounced his loyalty to George V, king of England.

I was a "Daddy's girl." On Cape Cod, the early settlers called it the "tortience," that special bond that exists between a father and daughter. He died when I was eleven, so the time I had with him was all too limited. Looking back, I was glad that I had severe childhood asthma and frequently missed school. When the attacks came, I'd spend a good part of the night wheezing and gasping for breath, but in the morning the asthma would ease off and I'd go downstairs to share breakfast with him.

A certain scent still reminds me of his shaving lotion. Phrases of songs he sang to me, off key if my aunt Agnes was to be believed, still run through my mind. "Sunday night is my delight . . ." That's all I can remember. The rest of the words are gone.

My memory of his physical appearance remains vivid; I see a man just under six feet tall with thinning hair and a strong face. He had a quiet voice. "'Tis, dear" was the way he would answer my questions in the affirmative. Like the brother and sister who came to the United States within a year or two of him, he did not have a brogue — just a few expressions and a lilt in his voice that was the gift of his Irish ancestry. Years ago, I met an elderly cousin in London who had been raised in Ireland. He was the son of my father's oldest sister. "I looked like Luke when I was growing up," he explained. "And as your granddad got older, he would call me Luke. Your dad was his favorite."

My father never did get to go home before he died.

I was thirty-four when I visited Ireland for the first time. My Irish cousins took me to Roscommon, and we walked the farm where my father had grown up. On the barn door I saw where, as a boy, he had scratched his name. Slowly I ran my fingers over the letters. *L . . . U . . . K . . . E.* My memory of him, the very scent of him at that moment, was so strong I felt as though I had returned not only for him but also with him.

As I stood there, I thought of the dried shamrocks that his mother would send him every year before St. Patrick's Day. I thought of the evening when he came home and opened a letter, then said quietly, "My mother is dead." I watched him go into his room and close the door.

As I stood in the spot where he had stood as a boy, I wrote a happy ending. He did get at least one visit home. He did see his mother again. There was a grand reunion and a marvelous party, and everyone caught up on the years they'd been separated.

My mother was the second child of a pair of Irish youngsters, Thomas and Bridget Kennedy Durkin. Like my paternal grandparents, they were from Sligo and Mayo. They too left Ireland and never returned. Perhaps Bridget was the one who passed on storytelling to me. I am told that she always said that she knew she could write a book. With nine children, she never did get the time to try. With my cousins, I drove to Sligo and Mayo and thought of my four grandparents, Marie Kelly and Patrick Higgins, Bridget Kennedy and Thomas Durkin, growing up, meeting, falling in love, and marrying. I thought of Marie and Patrick Higgins saying good-bye to three of their children when they left for the United States, of Bridget and Thomas barely twenty years old and saying good-bye to their families and never seeing them again. How much courage they all had, those who left and those who watched them go. On that visit I truly understood the meaning of the words *American wake.*

In my books my main character is almost invariably a young woman of Irish descent. She is not looking for trouble. She is not living on the edge, but something goes terribly wrong and through her own intelligence and courage she solves the problem.

"Why always Irish descent?" I'm asked.

My answer is that I know how that girl thinks. I know what her parents and grandparents told her. I know that she will overcome the problems, that when times are tough her faith and courage will get her through. And of course she will have a great sense of humor.

I know because I grew up taught by people like her, the children and grandchildren of the Emerald Isle.

CAROL HIGGINS CLARK

When I think about what it means to be Irish, my mind first wanders to the memory of my grandmother, Nora Higgins. She had such an adventurous spirit and a great sense of humor. When my brothers and sisters and I were little, she would take us to amusement parks and tire us out. At the end of the day, she was always the one who wanted to go on yet another ride. She died at eighty-one and right until the end was still hopping the bus from the Bronx out to our house in New Jersey. We'd pick her up at the bus stop in Westwood, a small brick structure adjacent to the train tracks. She made so many trips back and forth that when I was quite young I thought she actually lived in that spartan building.

"Nanny, do you have lamps in your apartment?" I remember asking her.

"Yes," she answered with a quizzical look on her face.

"But where are they?" I asked anxiously, picturing nothing but wooden benches and a cement floor.

"They're on the tables."

When I saw her real apartment I was greatly relieved to see that she not only had lamps but furniture and a bed!

Nanny had two sisters who were still alive when I was born. There had been nine brothers and sisters. Aunt Margie and Aunt Aggie were a lot of fun. Margie lived in Rockaway, New York. Her bungalow was down the block from the beach. In the summertime there was nothing better than taking that trip to Rockaway, swimming in the Atlantic Ocean, and having a big family barbecue in Margie's backyard. I remember being covered with sand and taking my turn in the little shower house in that yard, listening to the sounds of laughter as Uncle Richard fired up the grill and the others brought the hot dogs and hamburgers out from the kitchen. There was a sense of merriment in the air. My grandmother and her sisters had certainly had their share of heartache, but they always managed to look at the good side of life and enjoy themselves.

I've always been sorry that I never knew my maternal grandfather, Luke Higgins. I've heard so much about him from my mother. When I started writing my first mystery, I created a character named Regan Reilly, a private investigator. Naturally, I wanted to make her Irish. It seemed natural to name her parents Luke and Nora.

It is my grandmother's spirited nature that I have bestowed on so many of my older female characters. Early on in my writing career, people would remark that these characters had a lot of vim and vigor for their age. It didn't seem odd to me. I was just basing them on my varied experiences with my grandmother. She not only took us to amusement parks, but also helped us with our schoolwork, made us cups of tea, and always brought out bags of candy from the store downstairs from her "real" apartment. When she died, we slipped a tea bag in her coffin. I like to think she used that tea bag in heaven.

My grandmother had gotten married when she was nearly forty, then proceeded to have three children. One of them, of course, is my mother. My mother loves her Irish heritage, is a wonderful storyteller, and has a keen sense of humor. But she does love to scare people in her books! One book club calls her "Scary Mary." She says that as a little kid she once got in trouble for telling scary bedtime stories at a sleepover party. I'm certainly glad that didn't deter her from a writing career!

While my mother scares people, I try to make them laugh. As one reviewer put it, "Mary Higgins Clark goes for the jugular, while Carol Higgins Clark goes for the funny bone." In any case, we both credit our Irish ancestry for our storytelling ability.

A few years ago, my mother and I had a most enjoyable time coauthoring our first novel together, *Deck the Halls*. It is a Christmas story, and in it Luke Reilly is kidnapped. Regan works with the head of the Major Case Squad in New York City to get her father back. This terrific guy becomes Regan's love interest. We named him Jack and were pondering last names. We sat in silence for a few minutes. At the exact same second, we turned to each other, laughed, and said, "Reilly?"

Jack Reilly he was. He just had to be Irish! And we know that my grandmother would have approved wholeheartedly!

My parents definitely brought their love of and ability to play music over from Ireland. Dad was one of thirteen kids, born in Wicklow. Mom was one of three kids, from Galway. ◉ Perhaps it was the large number of children in my dad's family that forced him to learn an instrument; playing music allowed him to have something of his own. Meanwhile, my mother, growing up on the west coast of Ireland, had a long love affair with music. She played the tin whistle and for most of her adolescence felt the mystical, folkloric pull of traditional music. ◉ And she fed that love in us. She had to force the lessons on us young, undisciplined kids, but I'm so glad she did! At eight or nine years of age, my formal lessons with Noel Rice, also from Ireland, began. Although a flute player himself, he focuses on teaching these days, especially for children. In Chicago, he's very well known and is the president of the Academy of Irish Music. He runs a music school, mostly for kids. You may have heard his music on *Cruinn,* a CD produced by the Academy. ◉ Mr. Rice has made us into the musical family that we are today: my nineteen-year-old sister plays the fiddle. My thirteen-year-old sister plays the bodhran (Irish drum), and my youngest sister, who is nine, plays the flute. As for me, I've been playing the fiddle for more than ten years now. ◉ The most important lesson that I've learned from studying music is discipline, which comes from daily practice. I'll be applying this discipline in the fall when I begin college at the University of Illinois at Chicago. I'll be in the premed program and might focus on emergency medicine. ◉ I have my mother and Mr. Rice to thank, not only for kindling and nurturing my love of music, but also for giving me the tools to be as successful as I can in this life!

BRENDAN BYRNE Irish fiddler and premed student ◉ *Chicago, Illinois*

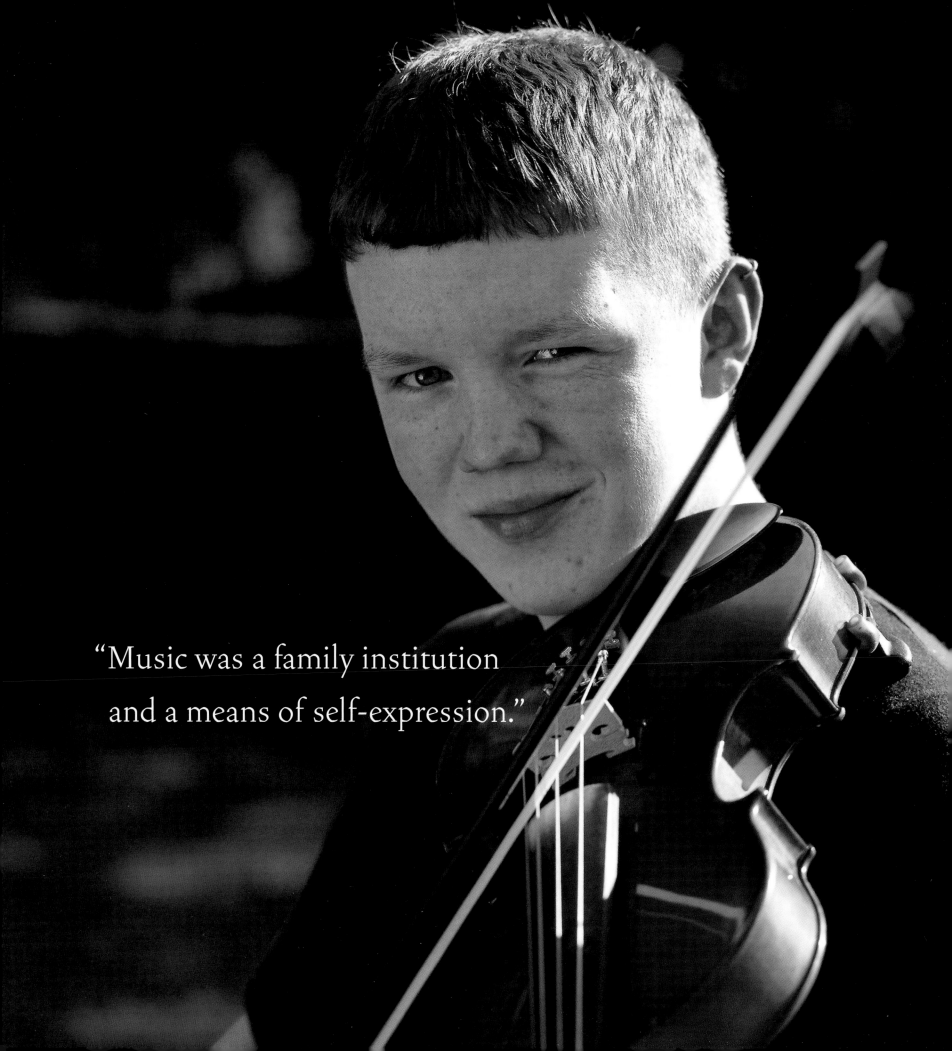

"Music was a family institution
and a means of self-expression."

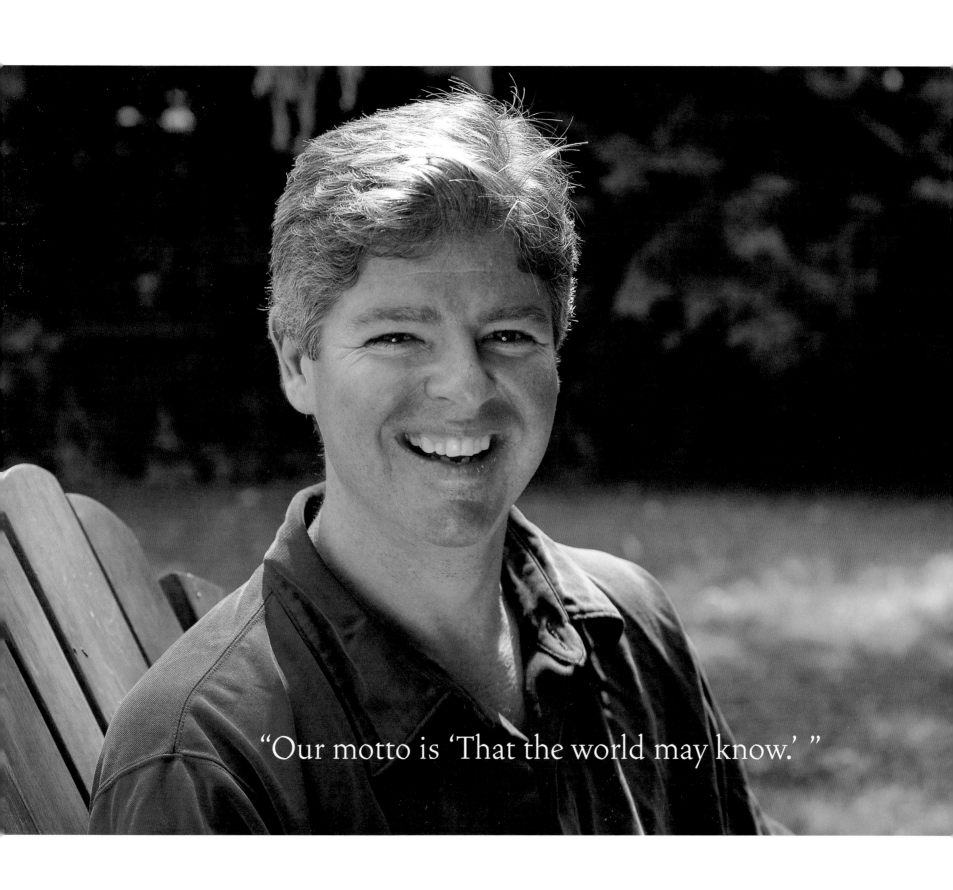

"Our motto is 'That the world may know.'"

I was lucky enough to grow up in a family that was proud of its historical and literary heritage and that demonstrated that pride in many ways, including our involvement in the American Irish Historical Society (AIHS). The original goal of the Society, which was founded more than one hundred years ago, was to reverse stereotypes about the Irish, especially the notion that they were uneducated. The aim was later adopted as a motto for its seal: That the world may know. And the world soon knew, through original members such as Theodore Roosevelt, tenor John McCormack, famed orator Bourke Cockran, and the Fenian John Devoy. ⊛ Much has changed since the Society was founded. Therefore, the modern mission of both the AIHS and the Institute for Irish American Studies is to educate new generations about their own culture, heritage, and the recognized achievements of Irish and Irish Americans into today's society. These groups foster research that expands, deepens, and strengthens critical understanding of the Irish-American experience. ⊛ Recent events include a presentation titled "The Irish Language in America," a film festival on the Irish in New York, and the establishment of an annual distinguished lecture in Irish-American studies. U.S. Poet Laureate Billy Collins, Karen Duffy, novelists James McCourt, Tom Kelly, Colum McCann, and Peter Quinn, poets Paul Muldoon and Seamus Heaney, and director Martin Scorcese have all served as guest lecturers. ⊛ Hopefully, our original mission of reversing stereotypes has been accomplished, but the push to reach a new generation of Irish and Irish Americans still continues.

CHRIS CAHILL Executive director, Institute for Irish American Studies, City University of New York ⊛ Editor and member of the executive council of the American Irish Historical Society ⊛ *New York, New York*

"We like Ireland because of its great bread and music."

ADA AND OONA CAHILL Students ◉ *New York, New York*

We like America because it's a strong and brave country. Being Irish means that you have a big family, and they're always around to have fun with you. Our family beach house has been in the family so long that we know almost everybody on the beach. Our family is always nice to us and never lets us down. We like music, dancing, and reading. We think that we inherit this from our dad and grandpa because they read a lot and encourage us to memorize poems. Our favorite is "Full Fathom Five." We think that America and Ireland are two of the best countries in the world.

All my children insist that they're Irish, despite the fact that Fionnbarr (eleven) and Ryan (nine) were born in Australia and the three "Southern belles," Neala (seven), Ailisha (five), and Siofra (three), were all born in Atlanta. All the children are all very proud of their Irish passports! ◉ Every night before going to bed, the girls demand stories about my childhood in Ireland. If I cannot remember a story, I quickly make one up. Recently, my brother Kevin was visiting and was given bedtime-story duty. When he asked the girls which story they wanted to hear, Neala replied, "The one where my daddy saved your life!" I had to remind Kevin how that one went. ◉ I was born in Derry, one of nine children. I worked in England and in 1981 moved to Australia, where I ultimately met my wife, Helen, who hails from Dublin. Helen was backpacking around the world at the time. She worked for me briefly, but I quickly decided that I'd either have to fire her or marry her. I married Helen, of course; otherwise you wouldn't be reading this. ◉ After our second child, Ryan, was born in 1994, we returned to Ireland to be closer to family. We sold our business and our house in Sydney and returned home, where we bought a castle, thinking we'd live there happily ever after. After 282 rainy days that year (Helen wasn't really counting!), we decided to move our soggy family to a warmer climate. We chose Atlanta as our new home, and I initially invested in another business and successfully lost all our money and had to start from scratch again. Now I run a thriving human resources outsourcing business headquartered in Donegal, with offices in New York, Atlanta, and Cleveland. ◉ Both grandmothers visit regularly. Helen's mother, Eta, has six grandchildren. My mother, Patsy, has thirty-two grandchildren; twenty-seven live in Derry, and there is regular contact between cousins. Throughout the year, there is a constant stream of Irish visitors to Atlanta, and almost every summer the Casey family travels en masse to Derry. ◉ I believe there's a tremendous advantage to being Irish in America, and the companies that I've established — Trinity, Claddagh Resources, and Devlin Partners — have always leveraged the Irish connection. Being Irish has opened many doors for me. Most of my clients play golf, and Ireland is the home of golf. Overall, it's an invaluable asset to be able to lay claim to the Irish heritage, and the fact that I have an Irish accent and personality gives me a competitive advantage. ◉ We have made an effort to remain close to our Irish culture. The children have traditional Irish names: Fionnbarr, after my best friend, a long-distance runner for Ireland; Ryan Leo, meaning "little lion king," after my dad; Neala, meaning "little chieftain or champion"; Ailisha, Irish for Alice, was chosen by Helen's mother; and finally Siofra, meaning "little fairy," or "elf." ◉ The children have always had an Irish nanny to further maintain the Irish way of life. Claire, Nicola, and Sheena, all from Donegal or Derry, have played an integral part in the children's Irish upbringing. ◉ I love being Irish, but I also love living in America. My family has the best of both worlds!

PETER CASEY Entrepreneur ◉ *Atlanta, Georgia*

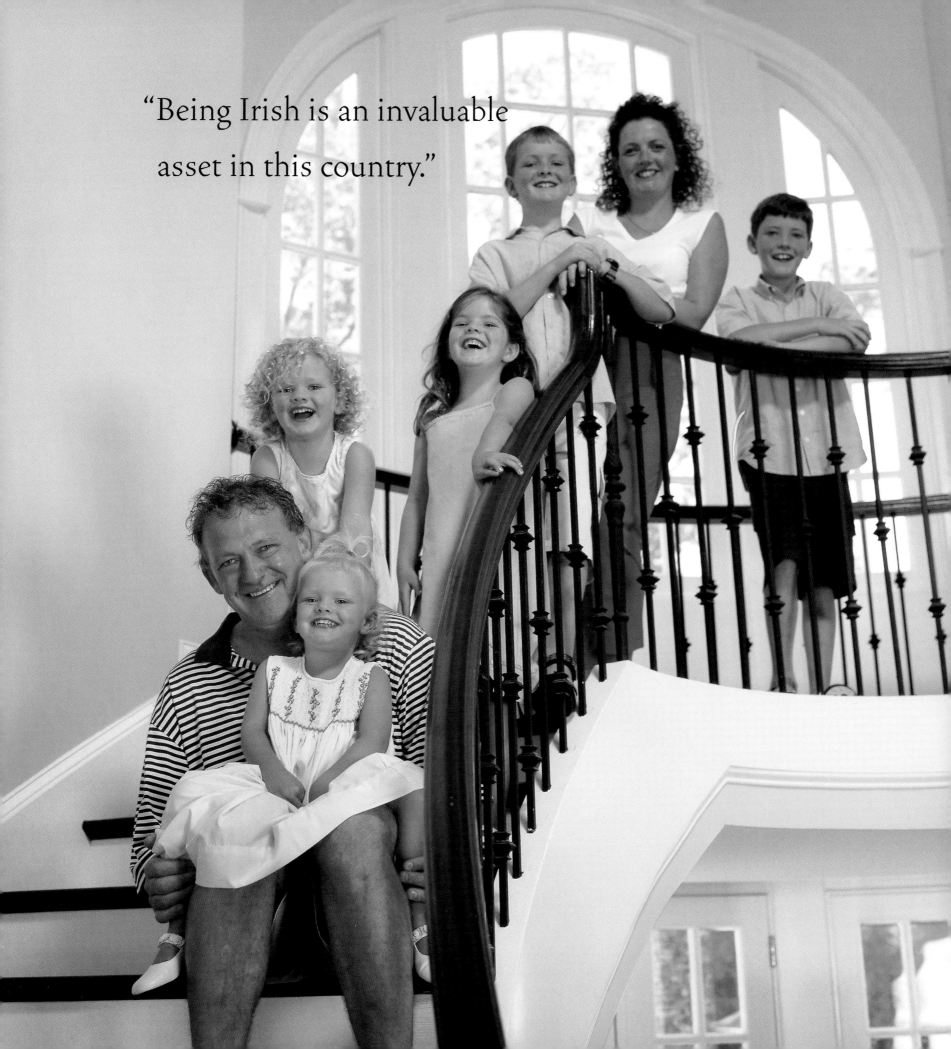

"Being Irish is an invaluable asset in this country."

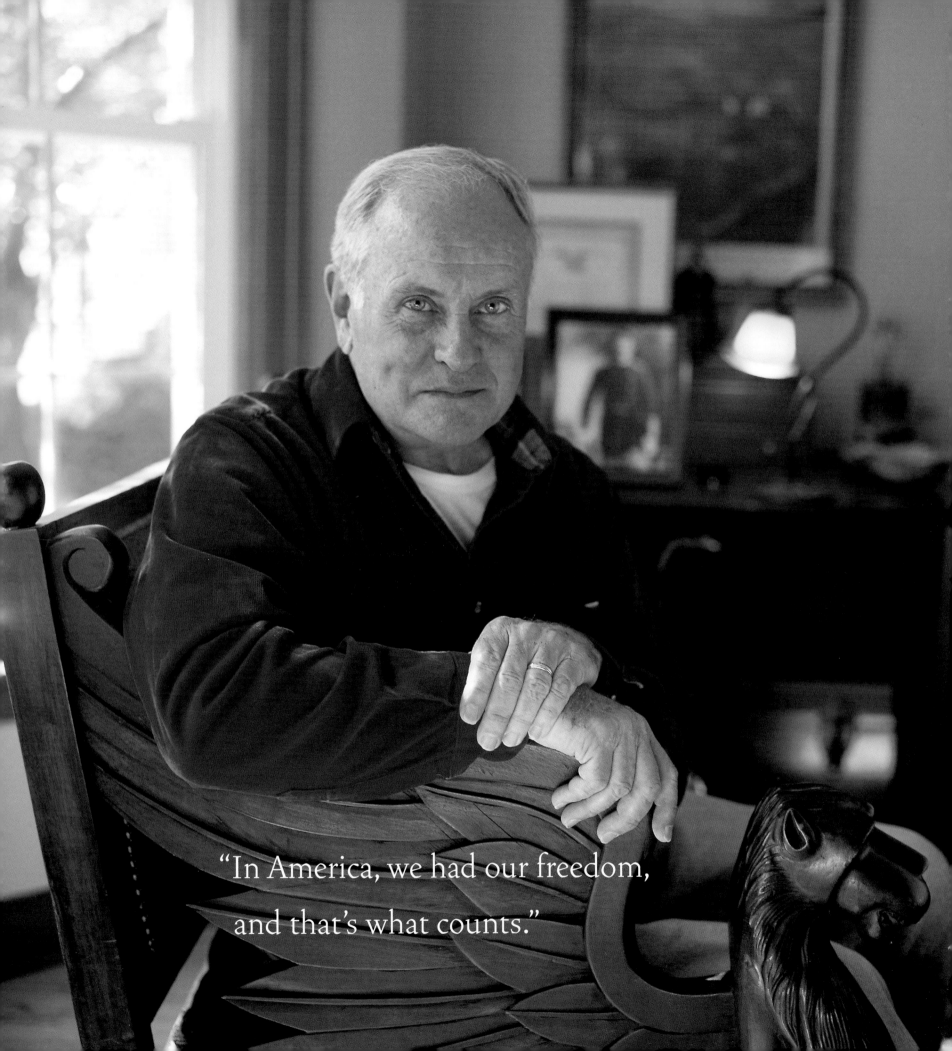

"In America, we had our freedom,
and that's what counts."

I am a third cousin to Michael Collins, the famous Irish freedom fighter, and freedom was always stressed in our family. I'm a thoroughbred — both my parents were Irish. My mother was from Skibbereen and my father from Clonakilty. My dad immigrated in 1923, right after the Civil War, and Mom came a few years later. They met in New York and got married in 1932, during the height of the Great Depression. Talk about optimism! Even though they arrived here with nothing, they were always generous. They had their freedom in America, and that's what counts. ◉ There was actually an interesting twist of fate that brought my mother to America. My mother's brother was involved in the Civil War. When tried for political uprising, he had the choice of going to a jail in England or to penal duty in Australia. ◉ Valuing his freedom and trusting God to send him in the right direction, he set off to Australia, where, after serving his sentence, he entered into business and became very successful. So successful, in fact, that he sent his sister a ticket to Australia. She was about to leave from Ireland when something happened that I consider very fortuitous. Otherwise, I wouldn't be here today. ◉ By accident, my mother overheard her parents' conversation, discussing their son's "Australian funeral" and how sad they would be if their daughter, too, went so far away. It was unlikely that they would see their children again. Hearing that and wanting to keep her parents happy, she decided to immigrate to America instead. ◉ She left Ireland with three gold sovereigns, but she never spent them despite the Depression and tough economic times in the 1970s. I only discovered them after she died; they are the only keepsakes that I have. They remind me of all the hardships that immigrants and their families endured, of the meager possessions that immigrants arrived here with, and of the lack of opportunity they faced at home and here when they first arrived. They also remind me of my father, who was forced to emigrate because he was the youngest son, and in Ireland, the family farm went to the eldest son, leaving nothing for him. But, most of all, those sovereigns remind me of the hope and charity that my parents had for us and instilled in us. My daughter married five years ago, and I gave her the sovereigns so that she, too, never forgets and passes on these values to future generations.

179

JIM COLLINS Retired finance manager, General Motors ◉ *Farmington, Minnesota*

Our city is a like an extended family of Irish Americans, all of whom follow many family traditions. I've lived here all my life, as have my parents. In fact, my mom, my aunt, my cousin, and I all went to the same school — St. Vincent's Academy. It's right next to the cathedral, and it's run by Mercy nuns. The same nuns that taught my mom are still there. My aunt, my dad's sister, Sheila Winders, taught there. The school was founded in 1845 and gives the same ring to all the girls who graduate. ◉ My great-great-grandparents came from County Kerry, Ireland. My dad has been tracing our family history, and we've found documentation that my great-great-grandfather got married in 1870. To do the research, we went to Kerry and met some of our cousins. It was so funny that they looked like us — this fellow Dennis looked like my grandfather, Joseph Patrick Counihan Sr. Next summer, we're going to Ireland again to continue our search. ◉ Here in Savannah, my great-uncle, Eddie Fahey, was the grand marshal of the St. Patrick's Day Parade in 2002. That is the greatest honor that an Irishman in Savannah can receive. We all walk together as a family. My dad, who is involved in all the Irish societies here in Savannah, knows everyone. ◉ As for my future, I'd like to do something in advertising. So, to secure my future, the last time we were in Ireland, I kissed the Blarney Stone.

CATHERINE COUNIHAN Student ◉ *Savannah, Georgia*

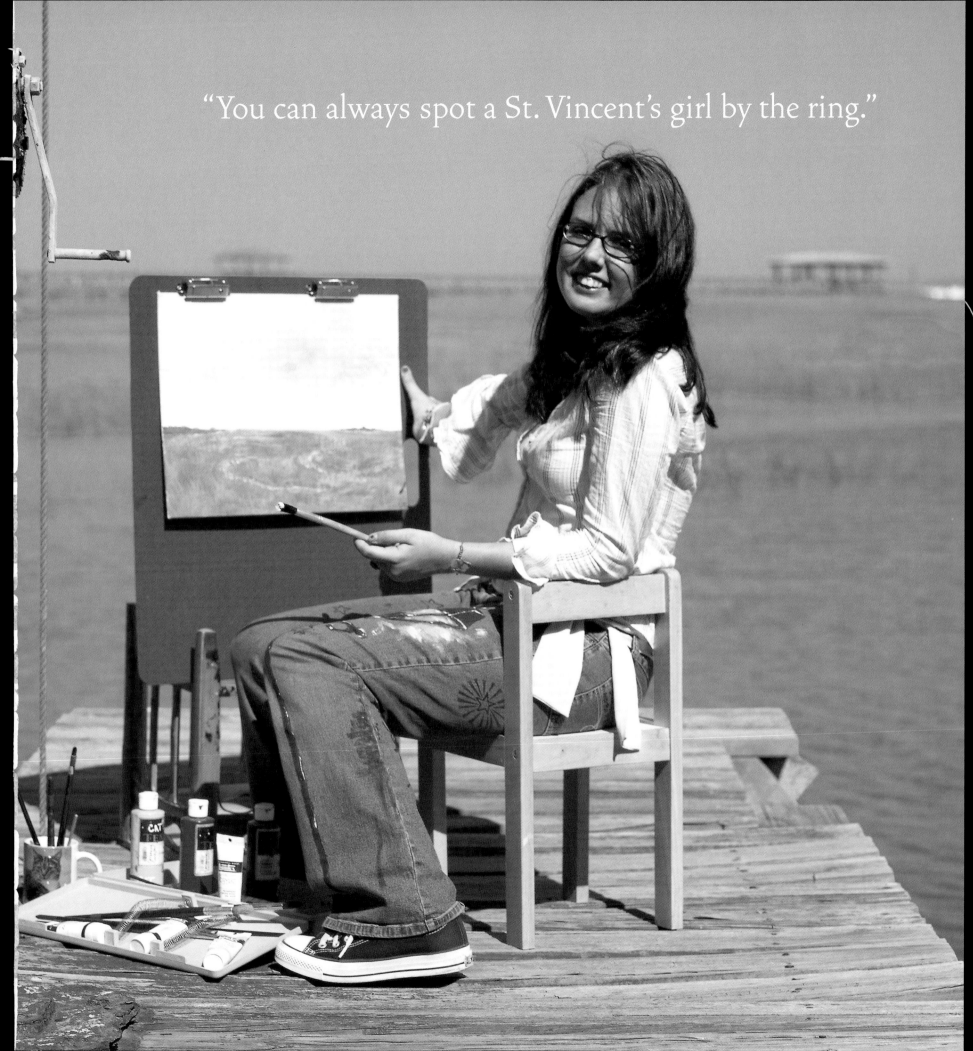

"You can always spot a St. Vincent's girl by the ring."

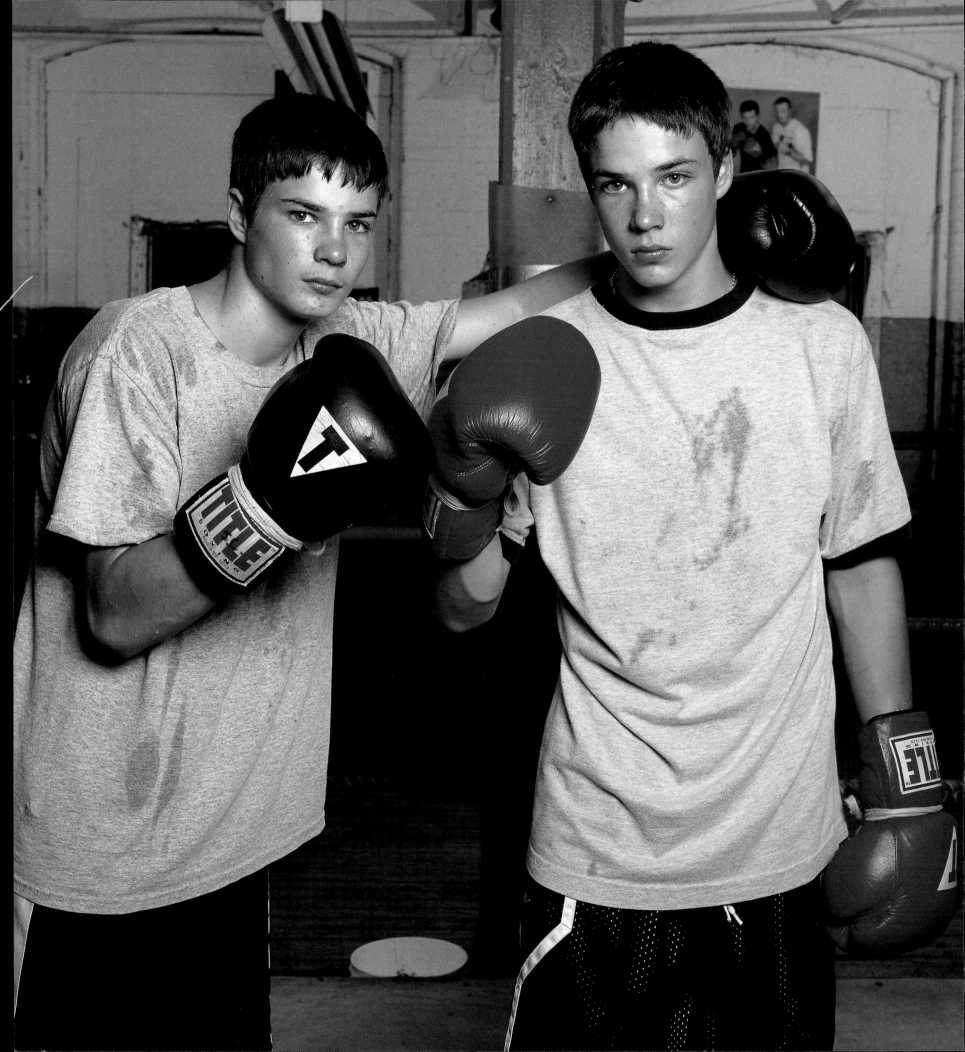

"We discovered old black-and-white pictures of our mom's uncle, Joe Fallon, a great Irish fighter, and we were inspired."

Our great-grandparents came from County Cork to settle in Boston. Our parents were born in Boston, and we grew up in Tewksbury. For as long as we can remember, we have always wanted to box, but our parents wouldn't let us until about a year ago. Our mom's uncle, Joe Fallon, was a boxer, so I guess she's scared of the risks. When we were really young, we found old pictures of my uncle in our basement. We were so proud. I mean, there are so many great Irish boxers. Mickey Ward, for example, was our idol! Now even our dad has gotten over his initial concern about boxing, and he's at every match! ⚙ We're middleweights now, and the training is really intense. We work out for two hours a day, lifting weights and boxing in the gym. And then, either before or after practice, we run a couple of miles. ⚙ We both want to go to college, but if either one of us is good enough to turn pro, he will.

JOE AND JOSH CROAKLEY Twin boxers ⚙ *Lowell, Massachusetts*

There are many things about my Irish heritage that I am proud of. But I like that fact that so many of the world's most famous athletes have Irish heritage — Mark McGwire, Paul O'Neill, Mark O'Meara, Derek Jeter, and even Muhammed Ali! ◉ I have pictures of all of them lining my room at home, for inspiration. I think of at least one of them every time I walk on the field. If I can be half as good at baseball or golf as any one of them, I will be a successful athlete.

CONOR McNAMARA Student ◉ *Long Island, New York*

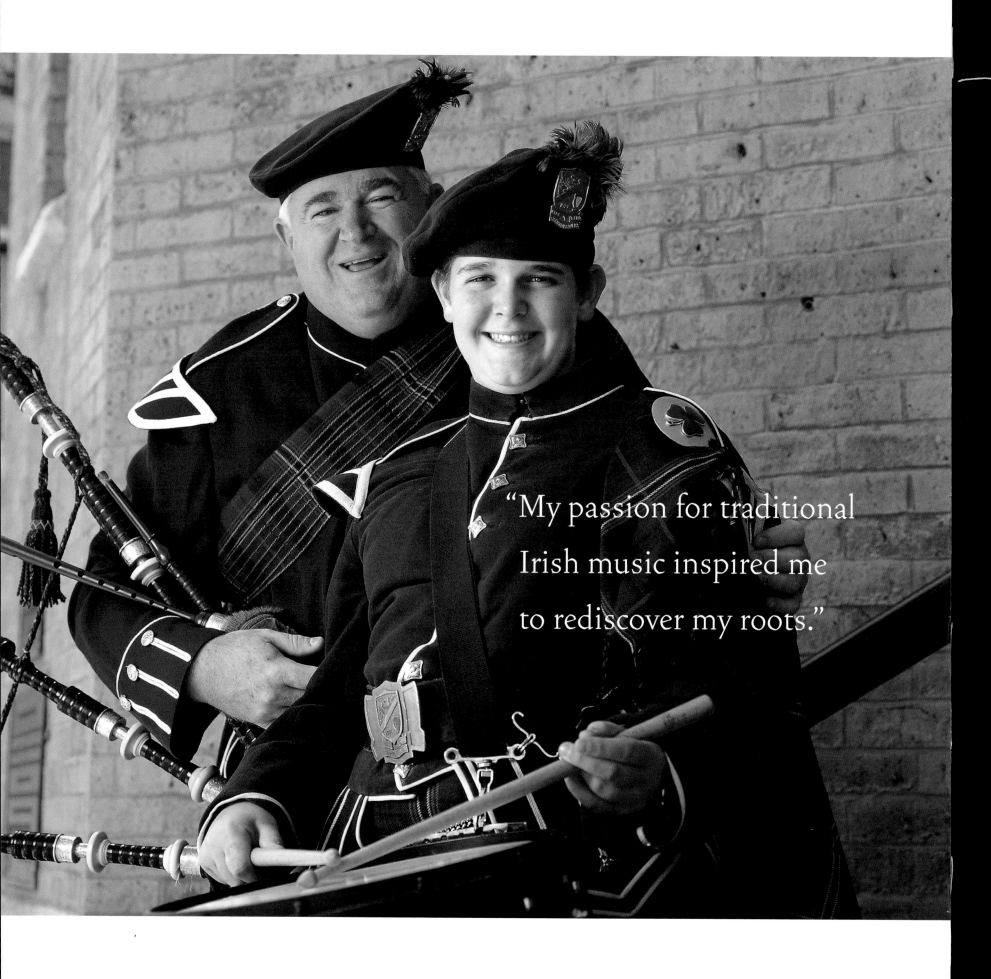

"My passion for traditional Irish music inspired me to rediscover my roots."

In my family, we carried on the Irish tradition of naming the firstborn son after his father. So my father is William Patrick Michael McTighe Sr., I'm the Jr., and my son is William Patrick Michael McTighe I. We're glad that we've carried on this tradition and think it's a shame that many have chosen not to. ◉ Despite embracing that part of the Irish culture, my parents, being second-generation Irish American, always stressed that we were American first and Irish second. For my parents, their closest tie to Ireland was their grandfathers, who immigrated here. So Ireland seemed to be a part of our distant past, while the American heritage dominated our day-to-day lives and self-identity. ◉ Ironically, my dad was the person who fueled my love for Irish culture. He was a Chicago policeman, and he took me to see the Shannon Rovers Irish Pipe Band. The band taught me to play the pipes. That was in 1967, and I'm still playing. In fact, the Shannon Rovers are the official band of the Chicago St. Patrick's Day Parade. I guess you could say that my passion for traditional Irish music inspired me to rediscover my roots. ◉ Of course, I'm still American, but Irish culture plays such a strong role in my life and the life of my children. For years I've been on the board of the Irish Fellowship Club, a local charity in Chicago comprising many of the city's prominent Irish-American business, political, and community leaders. One of the main objectives of the group is to provide high school scholarships to needy children of Irish descent. My work in this area has helped hundreds of teenagers reconnect with their culture. ◉ And we've passed this love of all things Irish to our three children, Billy, Mary Kate, and Maura. They've all shown a love of traditional Irish music and dance. Billy is going into the eighth grade. After dancing with the Mullane School for four years, he started playing the snare drum and is beginning pipe lessons soon. My daughters are phenomenal Irish set dancers. ◉ As for me, I've tapped into an incredibly rich heritage that I never knew much about. Soon, I'll be taking this love of all things Irish a step further. After the Shannon Rovers play in the St. Patrick's Day Parade in Chicago this year, we're heading straight to the airport to board a plane — we're taking the band to Ireland.

BILL McTIGHE JR. AND SON Piper ◉ *Chicago, Illinois*

St. Patrick's Day seems to be a common theme in my life. My earliest memories of family outings are of celebrating St. Patrick's Day with the close-knit community in the Irish Channel, where we were all born. It was my dad's favorite holiday. Now we go without my dad, but we remember him. He had a wonderful sense of humor, never knew a "stranger." My dad was your typical Irishman — big, burly, dark hair with green eyes; my mother was a redhead with blue eyes. Everyone would comment on how "Irish" we look. ❀ My husband was born on St. Patrick's Day but is of French heritage. Two of my dogs, Irish setters, of course, happened to be born on St. Patrick's Day. As a child, I spotted my uncle's Irish setters, with their mahogany coats gleaming in the sun, running against the green grass. It was truly beauty in motion. From that day forward, I knew I had to have those dogs in my life. ❀ It wasn't surprising that Ryan, my first dog, was born on St. Patrick's Day. In fact, his grandmother was also born on St. Patrick's Day. Named Ryan because it means "little king" in Gaelic, he is now a retired showdog. My female dog, Demi, is the most ladylike dog I've ever met. We named her after her penchant for drinking café au lait out of a demitasse cup. Mick, the baby, is now six months old and is appropriately named because he's a little ornery Irishman. When my dad used to become angry with my siblings and me as kids, he would yell, "OK, you Micks, get in line." My cat, Annie O'Leary, rounds out the household. ❀ Obviously, the other theme of my life is a love of animals. I started caring for animals at a young age because we grew up across the street from the local vet. Now this love has been passed on to my children. My oldest daughter is a vet in Maryland, and my youngest daughter works as the office manager for a vet. ❀ When I was growing up, my parents always stressed giving back to the community. I've been lucky enough to combine my charity work with my love of animals. Two of my dogs have been certified as therapy dogs; they're so gentle. They work with sick children at the hospital. Their size is what makes them good therapy dogs because they can put their head right on the bed. When people think of their Irish heritage, they shouldn't forget the dogs. The Irish setter is a wonderful ambassador.

202

SUE NOLAN MELANCON Manager, veterinary hospital
Irish setter breeder ❀ *New Orleans, Louisiana*

"As a child I spotted my uncle's Irish setters,
mahogany coats gleaming in the sun. . . .
I knew I had to have those dogs in my life."

"Since I was a child I've wanted to go to Notre Dame."

My great-great-grandfather on my father's side, John Mulvaney, came from the Mayo area and settled in central Illinois. On my mom's side, her great-grandfather, John Kelly, came over in the 1850s from County Cork. My paternal grandmother's older sister was born in Castlebar, Mayo, and her other four sisters were born in the United States. Our roots have been in America for a long time. ● We inherited a few traits from our ancestors, especially our strong work ethic and commitment to education. All of my relatives were very hardworking. John Mulvaney was an engineer and a lawyer. Another relative, John Gibbons, fought in World War I for Britain; after the war he came to the United States and built and ran streetcars. ● But it was my immediate family, especially my dad, that influenced me the most. My dad went to Notre Dame. I've wanted to go there since I was a child. And now I'm in my third year. I'm a history major, and Adene O'Leary's class on Irish history made such an impact on me that I decided to make Irish studies my minor. ● And now my next goal is to visit Ireland to see firsthand the place that I have heard about for so long. I hope I can visit Ireland with the Notre Dame Irish studies program — that would be the ultimate combination!

MAUREEN MULVANEY Student, Notre Dame University ● *Notre Dame, Indiana*

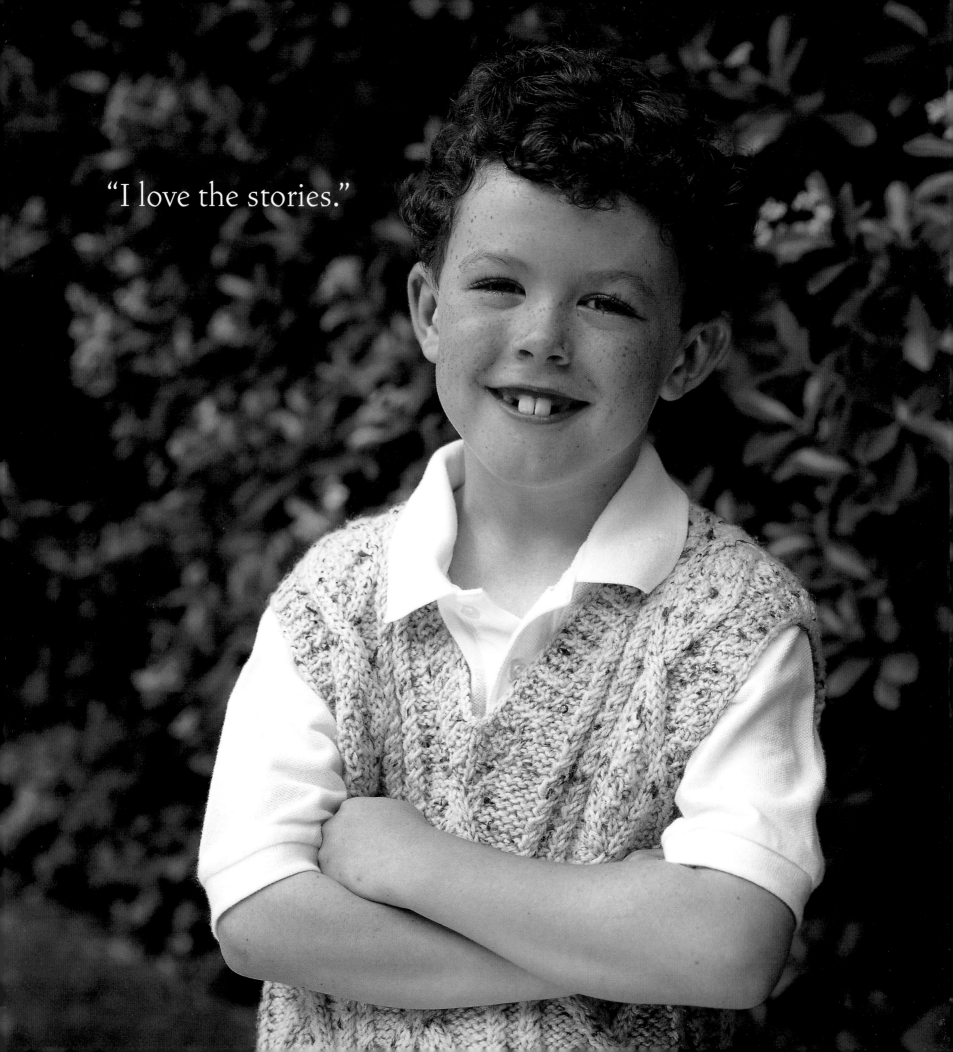

"I love the stories."

I love being Irish, and many things come to mind when I think of my culture. I think of hurling and of when I saw a hurling match in my Gran's county, Waterford. I think of Barry Power, my friend from Waterford who gave me my first hurly. When it rains, I think of being in Ireland. I love history, so I also think of the history of the Celts and of the Irish castles and caves. I also love Irish candy — like the caramels called Stars and Buttons. I like Irish music and am learning how to play piano. I think of the patron saint of Ireland, who I am named after. I think of St. Patrick's Day. My mom told me that she and my dad took me to my first St. Patrick's Day Parade in New York City when I was nine months old. She said that I fell asleep and got a sunburn on my face. ❂ Most of all, I think of the stories my Gran tells me about when she grew up in Waterford. I have thousands of cousins and uncles and aunts there, and I can't wait to go there to meet them all.

PATRICK D. PILCH Student ❂ *Manhasset, Long Island*

My Irish ancestors came from the most geographically diverse points in Ireland — Mayo, Cork, Clare, and Tipperary. They all came from farming families and melded into one family in Brooklyn, New York, between 1912 and 1915. ⚙ As many Irish families did, ours flourished in an urban setting. Beginning with our great-grandfathers and ending with my husband, we have a total of 100 years of police service in our family. Our grandmothers followed in the steps of so many Irish lasses and became domestics, learning the manners of the well-to-do. They passed on these social lessons to their children, ensuring their rapid ascent into American society. Although we grew to love city life for all its excitement and attractions, our roots called us back to the home country. My husband and I moved our family to upstate New York, an area that resembles Ireland, with its green rolling hills. ⚙ Living here, with our eight children, has allowed us to appreciate a normal pace of life and to celebrate our family. My husband and I have tried to instill traditions in our children and in our grandchild. Every Sunday, we have a huge family dinner, and whoever is nearby will show up. My husband is a big fan of Irish music and ensures that the house is always alive with it. Two years ago, at my daughter's wedding, there was a whole set of Irish music, and everyone, family or not, thoroughly enjoyed it. We've always relied on a sense of humor and strong faith in God to get us through the most difficult times. But we also believe strongly in luck. You see, in Irish tradition the seventh son of the seventh son has special luck. My husband is the seventh son and we have seven sons. ⚙ What that luck will bring us, we're not sure. But we're hoping to pass it on to our grandchildren. We have one grandson, Jack, and are expecting the next one any day now.

CAROLYN SWEENEY Homemaker ⚙ *Rosendale, New York*

"My husband is the seventh son, and we have seven sons."

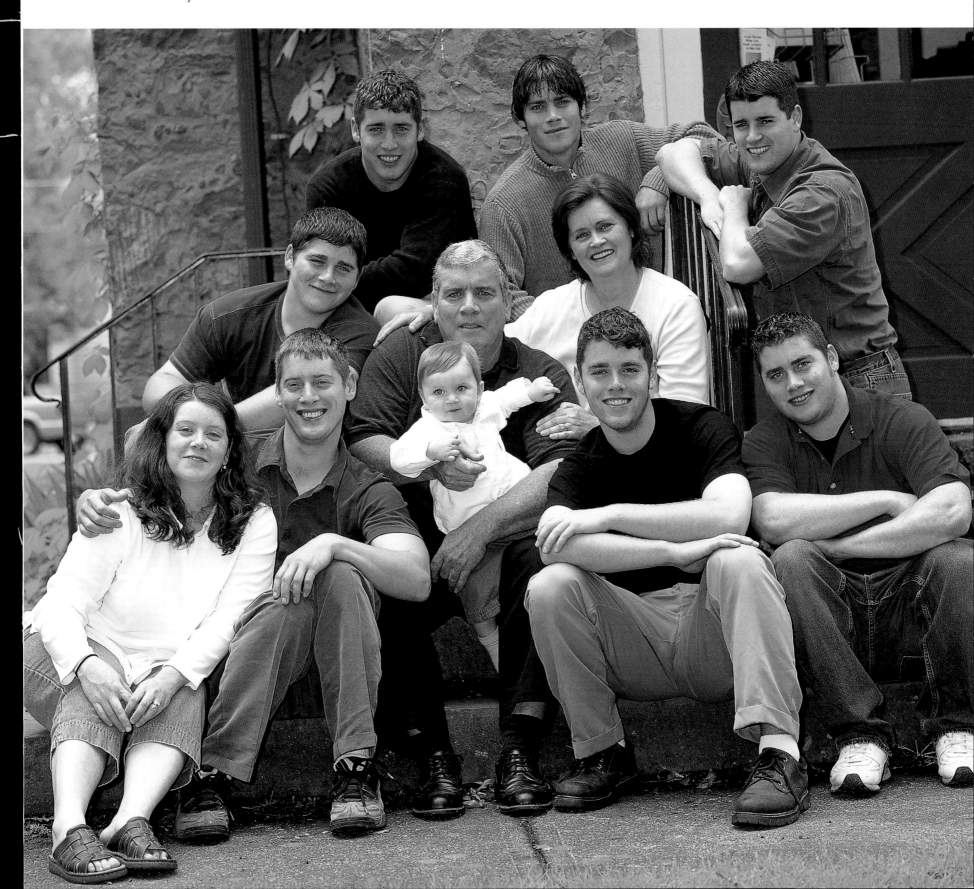

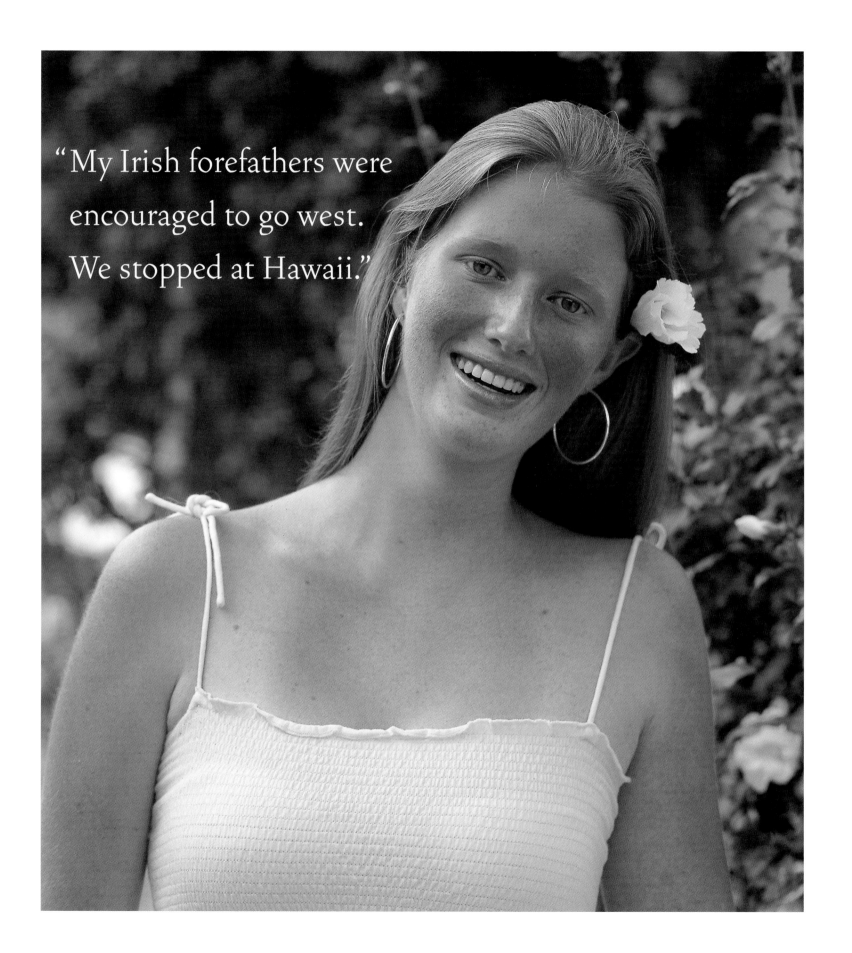

"My Irish forefathers were
encouraged to go west.
We stopped at Hawaii."

Leaving County Cork with his expectant wife, my great-grandfather journeyed to Winnipeg, Canada, in search of a better life. A few days after they got off the boat, my grandfather was born. That journey and subsequent freezing temperatures made my great-grandfather extremely tough. It's no wonder he became a boxer. At fifteen, he went to the San Francisco area to further his career. Fighting under the assumed name "Doug Irish Costello," he eventually won many titles. His real name was Patrick, and although he liked his real name well enough, he didn't want his mother to know his profession. She was strongly opposed to "the fighting," as she called it. Plus, he was underage. I often wonder how he kept it hidden from her. ◉ When I reflect on my past, I know that I inherited his "fighting spirit." He taught me to have patience and determination, to never give up, and to always strive to win. This spirit helps me win when I play competitive volleyball. Luckily, I've inherited athletic ability from both sides of the family. My older brother, Ryan, plays college volleyball at the University of California at San Diego. My other brother, TJ, plays in baseball, soccer, and basketball leagues. My great-grandfather played semipro baseball on the Tri-I team, made up of players from Iowa, Indiana, and Illinois. He later became a coal miner, and then a gold miner in Grass Valley, California. He was the epitome of "Go west, young man." Grandmother was a captain of the college basketball team. She was also a sharpshooter. My mom and dad both played volleyball at Pepperdine. My mom, Debra, was on the U.S. national team that was supposed to go to Russia the year we boycotted the Olympics. It was such a shame because she had worked so hard for that. She had moved to Los Angeles and had trained every day for five years to become an Olympic athlete. ◉ We can also thank our grandfather for our Irish temper. My grandfather, my mom, and I all have it. My mom always told me that I descend from the two most hotheaded races. My great-great-grandmother was half Cherokee. I'm not sure which side the hottest temper comes from, but I certainly have the red hair to match my red-hot temper.

KYLIE ZABRISKIE Student ◉ *O'ahu, Hawaii*

AFTERWORD

For almost two years we conducted a photographic and journalistic tour, meeting Irish Americans across the United States. Some of the people we met were famous; many were not. One lad had just made his First Communion, while another woman had just celebrated her one-hundredth birthday. No matter the age, no matter what part of the country they came from, all were proud of their Irish heritage and proud to be American. They all took their heritage seriously and actively celebrated it through family, social, religious, and musical organizations. ⊚ The beauty of this project is that the contributors shared with us their love of Irish-American culture through words of their own. The question we posed — What is the aspect of your Irish heritage that you are most proud of, and how has it helped you become the person you are today? — brought about lots of wonderful stories. The language of this love of heritage is shown not only in words, but also in faces. It's a glance, a twinkle in the eye, a glimpse into the soul. ⊚ Capturing Irish Americans through words and photographs was a deeply rewarding endeavor. These people are very special indeed — as energetic and diverse as America itself. We've met Irish Americans who live in tiny apartments, and others who live on cattle ranches; some whose Irish roots can be traced back generations, and some who have just started researching their past. All the people in the book have one similarity — they all love life, and life loves them back. ⊚ Through this cultural journey, we have come to know and love a people who possess many wonderful characteristics and who, above all, are very generous and kind. Generous and kind to family and friends, generous and kind to this writer and photographer. ⊚ *The Irish Face in America* is our tribute to Irish Americans. In it we have portrayed themes that are important to Irish Americans — the sanctity of family; the power of education; the endurance of faith; and the importance of passion, perseverance, and humor. This book holds the story of an extraordinary group of people. We stand in their shadow, knowing it is a privilege.

JULIA MCNAMARA AND JIM SMITH

ACKNOWLEDGMENTS

The Irish Face in America was made possible through the generosity and cooperation of countless people. This book would not exist without the enormous gifts of time, hospitality, and goodwill from the subjects of our photographs and interviews. We want to thank in a special way the models and their families and all the people who helped us along the way — there are simply too many to thank by name. ◎ A special word of acknowledgment and appreciation to the sponsors — Kodak, Guinness-Bass Import Company, and Mr. John Dearie of Irish Radio. Without their financial support and faith in our vision, we never could have gotten this project under way. A special thanks, as well, to all the Irish-American organizations across the country that helped us find models and supported us along the way. This includes but is not limited to: Glucksman Ireland House, the Irish-American Historical Society, the Irish Arts Center, the Irish American Society of New Orleans, the Ancient Order of Hibernians of Savannah, the Ireland Funds, the New Irish Program of San Francisco, the Irish American Society of Chicago, *Irish America Magazine*, the *Irish Echo*, the *Irish Gazette, IrishAbroad.com*, the Irish Tourist Board, Irish Radio, and WFUV. ◎ Special thanks to Mary Jo McConahay of the Pacific News Service, Gary Fong of the *San Francisco Chronicle*, and Dr. David Coady for their research and assistance with Father Bill O'Donnell. ◎ An especially warm thanks to Dr. Eileen Reilly of Glucksman Ireland House, Mike and Belle Mathis, and the entire staff at IMG Worldwide. ◎ Colleagues helped throughout the project. We very much appreciate the vision and constant enthusiasm of Julia Lord, our agent. We want to thank Ashma Vohra at the Duggal color lab in New York City. She monitored thousands of photos with care and charm. We also want to thank all at Bokland Custom Visuals in Albany, New York. We want to thank Irwin Miller of Calumet, who kept an eye on the upkeep of our cameras. We want to thank Don Snyder and Maryann Murphy of Hasselblad, who repaired and renewed very overworked Hasselblad cameras. Also, sincere thanks to Tedd Rama and Amelia Panico for their continued creative support. ◎ To the many people who hosted us and entertained us while on the road, we want to express our gratitude: thank you to Wayne Gisslen, Joan Thiry, Stephen and Meryl Titra, Heather Woods and Laura Smith, Christine McCarthy, Karen Duffy, Merv Griffin, and the Beverly Hills Hilton. ◎ An especially warm thank you goes to our generous contributing authors: Mary and Carol Higgins Clark, Terry Golway, Don Keough, Patricia Harty, and Pete Hamill. This book sails on their fine words, powerful ideas, and enormous talent. ◎ We also owe a debt of gratitude to the photo assistant and production manager, Ryan Basten. His time, talent, and sense of humor made the challenging work for this book possible and enjoyable. A note of heartfelt appreciation goes to Judy Lieberman, who helped produce many of the images. ◎ Thank you to Michael L. Sand, Eveline Chao, and the production staff at Bulfinch. We owe you a debt of gratitude for supporting our vision, and coordinating and producing our book with such loving care. ◎ Last but not least, we would like to thank our families: the McNamara family — Eileen, Ed, Kim, Dennis, Barbara, Conor, Caitlin, Kelly, and Marisol — whose faces provided Julia the motivation for this book; and the Smith family — Camille, Jim, Laura, Luke, Alison, and especially Anne Smith — who inspire Jim more than they will ever know.

CONTRIBUTOR BIOGRAPHIES

Terry Golway is city editor for the *New York Observer* and the author of several acclaimed books on Ireland and Irish Americans, including *The Irish in America* (edited by Michael Coffey); *Irish Rebel: John Devoy and America's Fight for Ireland's Freedom; For the Cause of Liberty: A Thousand Years of Ireland's Heroes; Full of Grace: An Oral Biography of John Cardinal O'Connor;* and *So Others Might Live: A History of New York's Bravest — the FDNY from 1700 to the Present.* Terry is married to Eileen Duggan and has two children, Katie and Conor. His father was a New York City fireman.

Pete Hamill is a columnist for the *New York Daily News* and the author of fifteen books. He was born in Brooklyn, New York, in 1935, the oldest of seven children of immigrants from Belfast, Northern Ireland. He has been a columnist for the *New York Post,* the *New York Daily News, Newsday,* the *Village Voice, New York* magazine, and *Esquire.* He has served as editor in chief of both the *Post* and the *Daily News.* He has published eight novels and two collections of short stories. His 1997 novel *Snow in August* was on the *New York Times* bestseller list for four months. His memoir, *A Drinking Life,* was on the same list for thirteen weeks. His other books include *Why Sinatra Matters,* an extended biographical/cultural essay, and *Diego Rivera,* an illustrated volume on the Mexican painter. His ninth novel, *Forever,* was published by Little, Brown and Company in the fall of 2002.

Patricia Harty, a native of Tipperary, is editor in chief and cofounder of *Irish America Magazine*, a publication devoted to the political, economic, social, and cultural issues of paramount importance to the Irish in the United States. *Irish America* has helped reestablish the Irish ethnic identity in the United States and has spotlighted political and business leaders, organizations, writers, and community figures who previously had no national vehicle for their aspirations. Harty is also cofounder of the *Irish Voice* newspaper, a weekly publication aimed at the immigrant Irish. She serves on the advisory boards for the Emerald Isle Immigration Center; SuitAbility, a nonprofit welfare-to-work program for women; and Glucksman Ireland House, New York University's center for Irish studies.

Mary Higgins Clark, born and raised in New York City, is the author of twenty-four internationally bestselling novels and short stories. She is a trustee of Fordham University and a member of the Board of Regents at St. Peter's College. She has thirteen honorary doctorates and was made a dame of the Order of St. Gregory the Great, a papal honor. She is also a dame of Malta and a dame of the Holy Sepulcher of Jerusalem. In April 1997 Mary received the Horatio Alger Award. She is an active advocate and participant in literacy programs. She was awarded the Grand Prix de literature of France in 1980, was chairman of the International Crime Congress in New York in 1988, and was, for many years, on the Board of Directors of the Mystery Writers of America.

Carol Higgins Clark was also born in New York City. She is the author of seven bestselling Regan Reilly mysteries and coauthor of two holiday suspense novels she wrote with her mother, Mary Higgins Clark. After obtaining her BA from Mount Holyoke College, Carol studied acting in New York and then at the Beverly Hills Playhouse. She has appeared in film, theater, and television series. She enjoys recording her novels and received AudioFile's Earphones Award of Excellence for her reading of *Jinxed*. Her novel *Decked* was nominated for both an Anthony and an Agatha award for best first novel.

Donald R. Keough is chairman of the board of Allen & Company Incorporated, a New York investment-banking firm. He retired as president, chief operating officer, and a director of the Coca-Cola Company in April 1993, positions he held going back to early 1981. His tenure with the company dates back to 1950. In addition, from 1986 to 1993 he served as chairman of the board of Coca-Cola Enterprises, Inc., the world's largest bottling system. From 1985 to 1989, he was chairman of Columbia Pictures, Inc., before it was sold to Sony, Inc. ⚙ Keough is currently on the boards of USA Interactive, YankeeNets LLC, Convera, and Berkshire Hathaway Inc., to which he was elected in May 2003. In addition, he is a member of the boards of McDonald's Corporation, the Washington Post Company, H. J. Heinz Company, and the Home Depot. He is chairman emeritus of the Board of Trustees and a life trustee of the University of Notre Dame and is a trustee of several other educational, charitable, and civic organizations. Keough was elected a fellow of the American Academy of Arts & Sciences in 2002 and inducted into the Junior Achievement National Business Hall of Fame in 2003.